THE ART OF COLOR AND DESIGN

"If arithmetic, mensuration and weighing be taken out of any art, that which remains will not be much."

Plato, in *Philebus*

"Those who are enamoured of practice without science are like a pilot who goes into a ship without rudder or compass and never has any certainty where he is going."

Leonardo da Vinci

"It is ordained that never shall any man be able out of his own thoughts to make a beautiful figure, unless by much study he hath stored his mind."

Albrecht Dürer

"One ought never to forget that by actually perfecting one piece one learns more than beginning or half finishing ten. Let it rest, let it rest and keep going back to it and working at it over and over again until there is not a note too much or too little, not a bar you could improve upon. Whether it is beautiful also is an entirely different matter, but perfect it must be . . . perfected, unassailable."

Johannes Brahms

"The artist is born to pick, and choose, and group with science, these elements, that the result may be beautiful—as the musician gathers his notes, and forms his chords, until he bring forth from chaos glorious harmony."

James A. McNeill Whistler

"The imagination voyaging through chaos and reducing it to clarity and order is the symbol of all the quests which lend glory to our dust."

John Livingston Lowes,
in *The Road to Xanadu*

"As our art is not a divine gift so neither is it a mechanical trade. Its foundations are laid in solid science; and practice, though essential to perfection, can never attain that to which it aims unless it works under the direction of principle."

Sir Joshua Reynolds,
in his seventh "Discourse"

"The actual process of studying and understanding the working of a natural design law, opens up a world of new ideas and frees the mind for real creation. Its very impersonal element encourages originality and precludes imitation. Knowledge of a basic law gives a feeling of sureness which enables the artist to put into realization dreams which otherwise would have been dissipated in uncertainty.

"As the trend of the individual and of society seems to be toward an advance from feeling to intelligence, from instinct to reason, so the art effort of man must lead to a like goal.

"The world cannot always regard the artist as a mere medium who reacts blindly, unintelligently, to a productive yearning. There must come a time when instinct will work with, but be subservient to, intelligence . . . In art the control of reason means the rule of design. . . .

"The determination of the form principles in a specific example of design means, in a sense, the elimination of the personal element. With this element removed the residue represents merely the planning knowledge possessed by the artist. . . . Invariably the higher or more perfect the art, the richer is the remainder when the personal element is removed."

Jay Hambidge,
in *The Elements of Dynamic Symmetry*

MAITLAND GRAVES

THE ART SCHOOL—PRATT INSTITUTE

The Art of
Color and Design

SECOND EDITION

McGRAW-HILL BOOK COMPANY, INC.

NEW YORK TORONTO LONDON

1951

Preface

Today we are all made acutely aware of a disturbing transition. Although history shows that these periods are recurrent, the present phase seems to be one of unusually rapid, complex, and extensive change. Bewildering shifts in social, ethical, economic, and political standards are following the clash of conflicting ideologies. Contemporary art naturally reflects this instability and lack of homogeneity in values. Perhaps never before have artists been so devoid of common ideals and criteria. Esoteric cults and antagonistic "isms" such as cubism, vorticism, Dadaism, and surrealism have created new tensions and much confusion.

They builded a tower to shiver the sky and wrench the stars apart,
Till the Devil grunted behind the bricks: "It's striking, but is it art?"
The stone was dropped by the quarry-side and the idle derrick swung,
While each man talked of the aims of art, and each in an alien tonque.[1]

Symptomatic of this confusion in art is the glib repetition of such ambiguous stock phrases as "significant form," "plastic relations," "feeling," and other terms so hackneyed as to have lost whatever meaning they may have originally held. Like "love" and "beauty" they are subject to many interpretations, some of which are vague or dubious.

[1] Rudyard Kipling.

Are certain harassed and puzzled art critics partly responsible for this ambiguity? Does their profession, placing them in a position of forced comment, occasionally compel them to take refuge behind verbal smoke screens of obscure or meaningless terminology?

If you're anxious for to shine in the high aesthetic line as a man of culture
 rare,
You must get up all the germs of the transcendental terms, and plant them
 everywhere.
You must lie upon the daisies and discourse in novel phrases of your
 complicated state of mind,
The meaning doesn't matter if it's only idle chatter of a transcendental
 kind.
 And everyone will say,
 As you walk your mystic way,
"If this young man expresses himself in terms too deep for me,
Why, what a very singularly deep young man this deep young man must
 be!"[2]

It would seem evident, therefore, that design principles and terminology need to be clarified and integrated on the basis of common experience, common understanding. On this neutral ground of reason the conservative and the radical artist may meet and exchange mutually helpful ideas.

Architects, for example, may disagree as to standards. Nevertheless, whether they are proponents of classicism or functionalism, they are in accord regarding mechanical principles. Whether it is the Parthenon or a modern skyscraper, a building is subject to gravitation and stands or falls according to whether or not the physical stresses have been correctly calculated. The same principle applies to the visual arts, for aes-

[2] From *Patience* by W. S. Gilbert.

vi

thetic structure is also subject to natural forces that are as potent as gravity. The artist builds with line, shape, and color. It is upon the integration of these elements that the success of any composition depends.

Many artists adopt a subjective approach and perhaps achieve such organization intuitively. They might, however, attain greater success if they had a conscious perception of aesthetic order. "The spontaneous untutored outpouring of personal feeling does not go very far in art. It is only the practiced hand that can make the natural gesture—and the practiced hand has often to grope its way."[3]

In the following pages it will be demonstrated that the time arts and the space arts are built on principles of order whose aesthetic validity is based on their psychobiological and sociological origin in the fundamental pattern of human behavior. It will be shown that—whether expressed temporally or spatially—these principles retain their basic character, and effect similar results in all art forms. These principles establish the basis for universal criteria that promote a keener perception and a broader, more integrated concept of aesthetic order. The artist and his creation can be no more universal than his criteria—his standards are the measure of the man and his work.

If the artist is to escape the dwarfing, distorting danger of narrow specialization—which has produced so many modern monstrosities—he must see his work big and he must see it whole. He must see it in relation to other art forms, and he must have the historical perspective to see its place in the structure of civilization on which he stands and on which he builds. He must cultivate the broad vision of the Renaissance man

[3] Willa Cather. See other quotations on page ii.

epitomized by Leonardo da Vinci—poet, painter, philosopher, musician, scientist, and architect. It is hoped that the following pages will contribute to the growth of this broad vision by stimulating further study of the manifestations of the principles of universal order in all art forms.

It is hoped that this book will be helpful to all practitioners of the space arts—to illustrators, photographers, nonrepresentational painters, sculptors, architects, decorators, industrial designers, art instructors, and their students. Its purpose is an orderly, clear, and simple analysis of the elements and principles upon which all visual art is built.

<div align="right">Maitland Graves</div>

New York, April, 1951

Contents

The Plan of Design Study

IN order to make our study of design as clear and simple as possible, we have divided it into the three following parts:

PART ONE: THE ELEMENTS OF DESIGN

In Part One we shall present and illustrate the seven elements of design. These elements are the materials from which all designs are built. The seven elements are

> Line.
> Direction.
> Shape.
> Size.
> Texture.
> Value.
> Color.

PART TWO: THE PRINCIPLES OF DESIGN

In Part Two we shall define the principles of design and illustrate the various ways in which the elements are related or organized according to these principles. We shall demonstrate that the aesthetic validity of the principles of design is predicated on their psychobiological and sociological origin in the

fundamental pattern of human behavior. We shall show that
—whether expressed spatially or temporally—these principles
of aesthetic order retain their basic character and effect similar
results in all art forms. It will be shown how these design prin-
ciples are used in the time arts and in the space arts. The prin-
ciples of design, aesthetic order, or art structure that will be
analyzed are

> Repetition.
> Alternation.
> Harmony.
> Gradation.
> Contrast, Opposition, or Conflict.
> Dominance.
> Unity.
> Balance.

PART THREE: ANALYSIS OF THE DESIGN ELEMENTS

Finally, in Part Three, we shall analyze or dissect the ele-
ments of design in the following order:

> Line.
> Direction.
> Texture.
> Proportion, or Size Relationship.
> Value.
> Color.

Part One

THE ELEMENTS
OF DESIGN

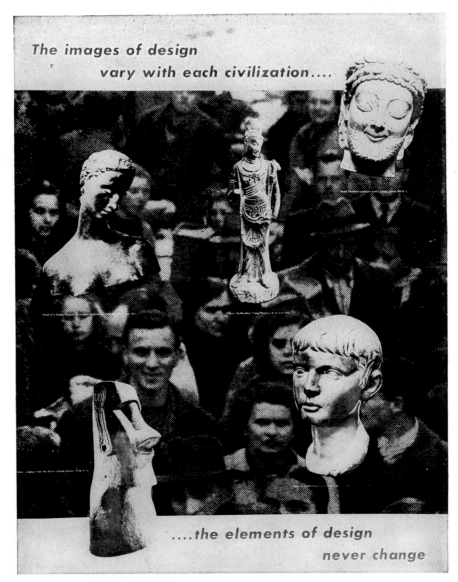

The images of design vary with each civilization....

....the elements of design never change

Courtesy of The Museum of Modern Art

2

CHAPTER I

The Elements of Design

ALL visual design may be reduced to seven elements, factors, or dimensions. These elements are line, direction, shape, size, texture, value, and color. These elements are the building blocks of art structure. They are the alphabet or scale of graphic expression. When an artist organizes these elements he creates *form*, which is design or composition. Art is man-made order, that is, structure or form.

In representational art the elements of line, shape, texture, and color are used to describe, depict, or illustrate solid objects in three-dimensional space. The effect of the subject matter of a picture relies on its appeal to reason, that is, upon our ability to recognize or perceive its meaning. Representational art is a convention. Although habit, training, and education have prepared us to accept this convention and respond to its appeal, we realize, nevertheless, that the objects and space are merely an illusion and do not exist. We know that they are only flat, colored patterns on a two-dimensional surface.

But a line, shape, texture, or color is a concrete actuality. These elements are more real than the objects that they rep-

resent. Their effect does not depend upon an appeal to our intellect but to our primary instincts, which are deeper, more fundamental. They make a direct visual impact; they evoke an immediate, vigorous response. The elements and the principles of design that govern their relationship are, therefore, real and powerful forces. If we would control and direct these forces, we must understand the elements and principles of design.

"THE BREAKER" BY LAMAR DODD

"BLACK-TOP TABLE" BY LAMAR DODD
(Turned upside down.)

Design versus Subject. These paintings were deliberately designed as two variations of the same compositional theme. Although the subjects of these pictures are completely dissimilar and unrelated, the pictures are, nevertheless, more alike than different because of similarity of design. This fact demonstrates that we may perceive and respond to the design of a picture more than we perceive and respond to its subject matter or representational content. In representational art, therefore, the elements and principles of design are as important as the subject. See Juxtapositions, pages 26 and 127. (*Both courtesy of the Luyber Galleries, N. Y.*)

5

The Elements

1. LINE
First, there is the line, either straight or curved.

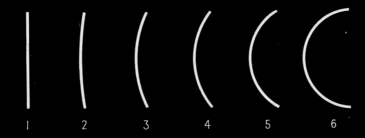

Adjacent lines such as 1 and 2 or 5 and 6 are similar or harmonious. 1 and 6 are in contrast or opposition to each other.

2. DIRECTION

A line has direction. The four primary directions are horizontal H, vertical V, left oblique L, and right oblique R.

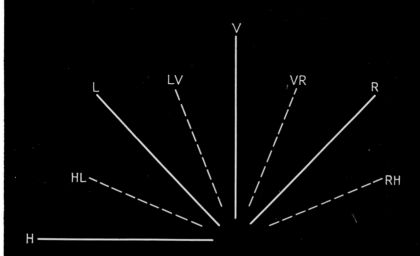

Adjacent directions such as V and VR or H and HL are similar or harmonious. Directions at right angles to each other such as H and V or LV and RH are complementary, being in opposition or contrast.

3. SHAPE

A series of lines of different directions defines a shape or pattern, triangular, round, and so forth.

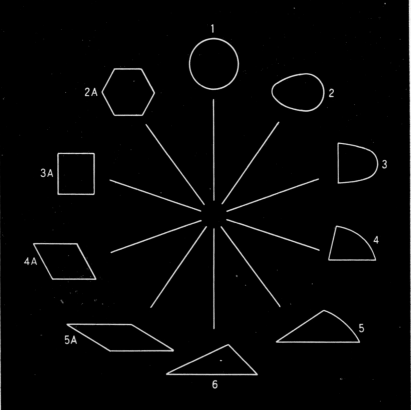

PATTERN OR SHAPE CIRCUIT

Here, as in the hue circuit on page 12, adjacent shapes such as 1 and 2 are similar or harmonious; shapes diametrically opposite such as 1 and 6 are contrasting.

4. SIZE

Lines and shapes, and the space intervals between them may differ in size or measure. Shapes A and B and space intervals R and S are harmonious or similar in size. Shapes A and E and space intervals R and U are contrasting in size.

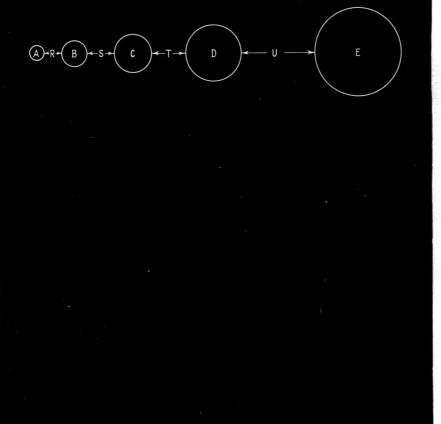

5. TEXTURE
A line or shape has texture, rough, smooth, and so forth.

As with the other elements, there is harmony and contrast of texture.

6. VALUE

A line or shape has value, black, white, or gray.

Neighboring values such as 1 and 2 or 8 and 9 are in harmony. Values 1 and 9 are opposed or contrasted.

7. COLOR

A line or pattern may have color, red, blue, yellow, and so forth.

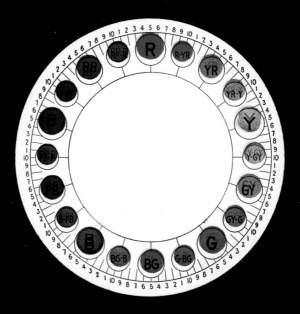

Adjoining hues such as red and red-purple are harmonic. Hues diametrically opposite such as red and blue-green are contrasting or complementary.

QUESTIONS

1. Name the elements of design.
2. In representational art, why are the elements as important as the objects that they depict?
3. In each of the following pairs of units, one unit differs from the other in one or more ways. For example, the third pair differ in line and direction. Name the differences in the other pairs.

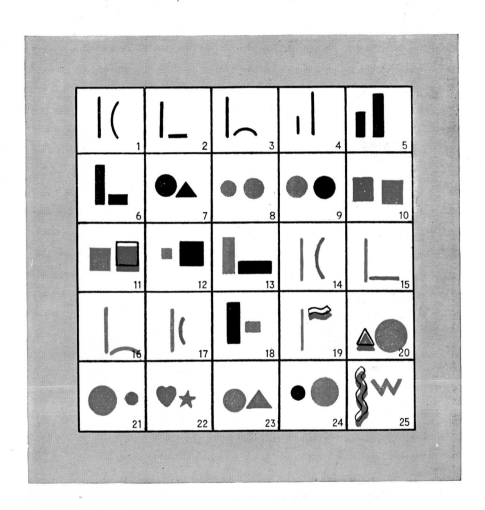

Part Two

THE PRINCIPLES
OF DESIGN

CHAPTER II

The Forms of
Elemental Relationships

I N the visual arts the forms resulting from certain re-
lationships of the elements, such as repetition, harmony, con-
trast, and unity, are essentially identical with the forms in the
arts of music, poetry, literature, and ballet produced by simi-
lar combinations. These forms have the same basic character
and significance and accomplish similar effects. The difference
lies in the medium in which they are materialized and in the
time element. In art, the form is visual and is perceived in-
stantaneously; in music the form is aural and the time element
prolonged. The essential difference, therefore, lies in the nature
of the intervals. In music they are time and pitch intervals; in
the visual arts they are space, shape, and color intervals. A
musical chord is the aural equivalent of visual intervals of
space, shape, and color, for in both the stimuli occur simulta-
neously. The ballet combines the two arts; it is visual music.

A principle of design, therefore, is a law of relationship or a
plan of organization that determines the way in which the ele-

ments must be combined to accomplish a particular effect. Now, there are only three possible ways in which things may be combined: they may be identical (repetition), or similar (harmony), or totally different (discord). The difference among these three fundamental forms of relationship is one of degree of interval and the kind and number of intervals involved.

REPETITION

Repetition in the visual arts concerns but one dimension, which is space. That is, the only difference between identical units is their position in space. The relationship, therefore, is

one-dimensional and is measured in terms of space interval that corresponds to the time interval between two successive, identical musical tones. Intervals of space, or the voids between objects, are as much a part of visual design as intervals of time, or the silences between sounds, are part of poetic, and musical design.

The diagram illustrates complete repetition. All six dimensions, shape, size, value, hue, chroma, and texture are repeated.

HARMONY

Harmony is a combination of units which are similar in one or more respects. Harmony is a medium interval or difference in one or more dimensions. Units are harmonious when one or more of their elements or qualities, such as shape, size, or color, are alike.

In the diagram below there is a medium interval or similarity in five dimensions. There is harmony of shape, size, value, hue, and chroma.

HARMONY

DISCORD

(*Extreme Contrast*)

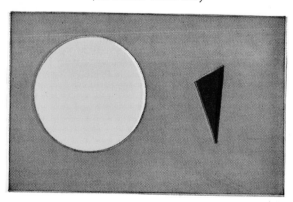

19

Complete repetition is one extreme. *Discord* is the opposite extreme. Harmony is between and combines the character of both.

In repetition only one kind of difference or dimension is involved. That is space interval.

Discord concerns all dimensions. Discord is a maximum interval of shape, size, value, and color. It is extreme contrast or difference. Discord is a combination of totally unrelated units.

Repetition, harmony, or discord, therefore, is simply a matter of degree of interval or difference between units. If two units have no dimension or quality that they share in common, they are totally unrelated and represent maximum opposition or contrast. If one of their dimensions is similar or identical, the units are harmonious. If two, more harmonious. If all their dimensions are the same, the units are identical.

These three fundamental forms, repetition, harmony, and discord, and their combinations are the basis of all art structure.

In the following pages we shall analyze harmony, contrast, and repetition separately and in greater detail and show the practical use of these design principles. Harmony and contrast will be discussed before repetition, because the use of repetition creates unity. Repetition, therefore, will be discussed together with unity and will be included in the chapter on Unity.[1]

[1] The terminology used in this book is based on Webster's Collegiate Dictionary, 5th ed. The terms are used according to their basic significance as defined therein.

HARMONY
A combination of similar units (Consonance).

EXAMPLES

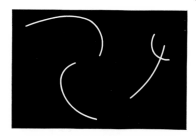

LINE

DIRECTION

SHAPE

SHAPE

MEASURE or AREA

VALUE

CHROMA or COLOR INTENSITY

HUE

21

Harmony

Harmony lies between the two extremes of monotony and discord. It combines the character of both.

Harmony is like the middle gray that is composed of two extremes—white and black.

Whether the design shall be nearer one extreme or the other depends upon the temperament of the artist, the emotions or ideas to be expressed, and the function of the design.

Fine design is often harmonic in character. However, harmony is not a requisite of all good composition. It is often considered so because most civilized people are conservative and therefore prefer harmony to the extremes of monotony or discord. Monotony bores them. Strong contrasts or discords are too violent, obvious, or naïve for their taste. Children and savages, as is to be expected, prefer the loud and garish. This preference is demonstrated particularly in their choice of color.

Fashions and tastes change. What one generation deems subdued and genteel is considered by another insipid. For example, in the contemporary arts harsh and discordant combinations are sometimes used that were once considered in bad taste or unaesthetic.

Much modern art is discordant in character; only the best possesses the unity necessary to fine design. Fine form transcends modes.

TYPES OF HARMONY

There are different kinds of harmony. There is harmony between dissimilar objects that are commonly associated, such as a bottle and a cork. This is a harmony of function. Literary association provides another type of harmony, that of symbolism, such as the pictorial symbolism of the dove and the olive branch. These types of harmony depend upon a suggestion to our conscious or reasoning mind. But objects of similar shapes, colors, or textures do not rely upon a rational appeal to the intellect. They are harmonious in themselves and therefore induce a more direct response.

Textile design based on harmonious lines and shapes. (*Pratt student exercise*).

Textile designs based on harmonious lines and shapes. (*Pratt student exercises.*)

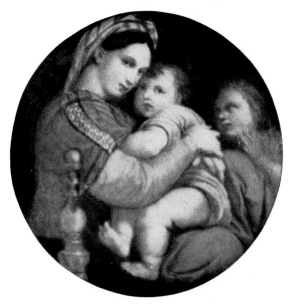

"Madonna of the Chair" by Raphael

A composition based on a harmony of curved lines organized within a circular shape. Unity and interest are produced by curvilinear repetition with variation. (*Courtesy of Artext Prints.*)

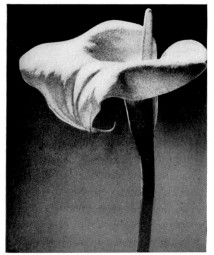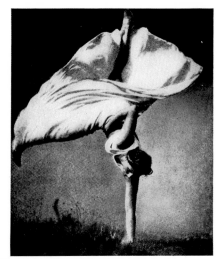

"Arum Lily and Dancing Lily"

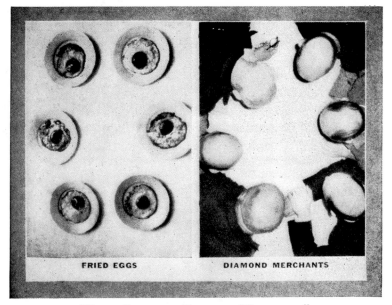

FRIED EGGS — DIAMOND MERCHANTS

"Fried Eggs and Diamond Merchants"

Harmony of Shape or Pattern. We all delight in the discovery of subtle similarities lurking in the midst of complexities. The challenge to detect unity masked by variety always stimulates interest. The amusing or satirical effect of the above juxtapositions results from the harmony or similarity of shape between completely different and otherwise unrelated objects. Also see page 127. (*Juxtapositions from Lilliput by Stefan Lorant, Editor.*)

26

 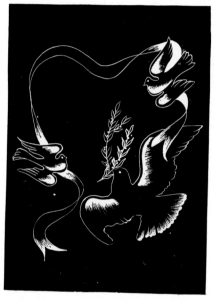

DOVE AND OLIVE BRANCH

Literary association provides another type of harmony—that of pictorial symbolism. (*Pratt student exercises.*)

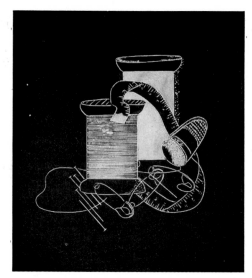

SEWING MATERIALS

(Pratt student exercise.)

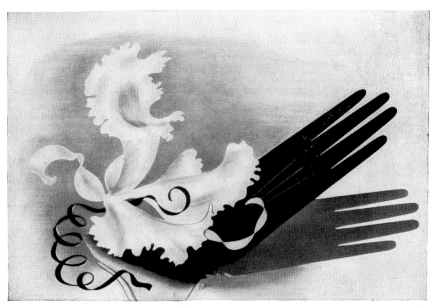

ORCHID AND EVENING GLOVE

There is harmony of function between dissimilar objects that are associated in use. *(Courtesy of Neenah Paper Co.)*

28

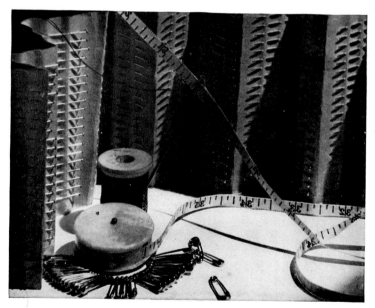

SEWING MATERIALS

Harmony of function. (*Pratt student exercises in photographic composition.*)

29

DRAWING INSTRUMENTS
Colors: black, white, and blue. Harmony of function. (*Pratt student exercises.*)

GARDENING TOOLS

Colors: black, white, and green. Harmony of function. (*Pratt student exercises.*)

31

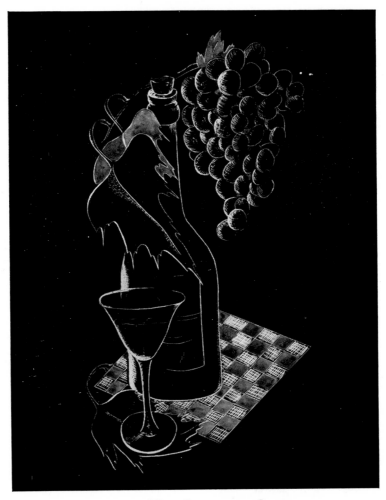

GRAPES, WINE BOTTLE, AND GLASS

Colors: black, white, and red. Harmony of function. (*Pratt student exercise.*)

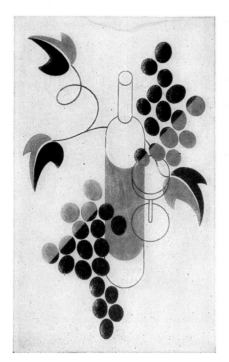 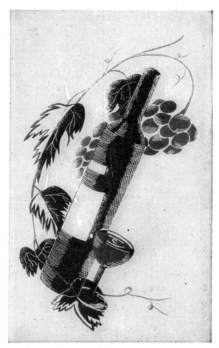

GRAPES, WINE BOTTLE, AND GLASS

Colors: black, white, and red. Harmony of function. (*Pratt student exercises.*)

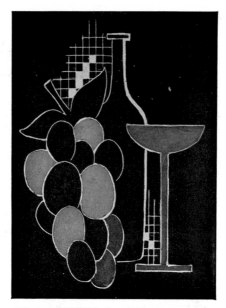

GRAPES, WINE BOTTLE, AND GLASS
Harmony of function. (*Pratt student exercise.*)

Harmony of Character. Lee Lawrie's sculpture (opposite) is innately archi-
tectural in character. His direct, vigorous manipulation of plane and volume
has the massive, monumental quality of Assyrian and Egyptian monoliths, to
which his work is closely akin.

The strong relief of the carving here illustrated is in brilliant and satisfying
contrast with the quiet, simple surfaces of the limestone walls.

The sculptured figures, starting as shallow incision, grade into deeper relief
as they ascend and climax in the full, round modeling of the heads. Through
this fluent transition the sculpture emerges naturally and inevitably from the
architecture. Ornament and building are welded into one harmoniously inte-
grated unit.

This quality that characterizes the best of today's architectural sculpture is
diametrically opposed to the sentimental, realistic gingerbread that was stuck
on so many buildings of the Victorian era.*

* The reproductions in this book have been chosen solely because of their
value as subjects for analysis. Each is selected because it is the best available
example of the application of the design principle that it illustrates.

34

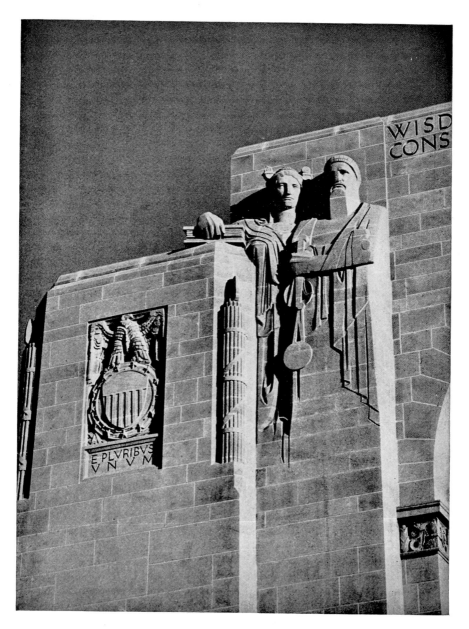

SCULPTURE BY LEE LAWRIE

35

GRADATION

A sequence in which the adjoining parts are similar or harmonious. Transition, flowing continuity, crescendo, diminuendo.

EXAMPLES

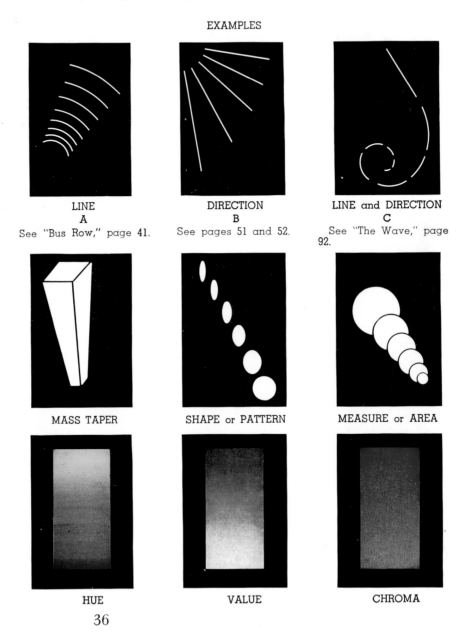

LINE
A
See "Bus Row," page 41.

DIRECTION
B
See pages 51 and 52.

LINE and DIRECTION
C
See "The Wave," page 92.

MASS TAPER

SHAPE or PATTERN

MEASURE or AREA

HUE

VALUE

CHROMA

CHAPTER IV

Gradation

G<small>RADATION</small> is a sequence in which the contrasting extremes are bridged by a series of similar or harmonious steps. Gradation, therefore, is a particular combination of contrast and harmony.

Gradation is clearly illustrated by the value scale,[1] in which black and white, the contrasting extremes, are connected by a continuous sequence in which the adjoining grays are similar or harmonious. All scales are various forms of gradation, because any scale consists of a succession of graded steps. The word "scale" derives from the Latin *scala,* which means steps, stairs, or a ladder. *Scala,* in turn, is akin to the still more ancient Sanscrit *skand,* meaning to mount, rise, or ascend. Gradation and scale are, therefore, synonymous.

Gradation is a common and basic form of natural order. It exists in the ascending crescendo of sunrise and in the falling diminuendo of twilight silently blending into darkness. The rising arch of a clear sky is a gradation of hue, value, and chroma that progresses from the pale, warm-green horizon haze to the dark, cold-blue zenith. All natural cycles, the wax-

[1] Value scale, p. 11.

37

ing and waning moon, the ebbing and flowing tides, the slow, measured passage of the seasons—all illustrate gradation in various forms. Gradation characterizes the flowing pattern of plant and animal life in all its successive, transitory stages from birth to death.

Because gradation implies change, movement, life, it is a most valuable and useful instrument of expression for the artist. In the cinema, the theater, the opera, and the ballet, gradation of light is one of the most effective devices with which to intensify mood and accentuate dramatic movement.

In painting, the flow of light over globular and cylindrical surfaces is expressed by shading with graded values.

The painter also uses gradation of size and gradation of direction or radiation—that is, linear perspective—together with gradation of hue, value, and chroma—that is, aerial perspective—to depict the relative positions of forms in space.

In design, gradation of line, direction, shape, size, value, and color—as shown on page 36—produces plans of order or compositional schemes that may be used in many different ways. Two of these plans of composition—based on gradation of size and gradation of direction or radiation—and some of the ways in which these plans may be used are illustrated on the following pages.

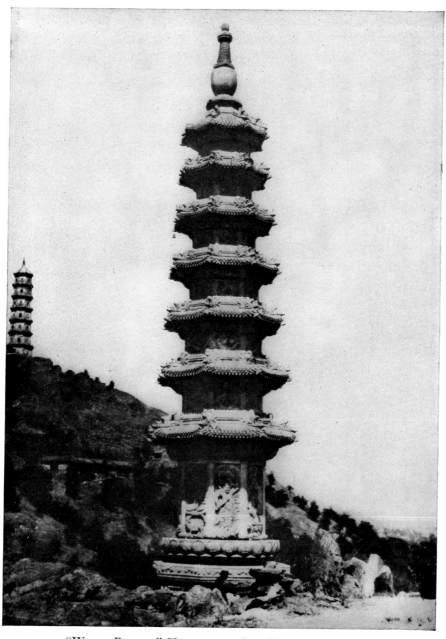

"White Pagoda," Hill of the Jade Fountain, Peiping

Gradation of Size, with Repetition of Shape and Object. Also see pages 40 and 41. *(Courtesy of the Metropolitan Museum of Art.)*

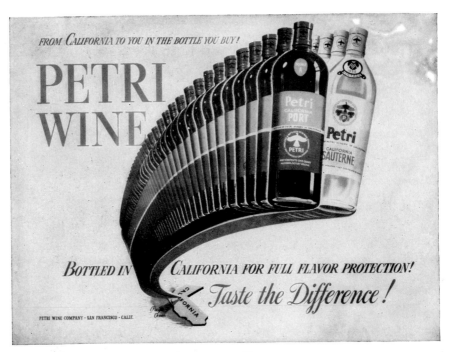

ADVERTISING POSTER

Gradation of Size, with Repetition of Shape and Object. In this plan of visual order, or compositional scheme, variety is produced by gradation of size; unity and dominance are created by repetition of shape and object. Also see pages 39 and 41. (*Courtesy of Petri Wine Co.*)

Gradation of Size with Repetition of Shape and Object. The paintings opposite show how universal is the appeal of a simple form of order. Two painters, one English and the other American, thousands of miles apart, responded to the same principle of gradation that existed in such different subjects as buses and elephants. Both compositions owe their unity to gradation, which is the dominant motif. Also see pages 39 and 40.

40

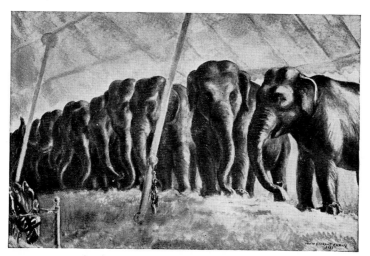

"Elephants at the Circus" by J. S. Curry
(*Courtesy of Artext Prints.*)

"Bus Row" by W. O. Hutchison
(*Courtesy of Studio Publications.*)

41

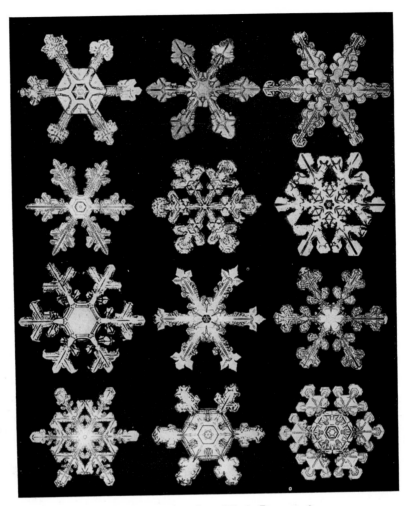

"Snow Crystals" by W. A. Bentley*

Radiation in Nature. Nearly all snow crystals are radiant patterns within hexagonal shapes. But no two of the countless billions of crystals are ever exactly identical; nature, the master designer, creates infinite variations of a repeated radiant theme.

Radiation, or gradation of direction, one of the most common and basic types of natural order, also occurs in many other different forms, such as starfish and flowers. Man perceived this radiant pattern in nature and then applied it mechanically in his wheels and gears and aesthetically in his jewelry, rose windows, and similar designs. (*From Snow Crystals, published by McGraw-Hill Book Co., Inc., 1931.*)

42

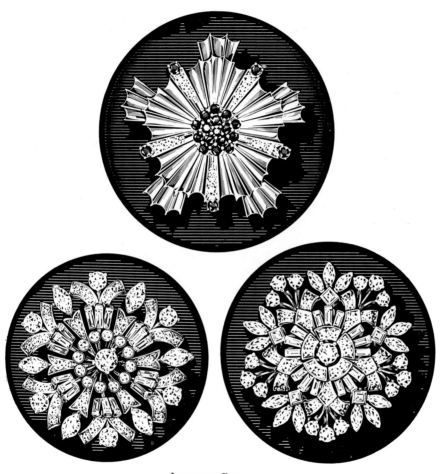

JEWELED ROSETTES
Radiation in jewelry design. (*Courtesy of Tiffany and Co., N. Y.*)

43

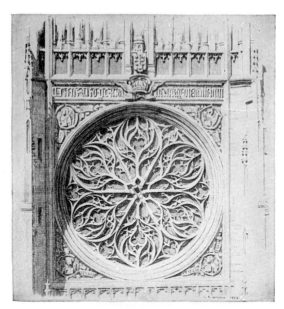

Exterior. (*Courtesy of Saint Thomas Church.*)

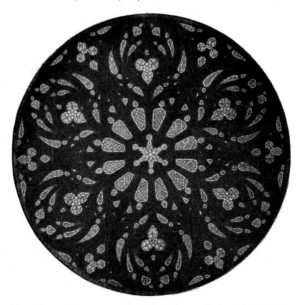

Interior. (*Courtesy of Heinigke and Smith, N. Y.*)

Radiation in Liturgical Art. Rose or wheel window in Saint Thomas Church, N. Y.

44

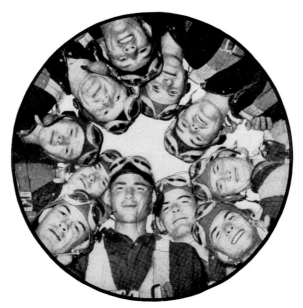

FLYING CADETS

Radiation in photographic composition. (*Courtesy of U.S. Army Enlistment Division.*)

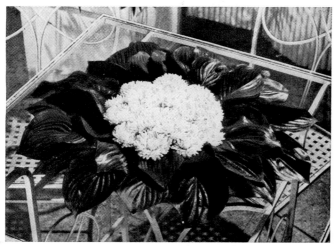

Radiation in Floral Arrangement. The design as a whole, consisting of leaves and flowers, forms one large radiant pattern that repeats the small radiant patterns of the flowers. Thus, the plan of composition is repetition of a radiant pattern with variation of size. (*Courtesy of The Coca-Cola Co.*)

45

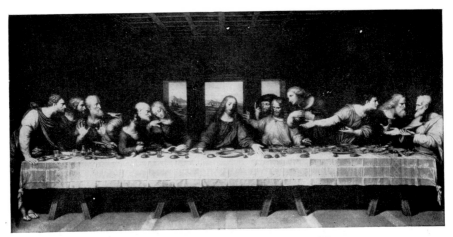

"THE LAST SUPPER" BY LEONARDO DA VINCI

(Courtesy of Ewing Galloway, N. Y.)

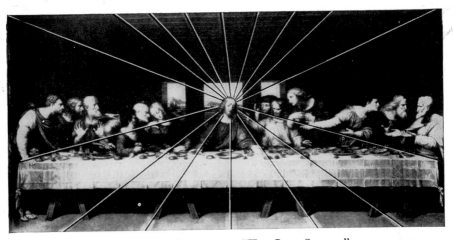

PERSPECTIVE ANALYSIS OF "THE LAST SUPPER"

Radiation in Painting. In his famous painting, "The Last Supper," Leonardo da Vinci has drawn the walls, floor, table, and paneled ceiling in parallel or one-point perspective. These perspective lines radiate from their vanishing point between the eyes of Christ, who is the dominant figure in this formally balanced design.

The perspective analysis shows that the floor lines on the left are not quite parallel with those on the right. Did Leonardo intend these lines to be not parallel—or did he make a mistake in his perspective drawing?

46

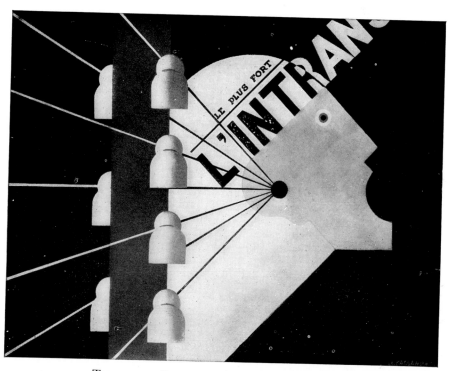

TELEPHONE POSTER BY A. MOURON CASSANDRE

Radiation in Poster Design. The perspective lines of the telephone wires radiate from the ear of the abstract head in the same way as the perspective lines of the room radiate from the eyes of Christ in the preceding illustration.

In the above poster, however, perspective radiation is used in a less representational, more abstract or symbolical manner than in "The Last Supper."

Radiation appropriately symbolizes voice communication, as in the above design, because sound waves are radiant. (*Courtesy of A. E. Gallatin and The Museum of Modern Art.*)

47

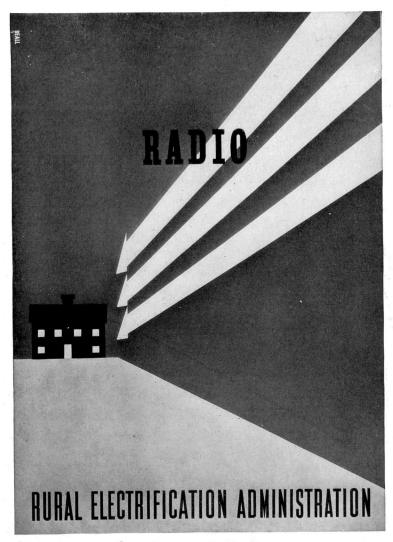

RADIO POSTER BY LESTER BEALL

Radiation in Poster Design. In the above and the preceding poster the same theme, voice communication, is aptly symbolized by the same device, radiation.

In this design radiation appropriately expresses voice communication by radio because both sound waves and radio waves are radiant.

Because of convergence to a focal point, radiation produces unity in design by emphasis or dominance, as in the above and the two preceding compositions. (*Courtesy of The Museum of Modern Art.*)

48

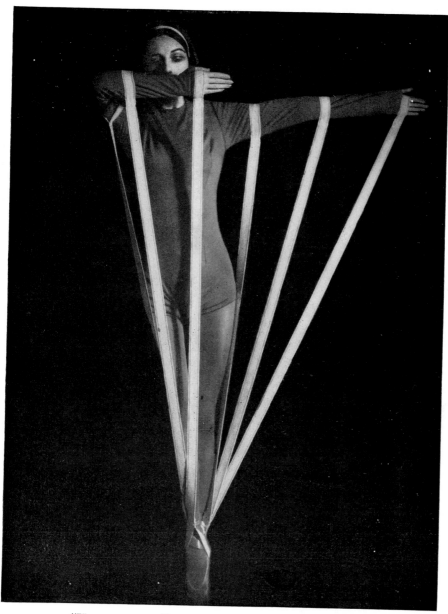

"Variations on Euclid," Dance Solo by Ruth Page*

Radiation in the dance. (*From Ballet by Maurice Seymour, published by Pellegrini and Cudahy, N. Y.)

49

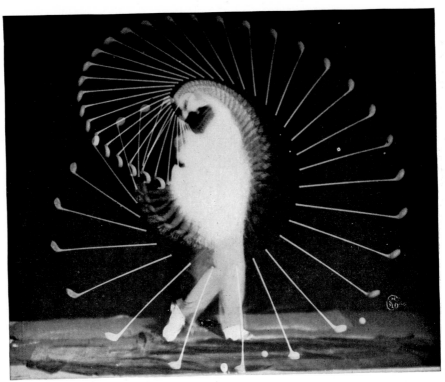

MULTIPLE-FLASH OR STROBOSCOPIC PHOTOGRAPH OF A GOLF STROKE

Radiation in Photography. In addition to radiation or gradation of direction, note the gradation of space interval produced by acceleration of the stroke.

Multiple-flash, or stroboscopic, photography shows in a single print successive action images made by exposing a single film in a rapidly interrupted beam of light. The effect is similar to that which would be produced by superimposing a sequential series consisting of many separate photographs of a moving object. Also see Gjon Mili's Photographic Dance Frieze on page 124.

Today, multiple-flash photography produces effects similar to those created in 1912 by the Italian futuristic device of kinetic, or dynamic, simultaneity—that is, the simultaneous presentation of sequential aspects of action in a single painting, as in Giacomo Balla's "Dog on Leash" and "The Swifts."* (*Courtesy of Dr. Harold E. Edgerton, Massachusetts Institute of Technology.*)

* See *Twentieth Century Italian Art*, The Museum of Modern Art, N. Y., 1949.

ILLUSTRATION FOR "TITUS ANDRONICUS" BY ROCKWELL KENT

Radiation in Illustration. The sturdy legs are the strong spokes of a wheel segment in which the right oblique is dominant. Their vigorous upward thrusts converge to the hub, making it the focus of interest. From this turbulent center radiate the agitated arms.

It is evident that Mr. Kent understands anatomy—and enjoys drawing it. Gastrocnemius, sartorius, and gluteus maximus are all here. Nevertheless, the anatomy is considered from a designer's viewpoint. Although interesting in itself, it is subordinated to the design. The arms and legs function primarily as elements of the composition. Their anatomical detail is of secondary importance. Each limb has been carefully considered and placed with precision. Each is made to serve as a vital factor in a well-integrated design.

The composition forms a triangle. The spread legs and the ground line repeat it. Of all shapes, the triangle is the most firmly balanced. From it the arrangement derives its stability.

Many old and famous religious paintings illustrate the use of radiation and the triangular composition. The formal stability of this arrangement and its natural center of interest especially suit such themes as "The Descent from the Cross," "Pietà," and "The Entombment." A modern example of triangular design is "Edith Cavell" by the well-known American artist George Bellows.

51

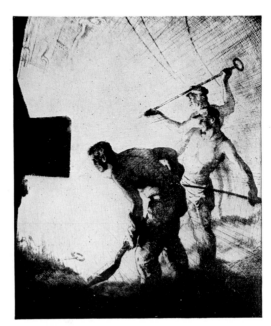

"Coal Heavers" by James Allen

Radiation in Illustration. See also page 51.
(Courtesy of Kennedy & Co.)

CHAPTER V

Contrast

Life consists of things and the difference between things. By contrast opposites are intensified and derive their meaning. From the contrast or interval between things is woven the rhythm that is life. Contrasting long and short waves bombarding ears and eyes create sound and color. Warm, soft, rough—cold, hard, smooth: through fingertips contrasting sensations, life vibrates inward. Contrast, opposition, conflict, or variety is the dynamic essence of all existence—and of all art forms that dramatize the life of man.

Contrast is as essential to design as unity. Variety stimulates interest and rouses excitement. Variety vitalizes design; spices composition. A composition with too little contrast is monotonous, insipid.

In any design a certain amount of variety is inevitable; a black line drawn on white paper automatically produces a contrast of values. How much more variety is necessary? The amount depends upon the temperament of the artist and the purpose of the design. Contrast is like salt; its use is governed by taste. Some temperaments prefer subdued and muted harmony; others demand strong opposition.

CONTRAST

A combination of opposite or nearly opposite qualities.

EXAMPLES

LINE

DIRECTION

LINE and DIRECTION

SIZE and SHAPE

SIZE and HUE

SIZE and VALUE

SIZE, SHAPE, and VALUE

SIZE, SHAPE, VALUE, and HUE

54

MEDIEVAL TEXTILE PATTERN

Contrast of square and circular shapes.

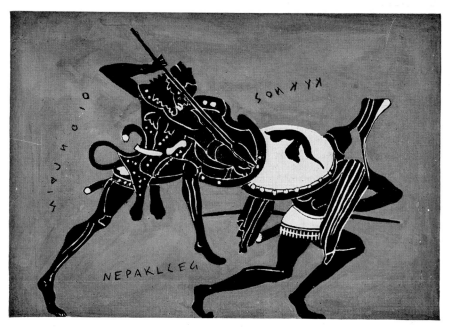

GREEK VASE PAINTING

Contrast or Opposition of Value (*black versus white*). Observe that the largest area of white is centralized. This focusing of the dominant value contrast creates a climax or center of interest that helps unify the composition.

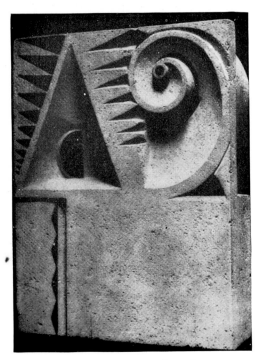

"ABSTRACT SCULPTURE" BY STORRS

Contrast of Line. The abrupt staccato movement of the angular serrated line provides an interesting contrast for the flowing curve of the spiral. The small curved shape within the triangle echoes the curve of the spiral. The crescendo-diminuendo of the spiral repeats the gradation of the serrated line. These repetitions unify the design. (*Courtesy of The Museum of Modern Art.*)

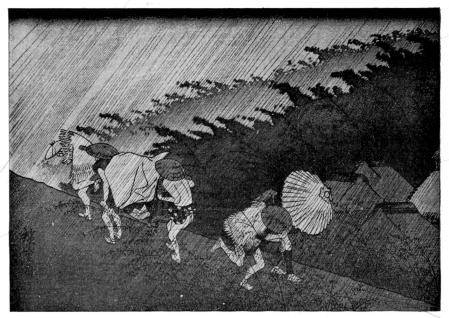

"Rain" by Hiroshige

Contrast of Direction. In this mobile composition, built on contrasting directions, the oblique lines of wind-driven trees and rain, the diagonals of hill and houses, and the movement of men are skillfully opposed.

The two figures moving briskly downhill toward the right effectively counteract the opposite movement of the group struggling slowly upward toward the left. This action of one group upon the other would seem to have been cleverly calculated to stimulate an oblique movement of the spectator's eyes, while holding them within the picture.

Further analysis reveals a sure control of other forces. The visual attraction in the lower right, produced by the vigorous activity of the two men, adequately compensates for the strong attraction in the upper left, formed by the converging directions of the hill line, the men, and the tree silhouettes.

In addition, the upper group is arranged to repeat the hill line but oppose the direction of the rain. The lower group is composed to contrast with the hill while harmonizing with the slanted lines of rain.

Umbrella and hat are expressive detail. They make visible the force of the wind and imply just enough resistance to restrain the downhill impetus from charging out of the picture. (*Courtesy of Shima Art Co., Inc.*)

57

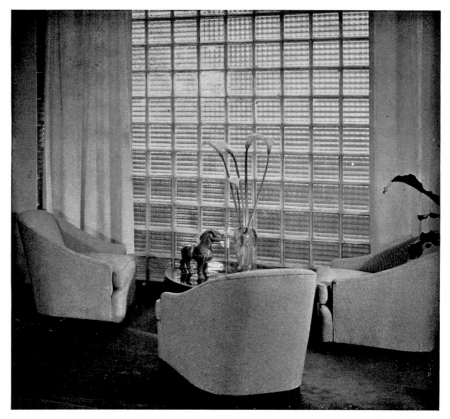

Contrast of Texture. Texture can be as important as color, particularly in interiors. With the introduction of new materials such as glass block, chromium, metallic paper, cork, and cellulose fabrics, texture has become a richer, more flexible element. The scope of the decorator, architect, and industrial designer is thus expanded.

In this cool, luminous room use is made of some of these satisfying textural contrasts. Although unified by color repetition or monochrome, it would have been somewhat monotonous had not the necessary variety been supplied by contrasting surface qualities. These are the rough, dull weave on the chairs, opposed to the smooth, glossy drapes and glass.

Modern interior design at its best is logical, direct, efficient. It is distinguished by its bold sweep of line, its immaculate planes. Compact, essentially utilitarian, its ideal application is to problems imposed by limited space as in aircraft, trains, the office, bathroom, and kitchen. If forced to its cold extreme, it becomes as hard and impersonal as the geometry from which it springs.

The pseudomodern or "modernistic" is branded with insincerity. It is recognized by its affected radicalism and by its showy gadgets. (*Courtesy of R. H. Macy & Co., Inc.*)

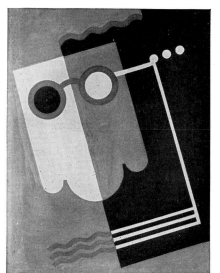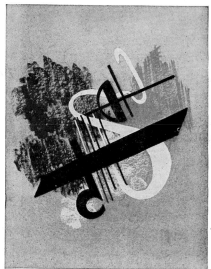

Contrast of line, direction, shape, size, and value. (*Pratt student exercises in nonrepresentational design.*)

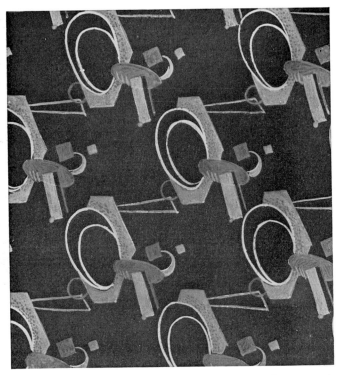

Contrast of line, direction, shape, and size. (*Pratt student exercise in non-representational textile design.*)

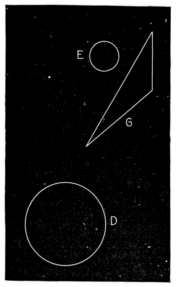

A and B show repetition of line; contrast of size and direction. B and C illustrate harmony of direction; contrast of line and size.

A and C show harmony of size; contrast of line and direction.

D and E show repetition of shape; contrast of size. D and G are harmonious in size; contrasting in shape.

E and G are contrasting in shape and size. If color were used, they could be harmonized by similar hues.

The above arrangements demonstrate how units that are contrasting in one dimension or element may be harmonized by another. Repetition, harmony, and contrast are combined. Extremes are harmonized. This principle can also be applied to texture, value, and color.

61

VARIETY OF CONTRASTS OR INTERVALS

Interest is produced by variety. The more variety a composition has, the more interesting it is. Interest may be created not only by variety of line, shape, size, value, and color but also by variety of unequal contrasts or differences among these elements (that is, strong, great, or major intervals, medium intervals, and weak, small, or minor intervals). In other words, unequal intervals create interest through variety, whereas equal intervals are monotonous and uninteresting because of the absence of variety. If, therefore, we want maximum interest, we must plan our shapes, sizes, values, and colors so as to produce the maximum variety of contrasts or intervals.

For example, if we wish to use three values in a composition, we would not use black, middle gray, and white, because the value interval or contrast between black and middle gray is equal to the contrast between middle gray and white. The following combinations produce more variety because of unequal value intervals and are for that reason more interesting.

1. Black, white, and a gray either lighter or darker than middle gray.

2. Black, middle gray, and light gray.

3. Dark gray, middle gray, and white.

In combination 1, the middle gray has been changed to a gray that is closer to one extreme than it is to the other. In 2 and 3, one of the extremes has been moved closer to the middle.

Presently, in the section on Value Organization on page 295, we shall demonstrate how this principle is practically applied in various compositions.

The same principle applies to the other elements of line, direction, shape, size, texture, and color.

For example, yellow is halfway between red and green. That

62

is, the hue interval or difference between red and yellow is equal to the hue interval between yellow and green, according to accurate measurements made in the Munsell Color Laboratory. A combination that will produce more variety or unequal intervals is red, green-yellow, and green. That is, the interval between red and green-yellow is greater than the interval between green-yellow and green. Perhaps that is why this hue combination and similar hue combinations, which are called a "harmony with contrast," are so popular. Later, in the section on Color Organization, we shall see how this same principle is used in planning color schemes.

QUESTIONS

1. Define a principle of design.
2. State your reasons for agreeing or disagreeing with the following statements: The principles of design used in the visual arts have no relationship to the principles used in the other arts. The painter, poet, writer, architect, and musician use completely different principles.
3. Name the three fundamental forms of relationship among the elements of visual design.
4. Define repetition.
5. What is harmony?
6. Define discord.
7. What is the essential difference among the above three design principles?
8. Name three kinds of harmony.
9. What is gradation?
10. What is contrast?
11. What effect does contrast have upon a design?
12. What is the character of a design with too little contrast?
13. Whether a design shall be harmonious or strongly contrasting in character depends upon what factors?
14. What is the virtue of a triangular arrangement in composition?
15. To which themes was the triangular arrangement found to be particularly appropriate?

EXERCISES

1. Make plates similar to those on pages 21, 36, and 54, but of your own designing, which illustrate:
 a. Harmony.
 b. Gradation.
 c. Contrast.
2. Look through magazines and art publications and search the files of your art reference library for paintings, designs, sculpture, and photographs that most clearly and dramatically illustrate each one of the above design principles. If possible, paste these in your notebook and bring them to class for discussion. Beneath each design write a short analysis pointing out exactly where and how the above principles of design have been used.
3. Make simple nonrepresentational designs using
 a. Harmonious lines and shapes, such as curved lines and circles, or straight lines and triangles. See the shape circuit on page 8. Use harmonious values with harmonious hues such as purple-blue and blue-green. See the hue circuit on page 12. See student exercises on pages 23 and 24.
 b. Do the above design in contrasting values with contrasting hues, such as purple-blue and yellow.
 c. Contrasting lines and shapes, such as straight and curved lines, circles and triangles. Use harmonious values and hues.
 d. Do the above design in contrasting values and hues. See student exercises on pages 59 and 60.
 e. Gradation of line, direction, size, value, and hue.
 f. Gradation of shape, size, value, and hue.
4. Transpose the above nonrepresentational designs into representational designs. Lay a sheet of tracing paper over each design and transpose each unit into a simplified, freehand representation of any object of similar shape. For example, straight lines, curved lines, and circles might be transposed into needles, thread, and buttons or a bicycle. Spirals might become sea shells, etc. Use the same colors.
5. Make designs based on harmony of function between dissimilar objects that are commonly associated, such as
 a. Scissors, needles, thread, thimble, tape measure, paper of pins. See student exercises on pages 28 and 29.
 b. Drawing instruments and blueprints. See student exercises on page 30.

64

 c. Gardening tools, watering can, hose, leaves. See student exercises on page 31.

 d. Wine bottle, wineglass, grapes and grape leaves. See student exercises on pages 32–34.

 e. Orchids and ladies' evening gloves. See page 28.

 f. Paper scroll, quill pen, and ink bottle.

6. Make designs based on literary association or pictorial symbolism, such as dove and olive branch, crown and scepter, etc. See student exercises on page 27.

CHAPTER VI

Unity

1. THE GRAVES DESIGN JUDGMENT TEST

Before studying this chapter, it is suggested that you take the unstandardized version of the Graves Design Judgment Test on the following pages. The test will be used to illustrate the design principles discussed later in this chapter and to demonstrate that these principles are not artificial, arbitrary rules, but are natural forces that are as real as one's sense of balance and as potent as gravity. The test will also be used for exercises in design analysis.

In order to avoid undue influence of ideas or prejudices associated with pictures or recognizable objects and to ensure that the decisions of the person taking the test will reflect an aesthetic response unaffected by factors foreign to pure design, nonrepresentational items are used.

Psychologists, personnel directors, educational and vocational-guidance counselors, will be interested to know that a 90-page standardized version of the Graves Design Judgment Test is published by the Test Division of the Psychological Corporation, New York 18, N.Y.

66

This standardized test has been devised to measure certain components of aptitude for the appreciation or production of art structure. The test accomplishes this measurement by evaluating the degree to which a subject perceives and responds to the basic principles of aesthetic order. Evaluation of these responses provides an objective criterion of the subject's aesthetic perception and judgment. The test is proving useful in educational and vocational guidance and in personnel selection.

The power of the Graves Design Judgment Test to discriminate between art and nonart groups is well established. In college-level studies totalling over a thousand cases, 30 per cent of the art group scored above the ninety-ninth percentile for nonart students, and three-quarters of the nonart group were distributed below the fifth percentile of those enrolled in art curricula. While less striking, the separation of art from nonart students in a high-school study was also distinct and definite, with half the art majors scoring above the eighty-fifth percentile of nonart students, and half the latter scoring below the tenth percentile of the former.

The reliability coefficients are consistently high, indicating that the test is reliable in a variety of applications. Several of the coefficients are over .90; the median is at .86. Even the lowest are high enough to indicate that the test is reliable with highly selected as well as unselected groups.

The standard error of measurement (SEM) is another index of the test's reliability, indicating the band of error which inevitably surrounds a test score. The chances are approximately two out of three that an obtained score does not differ from the true score by more than one standard error of measurement.

Psychologists and students of psychology may be interested to know that the first 20 charts of the unstandardized test on

67

the following pages have been analyzed by ocular photography in a study of the correlations between eye movements and the principles of design.[1]

DIRECTIONS FOR TAKING THE TEST

Following are 32 numbered charts. On each chart are two designs. Each design is designated by letters. These letters have no significance except to identify the designs.

1. On a sheet of paper write the numbers from 1 to 32 in vertical columns from the top to the bottom of the paper.
2. On each chart compare the two designs and decide which one you consider the better, that is, the one that you prefer. On your numbered paper write the letters of this design opposite its chart number.
3. When you have completed the test, turn to page 79 and compute your score by comparing your choices with the correct answers.

Check the correct choices on your answer sheet. Your score is the number of correct choices multiplied by 3. The maximum, or highest possible, score is 96.

[1] BRANDT, HERMAN F., *The Psychology of Seeing*, The Philosophical Library, New York, 1945, pp. 164–181.

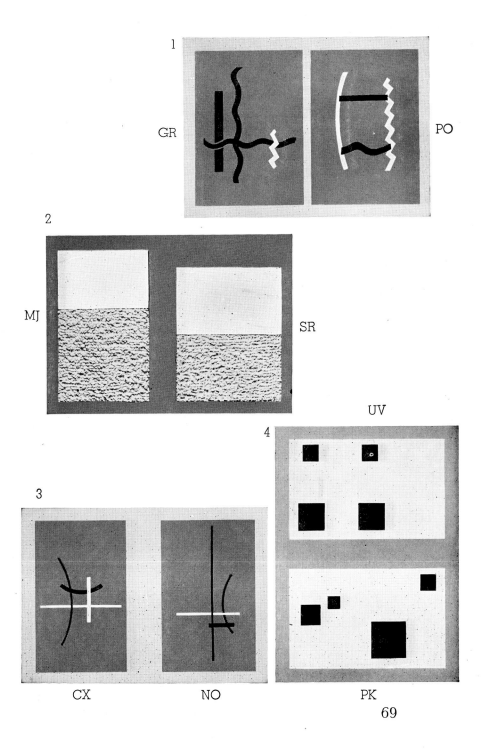

1

GR PO

2

MJ SR

UV

4

3

CX NO PK

69

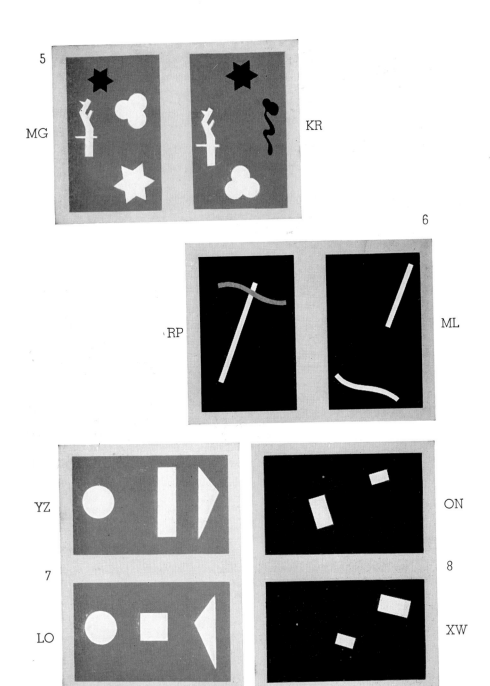

5

MG

KR

6

RP

ML

YZ

ON

7

8

LO

XW

70

WX

9

TS

FE 10 WD

EF 11 PX

71

12

DC

OF

13

TL

BY

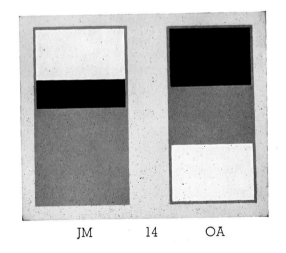

JM 14 OA

72

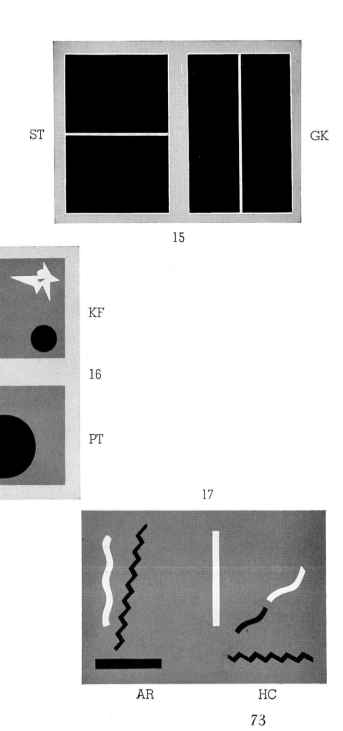

ST GK

15

KF

16

PT

17

AR HC

73

18

VH

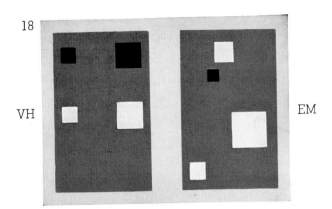

EM

RA

19

TI

EV

20

GU

74

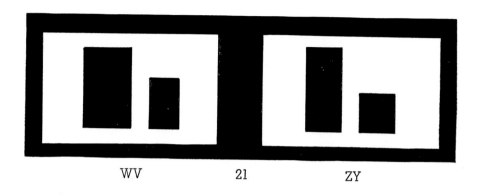

WV 21 ZY

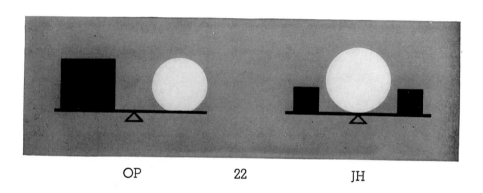

OP 22 JH

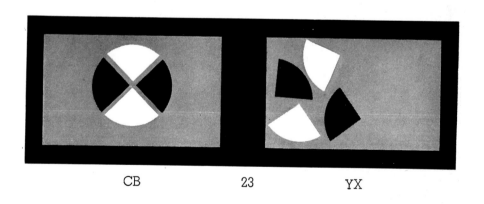

CB 23 YX

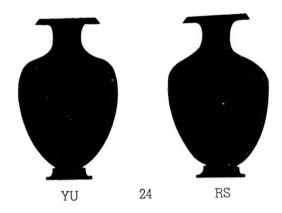

YU 24 RS

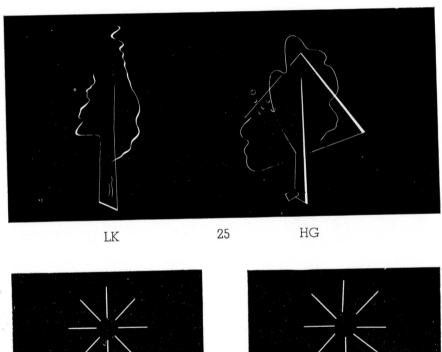

LK 25 HG

RG 26 KJ

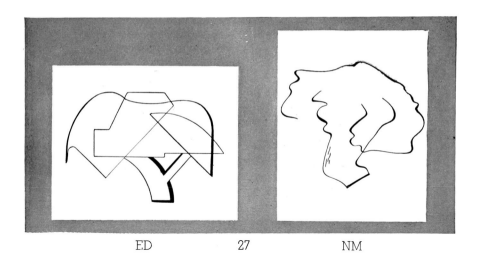

ED 27 NM

BA 28 WG

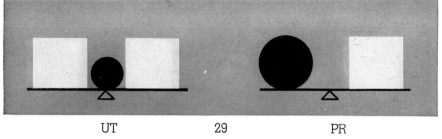

UT 29 PR

GF 30 IP

ZA 31 YB

XC 32 VE

78

Chart Number	The Better Design	Chart Number	The Better Design
1	GR	17	AR
2	MJ	18	EM
3	NO	19	TI
4	PK	20	EV
5	MG	21	WV
6	RP	22	JH
7	YZ	23	CB
8	ON	24	YU
9	WX	25	HG
10	WD	26	RG
11	PX	27	ED
12	DC	28	WG
13	TL	29	UT
14	JM	30	IP
15	GK	31	ZA
16	PT	32	VE

On pages 164 to 169 are analyses of the first 20 charts explaining why one design is better than the other. You will better understand the analyses if you first read the following pages that explain the basis of the test and the design principles involved. After studying these pages, you should be able to dissect the last 12 charts as an exercise in design analysis.

2. UNITY, CONFLICT, DOMINANCE: THE FUNDAMENTAL PRINCIPLES OF PSYCHOBIOLOGICAL AND SOCIOLOGICAL ORDER

Science, philosophy, and art are expressions of man's eternal urge to seek and to create unity in his universe. Man, as scientist and philosopher, seeks to reveal the infinitely complex and protean manifestations of unity in the world of time, space, mind, and matter. Man, as artist, creates aesthetic unity or

79

man-made order by organizing time, space, mind, and matter. But unity, the primary principle of cosmic order, retains its basic character and effects similar results irrespective of the form in which it manifests itself.

One of the manifestations of unity, the fundamental principle of universal order, is the law of self-preservation or organic unity.[2] The following pages will show that organic unity is the primary principle of psychobiological and sociological order that initiates the secondary principles of conflict and dominance. It will be demonstrated that the validity of unity, conflict, and dominance as principles of aesthetic order is based on their psychobiological and sociological origin in the fundamental pattern of human behavior.

Preservation of its unity is the first, vital necessity of every organism from microbe to man. On all planes man is constantly alert to resist the dangers that threaten his integrity and stability. On the biological and physiological planes, skin, phagocytes, and antibodies fight the invisible virus and bacteria that would destroy his physical entity. On the psychological plane, fear, pain, and anxiety are the defense reactions to visible attacks on his corporeal unity. On the psychic plane, ego-defense adjustments guard the stability and integrity of his personality.

Reactions protecting the unity of the individual on the psychobiological planes extend to the sociological plane to include defense of a hierarchy of related units: the family; racial, religious, social, fraternal, and political units; the nation and allied nations; and finally the species. The ancient axioms, "In

[2] Rosenzweig, Saul, *An Outline of Frustration Theory*, The Ronald Press Company, New York, 1944. Chap. 11, Personality and the Behavior Disorders, J. Mc V. Hunt, Ed.

80

unity there is strength" and "United we stand, divided we fall," are valid on all planes, including the aesthetic.

So preservation of unity automatically and inevitably forces conflict—either within the unit or externally with other competing units. These clashes range from the simple conflict of hunger versus fear on the physical plane to the complex psychical conflicts on the moral, ethical, and religious planes.[3]

Life is continuous conflict; no one can escape. Almost every situation produces a competition between incompatible responses that cannot all be made at once. In the mentally healthy individual these conflicts are resolved by dominance, the principle of integration or synthesis. First one and then another of the responses becomes dominant to form a rippling pattern of integrated behavior. Thus, in the normal pattern of human behavior, preservation of unity automatically causes conflict, which is resolved by dominance. Dominance restores unity, which starts other cycles of unity, conflict, dominance that continue as long as this principle of integration operates.

But when the law of dominance cannot function or is violated, the ripples of emotion may swell to tidal waves of passion that drown the individual in a psychological maelstrom. Too often, as the ever-increasing appropriations for insane asylums prove, the individual flouts the precept that "A man cannot serve two masters" and is torn apart mentally by equally strong conflicting impulses. When dominance stops, disintegration begins. Studies in clinical psychology show that severe mental conflict is one of the principal factors in functional disorders of personality. Unresolved conflict may induce psychoneuroses characterized by vacillation, restlessness, fear, anxiety, tan-

[3] JACOBI, JOLAN, *The Psychology of Jung*, Yale University Press, 1943.
JUNG, CARL GUSTAV, *Modern Man in Search of a Soul*, Harcourt, Brace and Company, New York, 1933.

trums, hysteria, amnesia, paralysis, or stupor. A classic example of insanity caused by an unresolved attraction-versus-repulsion conflict is the madness of Ophelia in Shakespeare's drama *Hamlet*.

But conflict may also be constructive. It may be the means by which the individual grows and matures—it may even be the only way that he can realize his destiny. This is the moral and ethical, as well as the aesthetic, concept of conflict expressed in the great tragedies in which the hero seeks battle, welcomes martyrdom and death.

Plays, novels, poems, and music dramatize the life of man in art forms that express the fundamental pattern of human behavior—unity, conflict, dominance. This protean pattern of psychophysical conflict and resolution is the epic theme of all

"Showboat" (opposite) is an allegorical painting that metaphorically illustrates the psychophysical and sociological conflict between men and women competing for survival on the world's stage. Each player, in his or her own way, struggles to assert dominion over the others. Driven by desire to satisfy the ego with power—the power of fame or the power of money—each actor strives to occupy the center of the stage, each one wants the spotlight, each hopes for the principal role.

In his grim "Showboat" and "Vanity Fair," Koerner cynically depicts the moral disintegration and social anarchy of postwar Germany. In these paintings of the human jungle that was Germany after World War II, Koerner repeats the theme of George Grosz's brutally bitter drawings of the same desperate and hopeless people after World War I. The sordid theme of these paintings and drawings—everyone for himself, and to hell with the rest—is a disillusioning reminder of the cutthroat savagery that lurks below man's hypocritically humane veneer, and of the dog-eat-dog conflict that breaks out during social cataclysms.

Koerner's paintings are social satires in the tradition of Goya, Hogarth, Daumier, and Grosz, but are expressed as grotesque psychological dramas in the manner of the medieval Flemish painter Bosch and the modern Spanish painter Dali. Koerner's technique, like that of Bosch and Dali, is meticulous, detailed, naturalistic. And, like them, he uses the surrealist device of juxtaposing realistic and weirdly distorted images to create an eerie fantasy resembling the dark, subconscious world of dreams. (*Collection of William March; photograph, courtesy of Midtown Galleries.*)

82

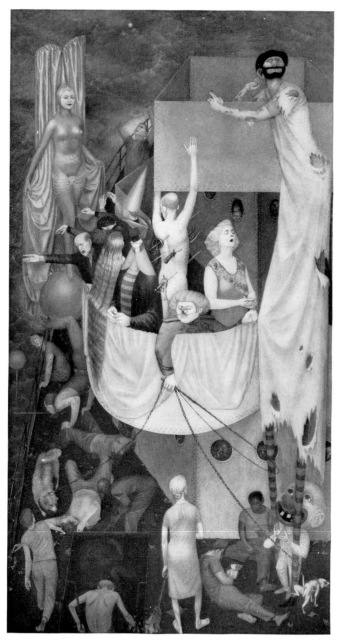

"Showboat" by Henry Koerner

83

fables, myths, legends, and allegories throughout history—from the Hindu *Upanishads* to the Greek *Odyssey* to the Icelandic sagas. From man's never-ending struggles—against fate, nature, Satan, or himself—has sprung the heroic male archetype celebrated in music,[4] poetry,[5] dance, and story.[6]

The hero has had a thousand symbolic reincarnations. He is Ulysses of the *Odyssey*, and he is Siegfried of the Nibelung Ring. He is Jason in search of the Golden Fleece and Sir Galahad in quest of the Holy Grail. As Prometheus, he challenges the gods. As Don Quixote, he battles windmills. He is Till Eulenspiegel capering through medieval Germany and Paul Bunyan stomping through the American backwoods with his blue ox Babe. He is Nietzsche's Superman and he is Superman of the American comics. He is a youth and he is a man. In primitive or adolescent societies he is a brawny boy—a shrewd, aggressive, and simple-minded extrovert. He is a variant of Hercules, Jack the Giant-Killer, Walter Mitty, or Tarzan of the Apes. He begs, borrows, or steals a magic sword, a cloak of invisibility, seven-league boots, and is johnny-on-the-spot when it comes to performing prodigious feats of muscularity, outsmarting and slaying the ogre, swiping the pot of gold, and kidnapping the blonde female.

In mature cultures he is an adult—less materialistic, but more introverted and complex. He is a modification of Arjuna, Oedipus, Christian, or Faust. He ponders the great enigma of existence—broods on the destiny of man. His conflicts are more psychological than physical, and his relationship to the female has acquired a new significance. She is either eliminated from

[4] *Ein Heldenleben*, by Richard Strauss and Fifth Symphony, by Ludwig van Beethoven.
[5] *Faust*, by Johann Wolfgang von Goethe.
[6] *The Pilgrim's Progress*, by John Bunyan.

the arena, as in the *Bhagavad-Gita,* or she serves as an instrument of discipline, a sort of spiritual proving ground—as in *Oedipus Rex, The Pilgrim's Progress,* and *Faust.*

The hero has had a thousand names, worn a thousand faces, but always—in all lands and in all times—he is man, the warrior.

Conflict is as necessary to dramatic design as dominance and unity. In fact, the resolution and integration of conflicting unities by dominance—the principle of synthesis—is dramatic design. There can be no plot without conflict. The necessity of conflict in dramatic structure—even on the puerile level of a grade C Hollywood movie made for a million American adolescents of all ages—is illustrated by the following anecdote: The writers assigned to the job of preparing the scenario of a motion picture based on a composer's life were stumped by the apparently complete absence of anything remotely resembling a major conflict in the hero's career. He had everything. This handsome and popular son of a wealthy and respected family had a healthy and happy childhood, attended a fashionable university, gained fame and riches as a composer, and was happily married to a beautiful woman. The scenario writers, after hopelessly wrestling with their dull assignment for some time, finally solved their problem by inventing one for the hero to solve. This bit of dramatic necessity took the form of a fictitious attraction-versus-attraction conflict between love and career. In the motion picture the conflict was, of course, happily but somewhat inexplicably resolved in the tried-and-true, trite, and tiresome Hollywood-radio tradition. A lucky coincidence in Atlantic City, involving five hundred bathing beauties, a $50,000 radio jack-pot, and a hurricane, miraculously saved the day in the nick of time. True love triumphed and the hero

85

and heroine walked arm and arm into the sunset as a celestial choir of one thousand female voices rose in exultant crescendo.

These attraction-versus-attraction conflicts are popularly known as "wanting to eat his cake and have it too." They are typified by the absurd predicament of the proverbial donkey starving in conflict between two equally desirable stacks of hay. (See "The Gentleman's Dilemma," page 87.) These conflicts are the dramatic themes involving love versus love, love versus career, love versus morality, honesty versus avarice, etc. In addition to the above, analysis reveals two other basic types of psychological conflict.[7]

The repulsion-versus-repulsion conflicts are expressed as "trapped between the devil and the deep blue sea" or, as in the song "Old Man River," "tired of living but 'feard of dying." This conflict, the theme of Hamlet's classic soliloquy "To be, or not to be . . . ," also creates the emotional tensions in O'Neill's *The Iceman Cometh*.

The attraction-versus-repulsion conflicts also take many forms, some of which are dramatized in Goethe's epic poem, *Faust*. One aspect, the male-versus-female conflict, is expressed by the plaintive "You can't live with them, but you can't live without them." This battle of the sexes is the plot of Shaw's amusing *Man and Superman,* in which the pursuing female triumphs, and his *Pygmalion,* in which the hunted male is the victor. August Strindberg's play, *The Father,* shows the sexes in more sordid conflict. In this psychological drama of domestic tragedy—based on the struggle between a father and mother

[7] MUNN, NORMAN L., *Psychology*, Houghton Mifflin Company, Boston, 1946. Chap. 14, Conflict.

HUNT, J. McV., *Personality and the Behavior Disorders*, Ed., The Ronald Press Company, N.Y., 1944. Chap. 12, Experimental Neuroses, H. S. Liddell, Ph.D. Chap. 14, Experimental Studies of Conflict, Neal E. Miller, Ph.D.

for control of their daughter—the neurotic and ruthless wife slowly and insidiously breaks down the mental stability of her husband, then causes his death by having him falsely declared insane and strait-jacketed.

A common, but somewhat different, version of the attraction-versus-repulsion conflict is the seriocomic plight of the lovesick, bashful boy who vacillates helplessly and miserably at a distance from the girl, unable either to approach or withdraw, to accept or reject. A more tragic aspect of the attraction-repulsion conflict is Hamlet's simultaneous love and hatred of his mother, which further adds to the melancholy of the neurotic Dane.

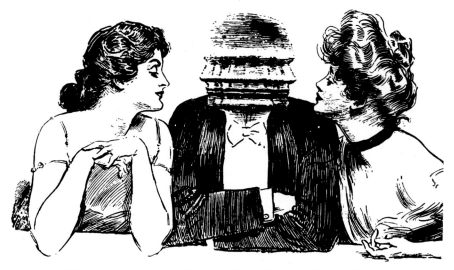

"THE GENTLEMAN'S DILEMMA" BY CHARLES DANA GIBSON

Conflict of attraction versus attraction. (*Courtesy of Mrs. Charles Dana Gibson.*)

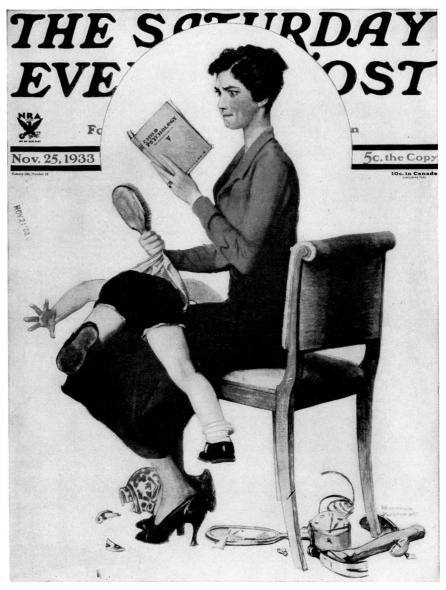

"To Spank or Not to Spank" by Norman Rockwell

Conflict of attraction versus repulsion. (*Courtesy of The Saturday Evening Post.*)

3. UNITY, CONFLICT, DOMINANCE: THE FUNDA-MENTAL PRINCIPLES OF AESTHETIC ORDER

The preceding pages demonstrated that the validity of unity, conflict, and dominance as principles of aesthetic order is based on their psychobiological and sociological origin in the fundamental pattern of human behavior.

The following pages will show that, whether expressed spatially or temporally, these principles of aesthetic order retain their basic character and effect similar results in all art forms. It will be shown how these principles are used in the time arts and in the space arts.

The time arts—music, poetry, literature—and the time-space arts—the drama and the dance—can develop a narrative theme of unity, conflict, and dominance as a moving sequence that begins, grows, and ends in time. The static or space arts—painting and sculpture—cannot do this, as abortive attempts have proved. Narrative painting and sculpture are limited to the illustration of a single scene arrested and detached from a continuously flowing stream of events in time. The scene can illustrate only one of the three principal phases of the narrative sequence: the unitary or rest aspect, the conflict aspect,[8] the dominance or resolution aspect.

But irrespective of which aspect the scene illustrates, the episode is expressed in lines, shapes, and colors that are organized according to the fundamental principles of visual order—unity, conflict, and dominance. The creation of aesthetic visual order is the problem common to all practitioners of the space arts—illustrators, photographers, nonrepresentational painters, sculptors, architects, decorators, and industrial designers.

[8] See "Showboat," "The Gentleman's Dilemma," "To Spank or Not to Spank" on pp. 83, 87, 88.

In the frozen visual order of the space arts, conflict, dominance, and unity exist simultaneously. Conflict is the aesthetic conflict or visual tension between opposing or contrasting lines, directions, shapes, space intervals, textures, values, and hues. Visual conflict or tension, also called opposition, contrast, or variety, is used to produce stimulus or interest.

But unity demands that this conflict or tension between competing visual forces be resolved and integrated by dominance, the principle of synthesis. This integration is effected by subordinating the competing visual attractions to an idea or plan of orderly arrangement. The opposing visual elements must be organized according to the idea or plan to form a unit that dominates its subordinate and conflicting parts. Some of these plans of visual order based on gradation and radiation have been shown on the preceding pages. Other plans based on repetition, repetition culminating in a dominant climax, repetition with variation and dominance, alternation, formal and informal balance will be illustrated and analyzed on the following pages.

Briefly stated, unity is the cohesion, consistency, oneness, or integrity that is the prime essential of composition. Composition implies unity; the words are synonymous. To say that a composition lacks unity is a contradiction of terms. If it does, it is not a composition. In the fine arts unity is axiomatic.

Weak structure or lack of unity in the visual arts is not so incoherent as weak structure in the other arts. In painting, the canvas and the frame help to unify the design. The canvas, a rectangle, is a unit to begin with. The frame isolates the painting in space, thus helping to bind its elements together. Because of the shape and frame, therefore, a certain amount of unity is inevitable even in the most chaotic painting or drawing.

90

The other arts are more exacting in this respect. In music, for example, tones are projected into boundless, shapeless space. Musical composition can depend upon neither frame nor spatial boundaries. Its structure alone can unify it.

STATIC AND DYNAMIC UNITY

There are two types of unity, static and dynamic. Static unity is exhibited by such structures as the regular geometric shapes, the equilateral triangle, the circle, and their derivatives. Natural inorganic forms such as snowflakes and crystals are examples or static unity.[9] Plants and animals are dynamic unities. The former are passive and inert; the latter, active, living, and growing. The static structures are fixed and without motion; the dynamic are fluent, expressive of a becoming, a crescendo approaching a climax.

Static designs are based on regular repetitive patterns and on the uniform, unchanging curve of the circle, whereas the dynamic are like the flowing continuity of the logarithmic spiral with its generating nucleus.

Any design, then, that emphasizes the exact and regular repetitive motif may be said to be static, and those stressing crescendo-diminuendo are dynamic. This is only a general classification, since some designs are not strictly within either of these two categories but combine aspects of both.

Static unity is characteristic of primitive ornament; it is analogous to the simple, savage rhythm of the tom-tom and to the slow, monotonous heartbeat of the primeval. The music of Occidental civilization employs the idea of transition or crescendo, synonymous with awakening and becoming.

The textile designs on page 113 are typical examples of static unity, or designs based on exact and regular repetition. Com-

[9] See p. 42.

91

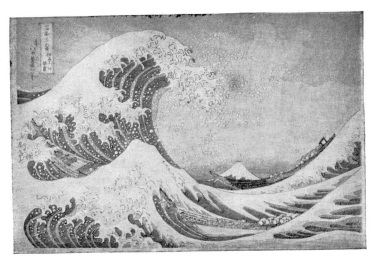

"THE WAVE" BY HOKUSAI

Dynamic Unity. The tremendous power of the sea is in the surge and sweep of line that overwhelms everything in its path. Observe how vividly the short staccato strokes of the subordinate rhythm accentuate by contrast the dominant flowing movement. A sweeping crescendo built on a gradation of line and direction is the unifying motif of the composition (note Diagram C on page 36). (*Courtesy of Shima Art Co., Inc.*)

pare them with Hokusai's "The Wave," an example of dynamic unity based on gradation. In "The Wave" unity is achieved through the subordination of the elements to a dominant rhythmic line having a flowing movement. There is a harmonic sequence culminating in a climax. The textile designs, on the contrary, have no dominant movement and no center of interest. However, static unity or uniform, allover, repetitive pattern such as these prints and Steichen's "Spectacles," page 114, is usually desirable in textiles, for which these designs were intended.

To summarize: there are two types of unity, static and dynamic, and many ways of achieving either. Any orderly arrangement in which the elements are subordinated to an idea or plan will produce unity.

92

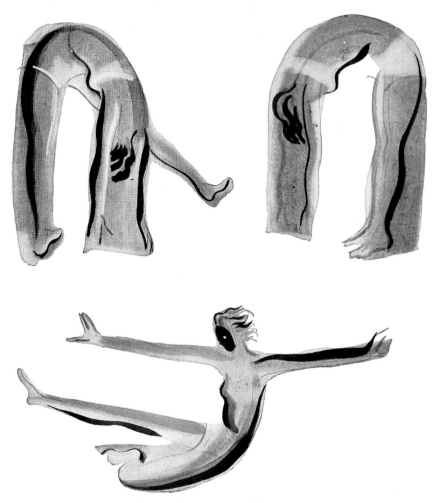

ACTION SKETCHES BY LEONARD

Dynamic Unity. The rhythmic motions of the human body are the perfect example of dynamic unity. It is then that the human will is visible as synchronized movement. The moving body is a vitalized coordination expressing one emotion, one idea. As the vivid sketches here and on the following page and Hokusai's "The Wave" demonstrate, movement may be expressed by a single sweeping action line that is its essence. (*Courtesy of Helena Rubinstein, Inc. from Mme. Rubinstein's book, Food for Beauty.*)

93

94

According to Plato, one of the greatest thinkers of all times, there are two worlds. One is the world of ideas, concepts, or noumena; the other is the world of matter, sensation, and phenomena. The world of ideas is perfect, unchanging or timeless, indestructible, and eternal. It is the world of divine teleology, the real world. But the world of matter is imperfect, ephemeral, and perishable, a world of chaos, delusion, error, evil, and death. Like the distorted reflection of the moon in troubled waters, the shadow world of matter is a faulty copy of the real world of ideas. Plato's concept of the universe is in accord with Hindu mysticism, which also states that the physical world has no true reality, but is maya, an illusion of the senses.[10]

Matter, by itself, is inert, dead, chaotic, meaningless until acted upon by the vital, creative force of idea. Idea molds matter, imposes shape, form, pattern, and design. Idea animates matter, imparts movement and direction to matter. Idea gives matter meaning, purpose, life.

> All are but parts of one stupendous whole,
> Whose body Nature is, and God the soul.
> Alexander Pope, "An Essay on Man."

The infinitely varied and complicated revelations of idea in the physical world of time, space, and matter are the only manifestations of idea that man can perceive with his senses. But man cannot for that reason say that material manifestations are the only possible expressions of idea.

For we know in part, and we prophesy in part. But when that which is perfect is come, then that which is in part shall be done away. When I was a child, I spake as a child, I understood as a child, I thought as a child;

[10] See *The Bhagavad-Gita*, S. Radhakrishnan, Harper & Brothers, New York, 1948. The ancient Vedantic philosophic concept of cosmic unity, translated from the original Sanskrit.

but when I became a man, I put away childish things. For now we see through a glass, darkly; but then face to face; now I know in part, but then shall I know even as also I am known.

<div align="right">Paul's First Epistle to the Corinthians, XIII</div>

In one of his famous Dialogues, the *Timaeus*, Plato implies that an idea has a transcendent, independent existence, that it seeks out the artist and forces him to act as an instrument through which the idea manifests itself in the material world. As in Luigi Pirandello's play, *Six Characters in Search of an Author*, the idea compels the artist to give it physical form and artistic life.

But whether the idea possesses the artist or the artist possesses the idea, the fact remains that realization of the idea in its most perfect possible form is the synthesizing motive that inspires, directs, and controls the artist in his selection of materials and means. The idea is an inseparable unit that insists upon its indivisibility and integrity. It will not tolerate rivalry; it compels each of its parts to be subordinate and to contribute to its wholeness. It requires that all its elements "belong," be appropriate to its purpose. It demands the exclusion or elimination of any part that is superfluous, nonfunctioning, or extraneous. Briefly stated, unity is motivation of the artist by one single idea that compels the artist to be an uncompromising perfectionist, demands that "he keep going back to it and working at it over and over again until there is not a note too much or too little, not a bar he can improve upon. Whether it is beautiful also is an entirely different matter, but perfect it must be . . . perfected, unassailable."[11]

The art of children at its best shows excellent unity of idea or purpose. This unity, expressed with naïveté and originality, is the strength and the charm of child art. When creating their

[11] Johannes Brahms.

best work, children are intense, single-minded, completely possessed by the idea. They are not confused and diverted by unassimilated theories. They ignore the irrelevant, concentrate on the basic idea, which they express with candor and directness. They are not inhibited, but boldly use anything that serves their purpose. But the ability to create the simple perfection seen in the art of the child is lost with the shedding of innocence, for the world of the child is a "never-never land" to which there is no returning.

UNITY OF STYLE OR CHARACTER

Unity may be achieved in subtle, mysterious ways. These cannot be analyzed. If you are like el Greco or van Gogh, unity need not greatly concern you. Your intense personality, expressed in unique style, will pervade your work. Its distinctive flavor will dominate your compositions and will impart a unity peculiar to itself. All great music, literature, and architecture have this emotional consistency, this intangible unity of character. It is the mark of a mature style.

Style cannot be taught, but develops gradually through years of slow growth and maturity. In its broadest sense, style refers to the technique, the manner, and character of the artist. Technique may be analyzed, manner described, but personality is as elusive as it is significant and real.

Style is the artist himself. When an artist has succeeded in expressing his personality clearly and vividly, he has achieved a genuine idiom.

UNITY BY DOMINANCE

As previously stated, the validity of the principle of dominance becomes clearly evident when we apply it to our own behavior. We are disturbed and unhappy when we are torn

97

between two equally strong conflicting ideas and are incapable of action until we make up our minds, make a definite decision, and allow one idea to dominate.

"United we stand, divided we fall" and "In union there is strength" are truths that are as important in the fine arts as they are in the arts of war or politics. Without dominance a design disintegrates.

There may be more than one major character in a novel or play, as Romeo and Juliet, or Macbeth and his wife. There may be more than one principal theme in a musical composition and more than one major part of a picture. But the principal parts must be intertwined, reciprocally dependent, must cooperate as a team whose importance is subordinate to the idea or design as a whole.

The ancient axiom, "A man cannot serve two masters," also applies to the space arts. Equality of conflicting visual forces produces incoherence.

Two visual forces of equal strength confined within a frame are like the two sheep the Cornwall farmer ties together to prevent their leaping the pasture fence. The two sheep jerk each other back and forth in an erratic and aimless manner and get nowhere. In looking at a design that has equality of competing visual attractions, we get something of the same impression of futility as we do when watching the restless, frustrated sheep.

As noted before, unity demands that this conflict or tension between competing visual attractions be resolved and integrated by dominance, the principle of synthesis. This integration is effected by subordinating the competing visual forces to an idea or plan of orderly arrangement. The opposing visual elements must be organized according to the idea or plan to

form a unit that dominates its subordinate and conflicting parts.

In these plans or designs, unity requires that one kind of line, one kind of shape, one direction, one texture, one value, and one hue be emphasized so that it dominates. Dominant means preponderant, outweighing, principal. For example, when a man is wearing a black suit and a white tie, we say that black is the dominant value. When we are in a forest and our dominant impression is one of verticality, we say that the vertical is the dominant direction, as it is in the illustration for Gray's "Elegy" on page 107. Therefore, when blue and green are used, either the blue or the green should be dominant. When opposite shapes—such as triangles and disks—are used, one shape should dominate as in TL on Chart 13, page 72, and PT on Chart 16, page 73. When contrasting straight and curved lines are used, either the straight or the curved should be emphasized as in NO on Chart 3, page 69. When the horizontal is opposed to the vertical, one direction should be dominant, as in NO on Chart 3.

This emphasis or dominance is produced by making one of the competing units larger, stronger in value contrast, and/or stronger in chroma or color intensity, as in "Cats' Eyes," page 129, the *Fortune* cover on page 131, and "Give 'Em Both Barrels" on page 133.

Dominance of one kind of line, shape, direction, texture, value, or hue can also be produced by repetition. For example, in WX on Chart 9, page 71, triangular shape and white value are emphasized and made dominant by repetition. In "Arms and Hands," page 106, right oblique direction is emphasized and dominates by repetition.

DOMINANT INTERVAL OR MAJOR CONTRAST

A dominant interval or difference among directions, shapes, areas, values, textures, or hues will further strengthen the unity of a design. In addition, unequal intervals produce a variety of contrasts, major and minor, which make a composition more interesting, as in PK, Chart 4; WX, Chart 9; EM, Chart 18; and EV, Chart 20, on pages 69–74.

DOMINANCE AND HARMONY

Inasmuch as harmonious units often have one or more identical dimensions, a certain amount of repetition exists (such as a green circle and a blue circle; this is a harmony of hue, repetition of shape). Consequently, it might be assumed that because unity can be created by repetition, harmony and unity are synonymous.

This is an error. A combination of harmonious units does not necessarily produce unity. Imagine a room painted in two harmonious colors, green and blue. Each is equal in chroma. Half the room is green, half is blue. The effect would be incoherent because neither color dominates.

To create unity one color must be dominant. It could be made so by increasing its area, by intensifying its chroma, or by doing both.

DOMINANCE AND DISCORD

Another misconception is the belief of some conservative artists that discord or violent contrast is incompatible with unity. But it is a mistake to assume that, because a design is discordant in character, it is consequently incoherent. Discord or extreme contrast and unity can coexist in the same composition if the principle of dominance is enforced. Some of the best modern and primitive art is proof that they can. Whether or

100

not one likes discord is another matter. Although vigorous contrast may be pleasing, it is more interesting when controlled and organized. Stimulus pleases, but order, too, is satisfying.

Lack of dominance produces disunity or disorder.

Dominance creates unity or order.

Dominance of Pattern. The phenomenon of magnetism, shown in the following experiment, demonstrates that dominance, the principle of synthesis, naturally imposes unity and order. On a stiff paper disk throw a handful of iron filings. The effect, shown at the left, will be chaotic because it lacks dominance. Now, place one end of a bar magnet beneath the paper and lightly tap the edge of the disk. Immediately the magnet asserts its dominion and imposes unity by arranging the filings in the orderly pattern of magnetic force which radiates from one dominant focal point, as shown at the right. See designs based on radiation, pages 42–52.

"STILL-LIFE COMPOSITION" BY NAN GREACEN

Anyone who can paint can easily make a pretty still life if he is given fine silks, Chinese ceramics, and flowers. But a real challenge to one's design ability is to select and arrange objects fom a junk yard. Here is one ingenious solution to the problem that creates order out of chaos. Unity has been imposed by the dominating theme of radiation inherent in the wheel and by the circular repetition of wheel and hose. Remove these, and the design disintegrates into the anarchy of the scrap heap.

Dominance of Curvilinear Plan. Unity is created by subordinating the floral elements to a dominant curve. This is the same simple and direct design plan used in the Neenah composition on page 104, "Dominoes" on page 105, "The Wave" on page 92, the Leonard sketches on pages 93 and 94, and the Petri poster on page 40.

A study of skillful compositions such as this floral arrangement, and the one on page 45, as well as "Toothbrushes" on page 138, will often show that the material itself has suggested its own arrangement to the ingenious composer.

In the above composition, it was the curve of the gold bird that suggested the line for the floral arrangement. Repetition of this curve by the curved forsythia sprays unifies the design by integrating bird and flowers. The gold and white urn provides additional unifying repetitions by echoing the gold bird and the yellow and white forsythia, narcissi, cinerarias, and primroses. A yellow-green background and golden brown table complete this harmonious color scheme. (*Courtesy of The Coca-Cola Co.*)

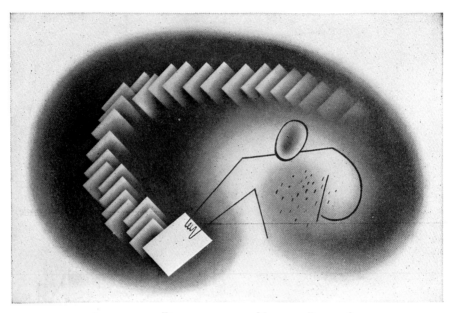

ADVERTISING DESIGN FOR THE NEENAH PAPER CO.

Dominance of Curvilinear Plan. Subordinating a repetitive series of straight-line, angular shapes to one dominant curve, as in this striking design and "Dominoes" (opposite), is always effective, for both contrast and unity are achieved at one stroke. These sweeping curves, like the flowing crescendo of Hokusai's "Wave" (page 92), are charged with the movement of living things: they are dynamic unities.

Textural contrast of clear, sharp, incisive line against soft, fuzzy tone contributes greatly to the interest of this composition. Note how apt are the arms of the little linear man; how well they function in the arrangement. (*Courtesy of Neenah Paper Co.*)

104

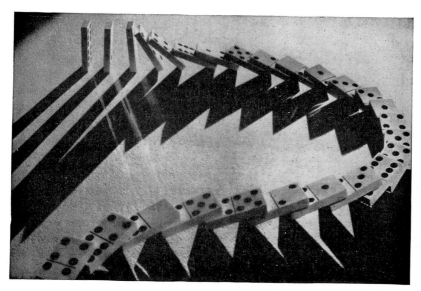

"DOMINOES"

Dominance of Curvilinear Plan. This design and the Neenah advertisement opposite, demonstrate two of the many possible applications of a very effective compositional plan. This simple plan, repetition culminating in a dominant climax, is the basis of both designs. This plan is comparable to a string of small firecrackers with a large one attached to the end . . . a series of little explosions ending with a big bang! The same satisfying sensation of finality and completeness is felt in "Dominoes." The angle and brilliancy of the illumination add much to its interest. The crisply serrated shadows are decorative and dramatic. (*Courtesy of Maryland Casualty Company and J. M. Mathes, Inc., Agency.*)

105

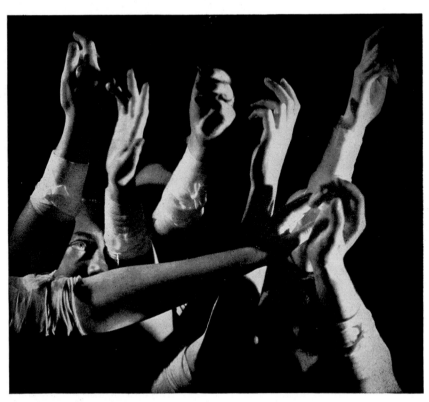

"Arms and Hands" by Gray O'Reilly

Dominance of Direction. A simple but well-organized composition with contrasting directions as the motif. The right and left oblique directions are opposed by the one nearly horizontal direction that forms strong and well-placed 90-degree angle contrasts with the left oblique. Here, as in the illustration for Gray's "Elegy," the directions are not equally emphasized . . . the right oblique is dominant or primary, the left oblique is secondary, and the nearly horizontal is subordinate. Note the balanced placement of the two left obliques. This same principle of dominance or unity with variety has also been observed in the relationship of the hands. Five hands face left; two face right. Five are almost closed; two are nearly open.

Note that this photograph, the abstraction, the Janniot bas-relief, and the Vassos illustration on the next page, as well as GR, Chart 1, NO, Chart 3, and AR, Chart 17, of the Design Test, all have contrasting directions with one direction dominating. This is an important factor in the design of each of these compositions.

106

ABSTRACT DESIGN

This design was derived from the photograph of the arms and hands. Try making similar abstractions based on the two illustrations below. After you have made the abstractions, build other compositions on them, using different subject matter.

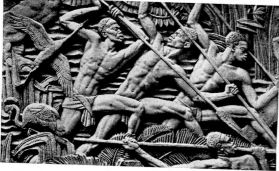

"OUBANGHI" BAS-RELIEF
BY ALFRED JANNIOT

Dominance of Direction. The positive character of the above design is produced by the strongly unifying principle of dominance by repetition. Interest is attained by the powerful right-angle contrast of direction—left oblique versus right oblique. The emphasis on the right oblique is reinforced by the turn of the heads, making it definitely the dominant direction. (*Courtesy of Louis Reynaud, Paris.*)

ILLUSTRATION FOR GRAY'S "ELEGY"
BY JOHN VASSOS

Dominance of Direction. Unity is achieved by means of dominance of the vertical direction. Note also that the two subordinate directions are not equally emphasized. The right oblique dominates the left oblique. (*Courtesy of E. P. Dutton & Co.*)

107

Unity is produced by dominance, and dominance is produced by repetition. Repetition is a basic and common form of natural order. The ebbing and flooding tides, the waxing and waning moon, the birth and death of plant and animal life, night and day, and the slow, measured passage of the seasons—all are rhythmical cycles that are eternally repeating the ancient, mystical theme of decay and resurrection.

Dominance or emphasis by repetition is the oldest, simplest, and most effective way of creating aesthetic unity. In prose, poetry, music, and the dance, repetition occurs in time. In painting, architecture, and sculpture, repetition occurs in space. But whether expressed temporally or spatially, repetition produces dominance and unity in all art forms, as will be shown.

Repetition may at first seem too simple and obvious a device to use except sparingly. But the many different examples of repetition with variation on the following pages will demonstrate that the use of repetition is limited only by the imagination, ingenuity, and skill of the composer, writer, or artist.

REPETITION IN THE TIME ARTS

Repetition with variation is the essence of musical development—the composer repeats in new forms what has been played before. The musical theme may be inverted, transposed into different keys, accelerated and retarded, played on various instruments, dynamically varied from pianissimo or softly to fortissimo or loudly as possible, opposed to conflicting or contrapuntal themes, expanded, elaborated, or embroidered.

Dramatic music, such as Wagner's *Ring of the Nibelung*, may also employ another repetitive musical device, the leit-

motiv or, literally, leading theme. Each principal character, idea, or object—such as the hero Siegfried, Fate, the river Rhine, the magic sword, or Wotan's celestial fire—is associated with an identifying musical theme, symbol, or leitmotiv which is repeated throughout the opera. Sounding of its leitmotiv or musical counterpart by the orchestra foretells the coming of the character or object and heralds its reappearance.

A literary device somewhat analogous to the musical leitmotiv is the repetition, throughout a novel or play, of an epithet, nickname, mannerism, physical oddity, or saying associated with a particular character. This device, used to build unity of characterization by making certain traits or qualities dominant by repetition, is extensively employed by Dickens in *David Copperfield*. For example, note the frequent reiteration by the optimistic and verbose Micawber that "something will turn up," and the constantly repeated protestations of humility by the false and whining Uriah Heep.

Repetition may also be used in the introduction or opening scene of a play or novel to emphasize its plot or title. For example, both the theme and the title of the photoplay *One False Step* are cleverly emphasized by repetition with variation in the prologue, which is a series of shots of a pair of feet making a misstep. But each shot shows a different pair and a different mishap. These shots with this title, incidentally, could have been just as effectively used as a "variation on a theme" series of photographic illustrations for an accident-insurance advertising campaign similar to those shown on pages 140 to 143.

The novel and play also use repetition of the opening scene by the closing scene to complete the dramatic cycle and to give unity and finality to the plot. Note, for example, the advancing and receding shots of the empty flat which occur both at the

109

beginning and at the end of Noel Coward's photoplay, *This Happy Breed*. Note also the shot of Shakespeare's London theatre, the Globe, that opens and closes Olivier's *Henry V*, and the railway station that is the setting for both the beginning and the end of Anna's tragic love affair in Tolstoy's novel *Anna Karenina*.

This same scheme is used in debate and literary exposition, where the premise is restated in the conclusion for the sake of clarity and coherence. It has been said that clear and effective teaching consists largely of repetition—of first telling the students what you are going to tell them, then telling them, and then telling them what you have told them.

Literature and poetry also utilize harmonic repetition of sound; that is, alliteration or repetition of the same first letter with different words, consonance or repetition of consonants with variation of vowels; and assonance or repetition of vowels with various consonants. In poetry the emotional effect produced by rhythm and tone color is emphasized by repetition of entire words as in the following example:

> Keeping time, time, time,
> In a sort of Runic rhyme,
> To the throbbing of the bells,
> Of the bells, bells, bells,
> To the sobbing of the bells;
> Keeping time, time, time,
> As he knells, knells, knells.
> Poe, "The Bells"

THE EMOTIONAL EFFECTS OF REPETITION

The emotional effects produced by repetition may be quite different—even opposite—depending upon what is repeated and how it is repeated. The following examples illustrate a few of these effects and indicate the emotional range covered.

110

Exact repetition, because of an absence of variation, contrast, or conflict, is monotonous and uninteresting. But it may also have a soothing and soporific effect. That is why we breathe slowly and steadily when we wish to calm ourselves. That is why we count sheep to lull ourselves to sleep, and that is why quiet but persistent reiteration, which induces a state of somnolency and receptivity, is the essence of hypnotic techniques.

But repetition may induce reactions quite the opposite of soothing monotony. Scheherazade's interminable and repetitive story in the *Arabian Nights* is an example of irritating monotony.

The disillusioned Sultan Schahriar, convinced of the faithlessness and deceit of all women, has vowed to put a stop to further marital infidelity by taking a new wife each night and then strangling her the next morning. In the course of time Scheherazade, the vizier's daughter, offers herself as wife and victim number sixty-six, provided the sultan will promise to let her tell him a tale before killing her. The unwary sultan promises; the monotonously repetitive story, concerning the incessant activity of millions of ants fruitlessly occupied in toting off millions of grains of wheat, starts and goes on and on day after day, until the sultan, in desperation, surrenders and promises to call off the strangulation if only Scheherazade will stop talking. Today, Scheherazade's filibustering tactics have become standard practice with many lawyers, politicians, and some of our distinguished members of Congress.

In the same category as the above are the Chinese waterdrop torture and some singsong radio slogans. The effect of the choicely odious doggerel perpetrated in these vocal trademarks is to irritate, exasperate, infuriate, or nauseate—depending upon the sensitivity, taste, and education of the victim. The

111

cynical defense of the hucksters of these and other examples of debased commercialism—"They smell but they sell"—echoes the politician who sneeringly advised his henchmen to "keep on throwing enough muck and some of it is bound to stick."

Another example of the maddening effect of insistent and monotonous repetition occurs in O'Neill's play *Emperor Jones*, where the sinister and ominous beating of the tom-tom finally drives the hero into a frenzy.

But in the following poetical excerpt reiteration is used neither as a soporific nor as an irritant; it merely serves to emphasize the dull despair and resignation expressed in the text.

> She only said, "The day is dreary,
> He cometh not," she said,
> She said, "I am aweary, aweary,
> I would that I were dead."
>
> Tennyson, "Mariana."

Yet reiteration may be used to induce reactions that are neither sleepy, sad, nor mad. Ravel in his *Bolero* uses repetition in a provocative, sensually exciting way. Beethoven repeats the famous "fate motif"—the four-tone knocking rhythm that is the first theme in the first movement of his majestic Fifth Symphony—to build up an intensely dramatic mood of mysterious expectancy.

EXACT REPETITION IN THE SPACE ARTS

In the space arts, as in the time arts, repetition may be exact repetition, or it may be varied repetition. Varied repetition will be discussed later.

Exact repetition of a unit has a strongly integrated, clear, and emphatic effect. In the space arts, exact repetition is used in wallpapers, rugs, textiles, architectural ornament, and adver-

112

tising photography. Examples of exact repetition are too simple and common to require much illustration or analysis here.

Exact repetition may be expressed in a regular, uniform, and monotonous sequence such as 1, 1, 1, 1, 1. Or it may take the more interesting and rhythmical form of *alternate repetition* or *alternation* described and illustrated on pages 115 to 124.

Exact repetition in textile design (*Pratt student exercises.*)

"Spectacles," A Repetitive Photographic Pattern for a Silk Design
by E. J. Steichen

Exact Repetition in Photography. Old wine in new bottles. A modern aspect of the ancient principle of the repeat. A repetitive design is appropriate for a presentation of the regimented machine product. Advertising photography makes frequent use of this idea. Repetition effectively emphasizes the product.

A photograph of Main Street per se is no more art than is a phonographic record of its traffic noises music. Both are mechanical reproduction. Neither is creation. That which turns photography into art is the same as that which turns noise into music-design.

Technical skill with lens and chemicals plus dramatic subject matter are not enough. The camera produces design only when it is controlled by a designer. The camera is merely a modern vehicle or medium of expression. (*Courtesy of Stehli Silk Corp.*)

114

Alternation is reciprocal repetition or exact, regular, and repeated interchange in sequence. Alternation may be expressed in many different sequences or rhythms. Some of these alternating sequences, expressed alphabetically or numerically, are: A, B, A, B, A, . . . etc.; or 1, 2, 1, 2, 1, . . . etc.; also A, B, C, A, B, C, A . . . etc.; 1, 1, 2, 2, 1, 1 . . . etc.; and 1, 2, 1, 3, 1 . . . etc. Alternation, or rhythmical repetition, is used in all art forms to create unity with variety.

On the following pages will be shown a few examples of alternation expressed temporally in music and poetry and alternation expressed spatially in architecture, photography, and textile design.

These examples will show that alternating sequences or rhythms derived from time forms, such as music or poetry, can be transposed and expressed in space forms, such as architecture, architectural sculpture, or decorative design, and vice versa. These simple transpositions of time designs into space designs, although in themselves relatively unimportant, are shown as further proof of an important point. These transpositions prove, by actual examples, the important fact—repeatedly emphasized throughout this book—that whether expressed spatially or temporally, the principles of aesthetic order retain their basic character and effect similar results in all art forms.

Other experiments, in which time designs are transposed into kinetographic space-time designs, will be described later in the section on the Abstract Film.

Simple and well-known examples of temporal-spatial alternation are the following rhythmical movements of men and animals: Walking is a simple alternating sequence of 1, 2, 1, 2,

1 . . . or left, right, left, right. . . . A dance sequence could be 1, 2, 1, 3, 1, 2, 1, 3, . . . or kick, step, kick, turn, kick, step, kick, turn. The tempo sequence of the tango is 1, 1, 2, 2, 2, 1, 1, 2, 2, 2 or slow, slow, quick, quick, quick, slow, slow, etc. The canter of a horse is 1, 2, 3, 1, 2, 3 . . . or—on the left lead—1 (right hind leg), 2 (left hind leg and right foreleg in unison), 3 (left foreleg). The trot is 1, 2, 1, 2, 1, 2, 1 . . . with diagonally opposite legs paired and moving in unison.

Much architectural sculpture, both ancient and modern, is based on spatial alternation. The well-known "egg and dart" motif, used in classic Greek architectural ornament, is a famous example.

A simple and common example of temporal alternation is the tremulously vibrating musical trill, shake, or quaver, that is, the regular and rapid alternation of two tones a minor or major second part. The lower tone is the principal note, the higher is the auxillary. The trill may be numerically expressed by the alternating sequence 1, 2, 1, 2, 1 . . .

In the rondo, temporal alternation is expressed in a more complex and elaborate musical form. Briefly and simply stated, the rondo is, essentially, the alternate repetition of the first strain in its original key after each of the other strains, as in Ravel's *Pavane for a Dead Princess*. The rondo musical form was derived from the rondel poetical form.

The rondel, a lyric form invented in the fourteenth century and mostly used by medieval French poets, consists of five stanzas in the alternating sequence 1, 2, 1, 3, 1, as shown on page 117. Stanza 1 is short, consists of two lines, and is alternately repeated. Stanzas 2 and 3 are longer, each consisting of four lines.

The alternating sequence of this poetical time design has been transposed into musical time design as the rondo. It can

also be simply expressed in time-space design as a dance sequence, such as step, dip, step, turn, step, dip, step, turn, or 1, 2, 1, 3, 1 . . . etc.

The rhythmical sequence, 1, 2, 1, 3, 1, of this poetical time design can also be transposed and expressed in space design as illustrated and described on pages 118 to 123, and in Exercise 11 on page 162.

1 Love comes back to his vacant dwelling
 The old, old Love that we knew of yore!

2 We see him stand by the open door,
 With his great eyes sad, and his bosom swelling
 He makes as though in our arms repelling
 He fain would be as he lay before:

1 Love comes back to his vacant dwelling
 The old, old Love that we knew of yore!

3 Ah, who shall keep us from over-spelling
 That sweet, forgotten, forbidden Love?
 E'en as we doubt, in our hearts once more,
 With a rush of tears to our eyelids welling

1 Love comes back to his vacant dwelling
 The old, old Love that we knew of yore!

Dobson, "A Rondel"

Temporal Alternation in Poetry. This poem is an example of time design based on the alternating sequence 1, 2, 1, 3, 1. The rhythmical sequence of the above time design has been transposed and expressed in the space designs on pages 118 to 121. This rhythmical theme can also be used for other space designs as described under "Photographic Dance Frieze," on page 124, and in Exercise 11, on page 162.

Still other decorative space designs could be made by a continuous allover printing of this or other rondels. In one of these designs, for example, stanzas 1 could be brown, stanzas 2 dull yellow, and stanzas 3 bright green.

Decorative space designs based on the time design of the rondel poetical form. (*Pratt student exercises.*)

Pratt student exercises.

Pratt student exercises.

120

Pratt student exercises.

121

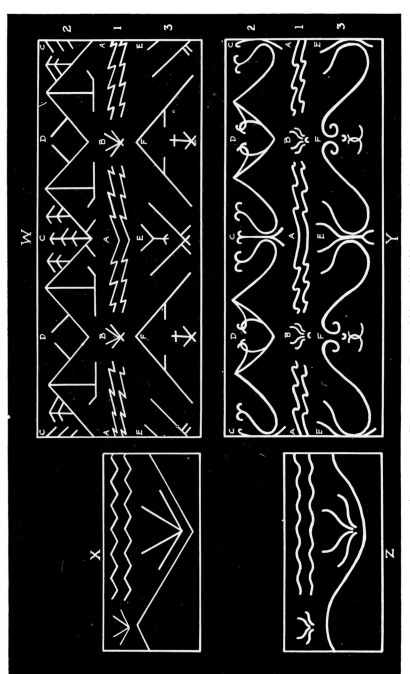

ANALYSIS OF DESIGNS ON PAGES 118 TO 121 (*See opposite*)

122

The decorative space designs, on pages 118 to 121, are based on the time design of the rondel poetical form on page 117. These space designs, executed by my students, are all variations of the same theme.

Each design consists of three different friezes or bands corresponding to the three different stanzas of the rondel. Frieze 1, like stanza 1, is narrow. Friezes 2 and 3, like stanzas 2 and 3, are wide. The friezes follow the same vertical alternating sequence 1, 2, 1, 3, 1 as the stanzas.

Each frieze consists of two different units or two different groups of units that are horizontally alternated as A, B, A, B, A; C, D, C, D, C; E, F, E, F, E.

These designs are only some of the many that can be evolved from W and Y, the plans of linear continuity shown opposite.

Plan W is based on alternation of large and small radiations, together with alternation of large and small zigzags, as shown by analysis X.

Plan Y, similar to plan W, is built on alternation of large and small curvilinear radiations, with alternation of large and small waves (analysis Z).

Temporal Alternation in Music—Old French Folk Tune. This melody is an example of time design based on the alternating sequence 1, 1, 2, 2, 1, 1. See also Old German Folk Song on page 156.

The sequence, or rhythm, of the above time design can be transposed to space designs as described under "Photographic Dance Frieze," on page 124, and in Exercise 10 on page 161.

Other decorative space designs could be made by a continuous or allover printing of this Old French Folk Tune, or similar musical forms. In these designs, sections 1 could be narrow and red on a black background, and sections 2 could be wide and black on a red background, for example.

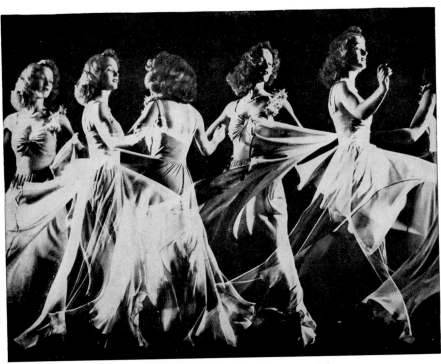

PHOTOGRAPHIC DANCE FRIEZE BY GJON MILI
(Mutiple-flash or Stroboscopic Photograph)

Spatial Alternation in Photography. The poetry of motion is a reality, not a figure of speech.

This frieze is an example of space design based on the horizontal alternating sequence A, B, C, A, B, C, A . . . etc., or front, side, back, front, side, back, front . . . etc.

This frieze (1) could be vertically alternated with a similar, but wider, frieze (2) in the sequence 1, 1, 2, 2, 1, 1 to form a decorative space design having the same sequence as the time design of the Old French Folk Tune on page 123. Also see Exercise 10, on page 161.

Or this frieze (1) could be vertically alternated with two similar, but wider, friezes (2 and 3) in the sequence 1, 2, 1, 3, 1 to form a decorative space design —like those on pages 118 to 121 and having the same sequence as the time design of the rondel poetical form on page 117. Also see Exercise 11 on page 162. (*Courtesy of Arthur Murray Studios, N.Y.*)

Varied repetition, or repetition with variation, is a basic and common principle of natural order. For example, although nearly all snow crystals are repetitions of a radiant pattern within a hexagonal shape, no two of the countless billions of crystals are ever exactly identical. Nature, the master designer, creates infinite variations of a repeated radiant theme. (See "Snow Crystals," page 42.)

In the space arts, varied repetition is produced by repeating one or more aspects, qualities, or attributes of a unit, theme, or motif, while changing one or more of its other aspects. That is, a unit is repeated but may be varied in direction, size, texture, value, hue, and/or chroma; for example, a large disk repeated by a smaller disk. This is *repetition of shape with variety of size*, as illustrated by "Spherical Obsession," page 128, "Cats' Eyes," page 129, "Fifth Avenue and Forty-Second Street," page 130, and the *Fortune* cover design, page 131. See also PK on Chart 4, and WX on Chart 9, pages 69 and 71, and Abstract Films on pages 414, 416.

Varied repetition may also take the form of a graded sequence such as "pagodas," page 39, and the Petri Wine poster, page 40, that illustrate repetition of shape with gradation of size.

Repetition with variation, also called *harmonic repetition,* is used in all art forms to produce unity with interest.

In architecture, exact repetition of such elements as windows, arches, and columns is obvious. But more subtle and interesting is the repetition with variation found in the proportions of classic Greek and Renaissance architecture. This subject will be analyzed later in the chapter on Proportion. But, to anticipate briefly, it will be shown that repetition with varia-

125

tion is effected by repeating a key ratio or proportional motif, while varying the dimensions.

The basic appeal of repetition with variation—as shown by the universal delight and interest in such things as marching men, pony ballets, and quintuplets—explains why repetition with variation is the foundation of advertising literature, radio and television commercials, advertising design, and illustration. Because of its popular appeal, because it can quickly, easily, and vividly emphasize a particular feature of the merchandise, and because it provides the graphic theme that unifies a series of advertisements, pictorial repetition with variation is the foundation of publicity campaigns. The *Ladies' Home Journal* "Mother-and-Daughter" series, the Wrigley Doublemint "Twin" series, the Pall Mall "They Are Longer" series, the Old Taylor "Signature" series, and the Dubonnet "Little Tippler" series are some typical examples of the popularity and effectiveness of variations on a repeated pictorial theme in advertising design. (See pages 140 to 143.)

"Paris Roof Tops and London Hat Shop"

"The Jolly Publican and the Ripe Pear"

Repetition of shape with variation of object. (*Juxtapositions from Lilliput by Stefan Lorant, Editor.*)

127

"Spherical Obsession" by Fabrizio Clerici

Repetition of Shape and Object with Variation of Size. Note the similarity in the use of repetition in the above and "Cat's Eyes" on the following page. (*Courtesy of Peter Lindamood, N.Y., and the Museum of Modern Art.*)

"Cats' Eyes"

Repetition of Shape and Object with Variation of Size. The two large central orbs repeat the smaller ones and dominate because of their stronger value contrast in addition to their larger size. The sharpness of the two large disks contrasts crisply with the soft background of fuzzy fur and fleecy clouds. This variety of hard and soft edges increases interest in this design just as it does in the Neenah composition on page 104.

Compare PK on Chart 4 (page 69), **EM on Chart 18** (page 74), the composition on page 260, the above composition, and the two compositions on the succeeding pages. Note that, although the subject matter is very different in each composition, all six compositions are built on the same plan of design— that is, repetition with variation and dominance. (*Courtesy of Climax Molybdenum Company.*)

"FIFTH AVENUE AND FORTY-SECOND STREET" BY HANS KNOPF

Repetition of Shape with Variation of Object and Size. The large centralized V of the street sign repeats and dominates the smaller angles of its echoing background. Like an exclamation mark, the lamppost climaxes the composition. (*Courtesy of Pix Pub., Inc.*)

130

DESIGN BY PETER PIENING

Repetition of Shape and Object with Variation of Size and Value. On the original "Fortune" cover design, the large V is dominant because of its brilliant vermilion color in addition to its larger size. (*Courtesy of Fortune Magazine.*)

131

MAGAZINE COVER DESIGN BY SAUL STEINBERG

Repetition of subject with variation of locale, and alternation of value or tonality. (*Courtesy of Saul Steinberg.*)

132

"GIVE 'EM BOTH BARRELS," WAR POSTER BY JEAN CARLU

Repetition of Shape with Variation of Object, Size, and Value. In this design—based on repetition of the foreground by the background—the foreground figure dominates by stronger value contrast, and by slightly larger size. *(Courtesy of Division of Information, O. E. M., Washington, D. C.)*

"THE SPIRIT OF MEXICO" BY JULIO DE DIEGO

Repetition of Shape with Variation of Object, Size, and Value. In this design repetition of shape with variation of object is expressed by the mountains in the background whose shapes echo the shapes of the foreground figures. The foreground figures dominate because of their larger size and stronger value contrast. (*Courtesy of Abbott Laboratories, Chicago.*)

"Bon Voyage"

Repetition of Shape with Variation of Object. The fluttering handkerchiefs are echoed by the fluttering gulls. The vertical, angular figures are repeated by the vertical, angular buildings. (*Pratt student exercise in varied repetition.*)

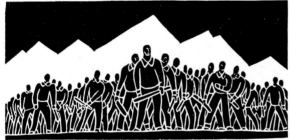

"Mob and Mountains" from Dale Nichols'
A Philosophy of Esthetics

Repetition of Shape with Variation of Object. The silhouette of the mountains repeats the silhouette of the mob. Jagged, zigzag line appropriately expresses the violent agitation of a mob. (*Courtesy of Black Cat Press, Chicago.*)

Cover Design for *Tomorrow Will Come,* by
E. L. Almedingen

Repetition of Pattern with Variation of Object. The radiant pattern of the sun rays repeats the radiant pattern of the up-stretched arms. See other designs based on radiation on pages 43–52. (*Courtesy of Little, Brown & Co., Boston.*)

135

"DANCER AND GAZELLES" BY PAUL MANSHIP

Repetition of Pose with Variation of Object. The relationship between the arms of the dancer and the forelegs of the fawns plays an important part in this composition. Note the unifying and harmonious repetition of flexed arm and bent forelegs; also, the extended arm echoing the extended forelegs.

Although more formal and passive, this composition is like Rockwell Kent's illustration for *Titus Andronicus* on page 51 in that both designs derive their stability from the same triangular arrangement.

"BALLET GIRLS" BY DEGAS

Repetition of Pose with Variation of Object. The "Ballet Girls" by Degas illustrates the use of harmonic repetition in pictorial composition to create unity. In this example, the repeat is informal and harmonious in comparison with the regular and exact repetitions of the block prints on pages 118 to 121. (*Courtesy of Raymond and Raymond.*)

136

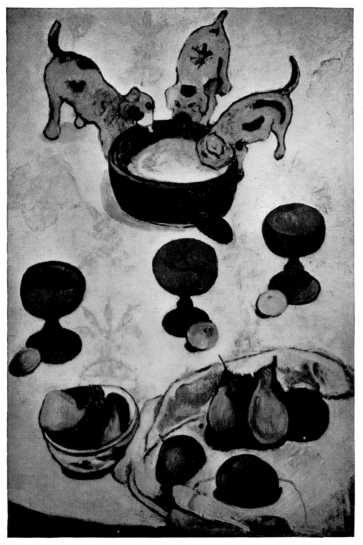

"Three Dogs, Three Wineglasses, Three Apples" by Gauguin

Repetition of Number with Variation of Object. This whimsically naive arrangement is the repetition of three different repetitive groups of three—dog, dog, dog, glass, glass, glass, apple, apple, apple.

Repetition makes three the dominant theme or idea. (*Courtesy of The Museum of Modern Art, collection of Mme. Sternheim, Paris.*)

137

"TOOTHBRUSHES" BY VICTOR KEPPLER

Repetition of Line with Variation of Size and Value. This composition demonstrates that it is not the material but its arrangement that makes good design. Hidden in a common, ordinary object may be the secret of a distinguished composition that will be perceived by the discerning eye of a designer. Here a toothbrush is the motif. Once the essential character of this key unit was grasped the composition grew naturally out of it.

Analysis. The most salient characteristics of the brush are the serrated contour of its bristles and its rough texture. These prominent qualities furnish the theme for the arrangement and are emphasized by harmonic repetition. The small, serrated bristle contour reappears in the large zigzag placement of the

138

VARIETY or INTEREST	UNITY
Contrasting small and large zigzags.	Repetition of the zigzag.
Contrasting values, black and white.	Black dominant.
Contrasting directions, right oblique versus left oblique.	Left oblique dominant.

DESIGN ANALYSIS OF "TOOTHBRUSHES"

brushes (repetition of line, variation of size). This light zigzag finds its reverse echo in the dark, jagged pattern formed by the cast shadows (repetition of line, variation of value). The straight lines of the brush handles and their shadows intensify the serrated lines by contrast.

Texture. The rough bristle texture recurs in the background, which makes this characteristic texture the dominant. The smooth, gleaming handles provide an effective foil to these prevailing dull, rough surfaces.

Direction. The oblique suggests movement and is therefore vigorous. The choice of this dynamic direction is appropriate to the purpose of this design, which is to attract attention. Left oblique is dominant; opposed by right oblique.

Values. A major value key (strongly contrasting values) reenforces the visual punch. (*Courtesy of Victor Keppler.*)

139

Repetition of Theme and Objects with Variation of Costume, Pose, and Props or Accessories. Note that, in addition to repeating the mother-and-daughter theme with variations, each illustration by itself is based on repetition of number with variation of object as in "Three Dogs, Three Wineglasses, Three Apples" on page 137. That is, each of the mother-and-daughter illustrations is based on repetition of two similar groups of two similar objects. In each illustration, both groups—mother and daughter, bitch and pup—and mother and daughter, baby and doll—are repetition of shape and object with variation of size. *(Courtesy of The Ladies' Home Journal, Curtis Publishing Co.)*

Ladies' Home Journal "MOTHER AND DAUGHTER" MAGAZINE COVER SERIES
BY AL PARKER

140

DUBONNET "LITTLE TIPPLER" SERIES BY A. M. CASSANDRE

Repetition of theme, object, and pose with variation of costume. (*Courtesy of Dubonnet Société Anonyme de France.*)

141

Old Taylor "Signature" Series by Pierre Brissaud

Repetition of theme with variation of locale, characters, and costumes. (*Courtesy of the National Distillers Corp.*)

PALL MALL "THEY ARE LONGER" SERIES BY JOHN FALTER

Repetition of theme and costume with variation of locale and characters. (*Courtesy of Pall Mall.*)

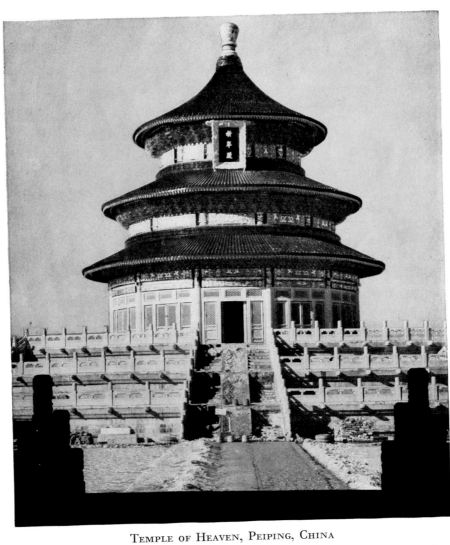

TEMPLE OF HEAVEN, PEIPING, CHINA

Repetition of shape and object with graded variation, or gradation, of size.
Also see pages 39, 40, 41. (*Courtesy of Ewing Galloway, N.Y.*)

144

"E Pluribus Unum"

Repetition of Shape and Object with Graded Variation, or Gradation, of Size. Other designs that also utilize this same plan of visual order, or compositional scheme, are shown on pages 39, 40, 41. (*Pratt student exercise in repetition and gradation.*)

Balance is equilibrium of opposing forces. There are two types of balance—formal and informal. *Formal balance* is the balancing on opposite sides of an axis of one or more elements by identical or very similar elements. Formal balance is often exactly symmetrical, or reverse repetition on opposite sides of an axis, as in men, animals, fish, insects, flowers, ships, airplanes, automobiles, most furniture, many old religious paintings, and most of the ancient architectural façades. One example of formal and exactly symmetrical balance is the Parthenon, shown on page 147. An example of formal, but not exactly symmetrical, balance is the Tomb of the Medici, shown on page 153.

Informal balance is the balancing on opposite sides of an axis of one or more elements by dissimilar or contrasting elements. Informal balance is always definitely asymmetrical, as "Dancers Practicing at the Bar" on page 150.

The concept of balance or stability is often illustrated by weights and a beam, as on the following pages. But these illustrations are intended only as abstract or schematic devices that should not be interpreted literally to imply that the concept of balance is limited to mass, weight, or gravity in architecture, sculpture, and painting. Balance is equally valid in music, poetry, literature, the drama, and the dance.

The function of a design determines the type of balance most appropriate to its purpose. Formal balance produces a stately, dignified, and serene effect proper to such objects as courts of law, banks, religious paintings, cathedrals, and monuments, such as the Parthenon, Notre Dame de Paris, the Taj Mahal, and the Tomb of the Medici, shown on the following pages.

Informal balance—less peaceful, less obvious, but more interesting—is being used more often in contemporary art and

architecture. This trend is a natural and appropriate manifestation of the turbulent spirit of our time, which is in such sharp contrast to the more serene character of the classic Greek period.

Because balanced, unified structures are stronger and function better than unbalanced, disunified contraptions, and because his own body is a balanced unit, man prefers the positives, balance and unity, to the negatives, unbalance and disunity.

The relationship of balance to unity, repetition, variety, and dominance is explained on the following pages.

THE PARTHENON (Model)

Formal balance in architecture. (*Courtesy of the Metropolitan Museum.*)

UNITY AND FORMAL BALANCE

Diagram 1 consists of one shape that is repeated. Unity, therefore, is created by repetition.

147

INFORMAL BALANCE IN ARCHITECTURE

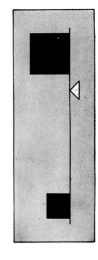

UNITY AND INFORMAL BALANCE

Diagram 2 is variation of one shape. That is, there is repetition of a single shape with variety of size. Because of variety of size this diagram is more interesting than Diagram 1.

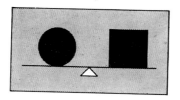

DISUNITY AND INFORMAL BALANCE

Diagram 3 consists of contrasting shapes. Because these opposing shapes are equal in size, neither dominates and disunity results. This diagram is, therefore, balanced but not unified.

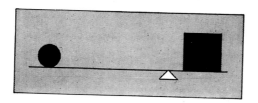

UNITY AND INFORMAL BALANCE

Diagram 4 also consists of contrasting shapes. Nevertheless, because one is larger or dominant, unity is created.

Variety of shape in addition to variety of size makes this diagram more interesting than Diagram 2, which is also informally balanced.

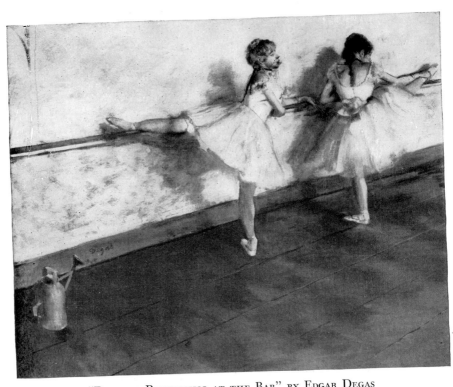

"DANCERS PRACTICING AT THE BAR" BY EDGAR DEGAS

Informal balance in painting. Also see page 156. (*Courtesy of the Metropolitan Museum.*)

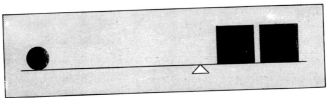

UNITY AND INFORMAL BALANCE

Diagram 5, like Diagram 4, consists of contrasting shapes and is also unified by dominance of size. Here in Diagram 5, however, dominance of size is reinforced by repetition.

150

Notre Dame de Paris (Model)

Formal balance in architecture. (*Courtesy of the Metropolitan Museum.*)

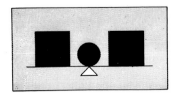

Unity and Formal Balance

Diagram 6, like Diagram 5, consists of contrasting shapes and is also unified by dominance produced by both size and repetition. The only difference is that this Diagram 6 is formally balanced, while Diagram 5 is informally balanced.

Because of variety of shape and size, this Diagram 6 is more interesting than Diagram 1, which is also formally balanced.

151

THE TAJ MAHAL, AGRA, INDIA

Formal Balance in Architecture. (Also see page 151.) The pure, symmetrical beauty of the Taj Mahal, tomb of a Mogul queen, is delicate, dreamlike, tranquil. The Taj, supreme masterpiece of Mogul architecture, was built in the 17th century by the Muhammadan Shah Jehan as a monument to his favorite wife, the beautiful, young Mumtaz-i-Mahal, whose name meant "Exalted of the Palace." The Taj also contains the cenotaph of the Shah, whose plan for his own tomb—to be built on the opposite bank of the river and connected to the Taj by a bridge—was never accomplished because of disasters at the end of his reign. (*Courtesy of Ewing Galloway, N.Y.*)

UNITY AND FORMAL BALANCE

Diagram 7 above is similar to Diagram 6 except that dominance has been reversed. That is, in Diagram 7, the larger circle now dominates the smaller squares.

EVENING AND DAWN, MEDICI TOMB BY MICHELANGELO

Formal balance in sculpture. Also see "Dancer and Gazelles," on page 136. (*Courtesy of the Metropolitan Museum.*)

"La Fiesta de Las Flores" or "Mexican Flower Festival" by Diego Rivera

*Formal Balance in Painting.** In modern paintings, which often reflect to-
day's instability and agitation, formal balance is used less frequently than in
paintings of more placid periods. The above modern painting is an exception
to the contemporary trend. (*Collection of The Museum of Modern Art; gift of
Mrs. John D. Rockefeller Jr.*)

* Also see p. 46.

154

Formal Balance in Caricature. In addition to formal balance, this design illustrates radiation or gradation of direction, and repetition of shape with gradation of size. (*Courtesy of William Chaiken and The Art Students League, N.Y.*)

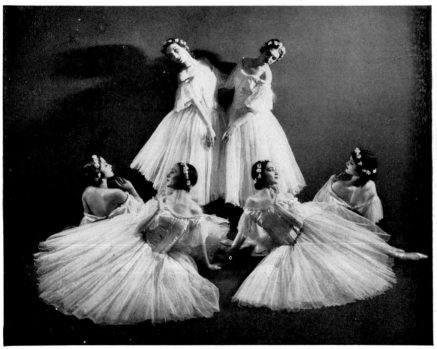

"FOKINE BALLET LES SYLPHIDES" BY ALFREDO VALENTE
Formal balance in the dance. (*Courtesy of Alfredo Valente.*)

155

OLD GERMAN FOLK SONG

Temporal Balance. Formal and symmetrical balance in music. The Old French Folk Tune on page 123 is another example.

JAPANESE JUGGLER

Informal balance in advertising design. (*Courtesy of Climax Molybdenum Co.*)

156

4. SUMMARY

1. Unity, the primary principle of aesthetic order, initiates the secondary principles of conflict and dominance.

2. The validity of unity, conflict, and dominance as principles of aesthetic order is based on their psychobiological and sociological origin in the fundamental pattern of human behavior.

3. Unity, conflict, and dominance, the fundamental principles of aesthetic order, retain their basic character and effect similar results, whether expressed in the time arts or in the space arts.

4. The aim of design is the creation of an interesting and balanced unit.

5. In the space arts, interest is created by aesthetic conflict or visual tension between opposing or contrasting lines, directions, shapes, space intervals, textures, values, and hues. Visual conflict or tension, also called contrast or variety, is used to produce stimulus or interest.

6. Unity, the prime essential of design, is cohesion, consistency, oneness, or integrity. Unity demands that conflict or tension between competing visual forces be resolved and integrated by dominance, the principle of synthesis. This integration is effected by subordinating the competing visual attractions to an idea or plan of orderly arrangement. The opposing visual elements must be organized according to the idea or plan to form a unit that dominates its subordinate and conflicting parts.

7. In these plans, unity requires that one kind of line, shape, direction, texture, value, and hue be dominant. Dominance or emphasis is produced by making one of the competing units larger, stronger in value contrast, and/or stronger in chroma

157

or color intensity. Or one of the competing units can be empha-sized and made dominant by repetition.

8. A dominant interval or major contrast strengthens the unity and interest of a design.

9. Repetition may be utilized in innumerable and different ways. Its use is limited only by the imagination, skill, and in-genuity of the composer, writer, or artist.

10. Repetition may be exact repetition, or it may be varied repetition.

11. Exact repetition may be regular, uniform, and monot-onous, as 1, 1, 1, 1, 1.

12. Exact repetition may also take the more interesting and rhythmical form of alternation or alternate repetition. Alter-nation is reciprocal repetition or exact, regular, and repeated interchange in sequence such as 1, 2, 1, 3, 1. Alternation may be expressed in many different temporal and spatial sequences. Alternating sequences or rhythms derived from such time de-signs as music or poetry can be transposed and expressed in space designs, such as architecture, architectural sculpture, or decorative design, and vice versa.

13. Varied repetition is produced by repeating one or more aspects, qualities, or attributes of a unit, theme, or motif, while changing one or more of its other aspects.

14. Varied repetition may also take the form of a graded se-quence, or repetition with gradation.

15. Repetition with variation or harmonic repetition is used in all art forms to create unity with interest.

16. Balance is equilibrium of opposing forces.

17. There are two types of balance—formal and informal.

18. Formal balance is the balancing on opposite sides of an axis of one or more elements by identical or very similar ele-

158

ments. Formal balance produces a stately, dignified, and serene effect.

19. Informal balance is the balancing on opposite sides of an axis of one or more elements by dissimilar or contrasting elements. Informal balance is less peaceful, less obvious, but more interesting than formal balance.

20. The function of a design determines the type of balance most appropriate to its purpose.

QUESTIONS

1. Are the principles of design arbitrary, man-made rules?
2. Why are the principles of aesthetic order valid?
3. Do these principles differ fundamentally in different art forms?
4. What is the primary requisite of all design?
5. Define unity.
6. Why is unity essential in design?
7. What is meant by unity of idea?
8. What is unity of style or character?
9. What is the aim of design?
10. How is interest created in the space arts?
11. How is unity produced?
12. What does dominance mean?
13. Why is the principle of dominance so important?
14. What are four ways by which dominance is produced?
15. Does a combination of harmonious elements necessarily produce unity? Why?
16. Are discordant designs necessarily incoherent? Why?
17. What is the oldest, simplest, and most effective way of creating unity?
18. Cite an example of the use of repetition in music, literature, poetry, and the drama.
19. Exact repetition is used in . . . ? Give examples.
20. Exact repetition may take what more interesting and rhythmical form?
21. What is alternation?
22. Give examples of temporal-spatial alternation.
23. Cite an example of the use of spatial alternation in architecture, photography, and textile design.

159

24. Name an example of the use of temporal alternation in poetry and music.
25. Is photography art? Why?
26. How is varied repetition produced?
27. For what is repetition with variation used?
28. Why is pictorial repetition with variation the foundation of advertising campaigns?
29. Give an example of the use of pictorial repetition with variation in a series of advertisements.
30. In the example cited of variations on a repeated pictorial theme in advertising, what is the theme, and what are the variations?
31. Define balance.
32. Name the types of balance.
33. Define formal balance.
34. What effect is produced by formal balance?
35. Name an example of formal balance in architecture, sculpture, painting, and music.
36. Define informal balance.
37. What effect is produced by informal balance?
38. Name an example of informal balance in architecture and painting.
39. What determines the type of balance most appropriate for a particular design?

EXERCISES

1. Make action sketches of the nude, like those on page 93, and of animals. Express the movement with simple, sweeping lines made with the broad side of a piece of chalk, crayon, pastel, or charcoal. All parts of the body should be dominated by this flowing continuity so as to form a smoothly integrated unit.
2. Design a composition based on dominance of curvilinear plan and repetition culminating in a dominant climax, such as the Neenah design, and "Dominoes" on pages 104 and 105.
3. Design a composition built on repetition with variation and dominance, such as those shown on pages 129 to 138.
4. Design a composition based on repetition with graded variation, or gradation of size, such as the Petri Wine poster on page 40, and the student exercise on page 145.
5. Search the files of your art reference library for paintings or designs in which the above compositional plans are used. The magazine *Fortune* and the American and European annuals of advertising art are also excellent fields for research. If possible, paste the examples

160

that you may find in your notebook and bring them to class for discussion. As an exercise in design analysis, dissect each example as follows. What design principles does it illustrate? If you had been the designer, could you have made any changes that would have enhanced the composition? If so, what changes would you have made?

6. Find examples, such as those shown on preceding pages, of formal and informal balance in architecture, sculpture, and painting. Bring these examples to class for discussion.

7. Search magazines for examples of pictorial repetition with variation in a series of advertisements, such as those shown on preceding pages, and bring these examples to class for discussion. Decide what is the theme, and what are the variations.

8. Plan and make rough sketches or layouts for a series of two or more advertisements based on variations of a repeated pictorial theme, such as those previously shown.

9. Design a hand-blocked print for a textile, wallpaper, book jacket, or decorative wrapping paper, such as those shown on pages 118 to 121. These student exercises were based on the analysis shown on page 122. Base your design on the same analysis. As subject matter use material with which you are familiar, such as native birds, fish, trees, insects, or flowers. These should be reduced to their simplest, most characteristic elements. This design might then be traced on linoleum, cut out, and printed on paper or textiles. Much can be learned from a study of Italian hand-blocked papers and European peasant prints.

10. Design a hand-blocked print for textile, wallpaper, book jacket, or decorative wrapping paper, similar to those shown on pages 118 to 121. Use the following plan in which both vertical and horizontal alternating sequences are the same as the alternating sequence 1, 1, 2, 2, 1, 1 of the "Old French Folk Tune" on page 123.

1	A	A	B	B	A	A
1	A	A	B	B	A	A
2	C	C	D	D	C	C
2	C	C	D	D	C	C
1	A	A	B	B	A	A
1	A	A	B	B	A	A

Plan for a space design derived from the time design of the Old French Folk Tune, on page 123.

161

Make friezes 1 narrow with red motifs, and friezes 2 wide with black motifs. Or do the design in monochrome. Make each of the four different letters (A, B, C, and D) a different decorative motif or group of motifs. Use Grecian, Indian, or other motifs. Or plan your own alternating sequences, color scheme, and motifs.

11. Design a hand-blocked print for a textile, wallpaper, book jacket, or holiday wrapping paper, similar to those shown on pages 118 to 121. Use the following plan in which both the vertical and horizontal alternating sequences are the same as the alternating sequence 1, 2, 1, 3, 1 of the rondel poetical form on page 117. Make friezes 1 narrow with brown motifs, frieze 2 wide with dull yellow motifs, and frieze 3 wide with bright green motifs. Or do the design in mono-chrome. Make each of the nine different letters (ABCDEFGHI) a different decorative motif or group of motifs. Use Chinese, Egyptian, Persian, or other motifs. Or plan your own alternating sequences, color scheme, and motifs.

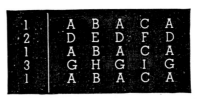

Plan for a space design based on the time design of the rondel poetical form on page 117.

12. Make charts that are the reverse of those in the Design Judgment Test. That is, reverse the values, making all the white elements black and all the black elements white. Also reverse the dominant elements. For example, in PX, Chart 11, the one curved line is made straight, and the three straight lines are made curved. This will make the curved lines dominant. In TI, Chart 19, the three straight white lines are changed to black curved lines, and the one black curved line is changed to a straight white line. In WX, Chart 9, the three white units are changed to black, the three triangles are changed to circular disks, and the white disk is changed to a black triangle. Be careful, however, not to change the sizes or positions of the units. In those charts that have a gray background it is not changed. Just be careful that the background on the charts that you make is an exact middle gray so that the black and white units stand out with equal strength against it. If in doubt regarding the reversal of any chart, refer to the analysis of the design. Test your friends or classmates with these reversed charts to see whether they prefer the better designs.

162

EXERCISES FOR ART WITHOUT FRAMES

There are artists who cannot paint—neither can they draw. Their art is not on sale in galleries—neither is it in museums. Their designs are three-dimensional designs for everyday living. This art without frames may be a garden, room, dinner table, or flower arrangement. These design media, particularly floral, vegetable, or still-life arrangement, offer the person with no technical training in drawing or painting a simple, satisfying, and natural way of exercising his sense of design.

A fine floral or still-life composition requires discriminating selection based on careful consideration of the design elements of line, direction, shape, size, texture, and color. The following exercises, therefore, can be highly creative accomplishments, even though they may never be drawn, painted, or photographed.

1. Arrange a still life composition using a contemporary industrial product, as in "Spectacles" on page 114 or "Toothbrushes" on page 138. Try to make your compositions grow naturally out of the character of the subject, as explained in the analysis of "Toothbrushes." This and the following exercises have their practical application in advertising photography, store-window displays, or industrial exhibitions at fairs or museums.

2. Compose a still-life arrangment for a title panel of an exhibit that dramatically symbolizes a contemporary industry, such as (a) plastics, (b) steel, (c) ceramics, (d) wood, (e) glass, (f) dyes, (g) chemicals, (h) textiles, (i) drugs.

3. Arrange a composition featuring a flower or plant used commercially, such as flax, cotton, corn, peanut, tobacco, coffee, tea, or sugar cane. Supplement these with still-life accessories that show the manufactured products.

SUGGESTED READING

Brahams, Caryl, ed., *Footnotes to the Ballet*, Henry Holt and Company, N.Y., 1938.

Frazer, Sir James G., *The Golden Bough*, The Macmillan Company, N.Y., 1948.

McKinney and Anderson, *Discovering Music*, American Book Company, N.Y., 1934.

Parker, De Witt H., *The Principles of Aesthetics*, F. S. Crofts & Co., N.Y., 1946.

Richter, Irma A., ed., *Paragone—A Comparison of the Arts, Leonardo da Vinci*, Oxford University Press, N.Y., 1949.

Spengler, Oswald, *The Decline of the West*, Alfred A. Knopf, Inc., N.Y., 1945.

5. ANALYSIS OF THE GRAVES DESIGN JUDGMENT TEST

On each chart one design is organized in accordance with the fundamental principles of aesthetic order stated on the preceding pages, while the other design violates one or more of these principles, as will be explained specifically in the following analyses.

Chart 1. GR is the better design, because it is more unified than PO, and at the same time it has as much variety. In GR there are contrasting values with the black preponderant. There is a contrast of line with curved lines dominant. There are contrasting directions with the vertical dominating. GR is also more interesting than PO because of a variety of spacing; that is, the three vertical lines are not monotonously spaced, as are the lines in PO, but have large and small spaces between them.

PO is structurally weak. There are contrasting values, lines, and directions, none of which dominates.

Chart 2. MJ is right because (1) rough and smooth textures contrast, with the rough dominant; therefore the design is unified. (2) MJ is emphatically a vertical rectangle. It is decisive in its direction. The vertical length definitely dominates the horizontal width. SR is vague as to its direction. (3) MJ is a more interesting shape than SR because of the greater contrast between its length and width. (4) MJ is a better proportioned and more unified shape than SR because the sides are related by a repeated ratio or continued proportion. Thus

$$\frac{\text{Width}}{\text{Length}} = \frac{\text{length}}{\text{width} + \text{length}} = \frac{1}{1.618} = \text{Golden Mean}$$

(Repetition of a ratio creates unity.) (5) The smooth and rough areas and the total area of the rectangle are also related.

164

$$\frac{\text{Smooth area}}{\text{Rough area}} = \frac{\text{rough area}}{\text{smooth} + \text{rough area}} = \frac{1}{1.618}$$

(6) Contrast in size and shape of the small and large areas creates interest and variety.

Chart 3. NO is the better design. Straight lines are opposed to curved line, vertical contrasts with horizontal, thick line to thin line, and black opposes white. Straight, thin lines, vertical direction, and black value dominate and create unity.

Chart 4. PK is right. Although both UV and PK are unified by the repetition of shape and value, PK is more unified than UV because of the dominant area, dominant area contrast, and dominant space interval. The variety produced by the unequal area contrasts, and unequal space intervals also make PK more interesting than UV. (See page 62.)

Chart 5. In MG four different combinations are formed in which three of the shapes combine to form a dominant group. There are three white shapes opposed to one black, three symmetrical shapes opposed to one unsymmetrical shape, three rotund shapes versus one long shape, and three angular shapes against one curved shape. In addition, the stars are dominant. Each of the shapes combines with two others to form a majority that dominates the fourth.

Chart 6. RP illustrates how value contrast may be used to emphasize one line and direction. Unity is thus produced by the dominance of the straight, right oblique line. RP is also more interesting than ML because of variation in the lengths of the lines and because of a greater variety of value.

Chart 7. YZ is right. The contrast between the circle and the rectangle is greater than the contrast between the rectangle and the triangle and therefore produces a subdominant shape contrast. The dominant contrast is between the triangle and

the circle. These three unequal shape differences create a variety of contrasts that make it more interesting than LO. This design is also more unified because it more closely approaches a dominant shape. In YZ the spaces or distances between the shapes are unequal and therefore produce interest.

Chart 8. ON is right because (1) it is balanced. (2) There is contrast of direction with the dominant (left oblique at 75 degrees) in harmony with the vertical short sides of the enclosing shape. This produces a better balance of direction by reenforcing the verticals or short sides that otherwise would be overpowered by the horizontals or long sides. This results in a stronger and more interesting contrast of direction.

Chart 9. WX illustrates how unity is created by dominance of shape, measure, value, and space interval. These are contrasting shapes, with the triangles dominant. One of the triangles is also dominant in size. There is opposition of value, with the white predominating. WX is, therefore, unified. WX is more interesting than TS because of the variety produced by the unequal space intervals between the units of WX.

Chart 10. This chart is a variation of Chart 5. The principal difference is that here there is one less dimension or element, that is, the factor of value contrast. WD is a better design than FE for the same reasons that MG is a better design than KR. In WD the hearts and curved shapes are dominant. In WD three rotund, symmetrical shapes oppose and dominate one long unsymmetrical shape.

Chart 11. PX is the more coherent design because of the predominating straight lines. Of the hundreds of people who have taken this test, more than 90 per cent prefer PX to EF. It is interesting that by simply changing the bottom line of EF from curved to straight such a great change occurs that

the popularity of the design increases about ten times. Inasmuch as the only difference between these two designs is that PX is unified by dominance and EF is not, it would seem that unity is immediately sensed and strongly desired by most people.

Chart 12. In DC we have unity of value created by dominance of area. That is, black is the dominant value because of its larger area. DC is also more interesting because of variety of the shapes and sizes.

Chart 13. In TL the black triangle dominates because it makes a stronger value contrast against the background than does the gray circle. In BY this dominance is lacking. Neither one of the equally strong conflicting shapes has the ascendency. In addition, BY is not so interesting as TL because BY has not so much value variation.

Chart 14. JM is a better design than OA for the following reasons: (1) In JM the three areas are related to each other, to the entire rectangle, and to the width and length of the entire rectangle by a repeated ratio or continued proportion. Thus

$$\frac{\text{Black}}{\text{White}} = \frac{\text{white}}{\text{gray}} = \frac{\text{gray}}{\text{entire rectangle}} = \frac{\text{width}}{\text{length}} = \frac{1}{1.84}$$

(2) In JM one value, the gray, dominates, whereas in OA all the values are equal in area. Sir Joshua Reynolds states that after analyzing many of the paintings of the Venetian and Dutch masters he concluded that the best proportion of values was one-half gray, one-quarter light, and one-quarter dark. This means that these painters did not use equal amounts of each value but allowed the gray to dominate, as we have done in design JM. (3) JM is also more interesting than OA because of the variety of sizes and shapes of its unequal divisions.

167

Chart 15. In ST the horizontal top and bottom edges of the rectangle together with the horizontal line through the center are exactly equal in length to the two vertical sides. In consequence neither direction is dominant. In GK the vertical center line together with the two vertical edges is greater than the two horizontal edges. In GK, therefore, the vertical direction dominates.

Chart 16. (1) PT is better placed and better balanced. (2) It is more unified than KF because of the dominance of one of two contrasting shapes. (3) PT is more interesting than KF because of the stimulating contrast between the contacting extremes of dark and light, angular and curved.

Chart 17. In AR the upright lines are dominant. In AR the nonstraight lines dominate the straight line. Of the two nonstraight lines, the serrated is stronger than the curved. In AR there is a dominant value, black.

Chart 18. EM is a better design than VH for the following six reasons: (1) EM is composed of contrasting black and white values, with the white preponderating. (2) In EM the large white square dominates the composition. In VH there is conflict for ascendency between the equally powerful large black and white squares; neither rules. (3) The arrangement of the squares in EM is better balanced than in VH. (4) In EM there is one dominant major interval or strongest contrast. This contrast is the difference between the small black square and the large white square. VH lacks this unifying relationship, since there are two equally strong major contrasts. (5) In EM there is more variation in the sizes of the squares than in VH, which makes EM the more interesting design. (6) In EM there is more variation in the space intervals or distances between the units than in VH. Starting in the lower left-hand

168

corner of EM and stepping from one square to another, we find that we are following a curving S-shaped path that leads us along in pleasantly rhythmical movement resembling a simple dance step. In VH, as we clump from square to square with even steps, we find ourselves moving monotonously around a circle.

Chart 19. This chart, based on Chart 11, includes the additional factor of value contrasts. TI is a better design than RA because of the dominance of one kind of line, the straight. In addition, TI is more unified than RA because one value, white, is dominant.

Chart 20. In EV there is a dominant shape (round), size (large disk), and value (black). These are the dominant elements. The distance between the large and small black disks is the dominant space interval.

A difference of shape, size, and value between the large black disk and the small white star produces an interval or difference in three dimensions, that is, shape, size, and value. This interval is the major or strongest contrast in composition EV and forms the climax or center of interest. EV is, therefore, more unified than GU, which has no dominant shape, size, or value. Because of equal area and space intervals and the absence of a major contrast, GU is not so interesting as EV.

Charts 21 *to* 32. As an exercise in design analysis, you should be able, after reading the preceding pages, to dissect the designs on charts 21 to 32 and explain why one design is better than the other.

6. THE TASTE TEST

The following test is entitled Taste Test, primarily to differentiate it from the preceding Design Judgment Test. But the Taste Test is, essentially, also a design judgment test be-

cause, as will be explained later, good taste is good design, and bad taste is bad design. The chief differences between the two tests are that the Design Judgment Test consists of less familiar and nonrepresentational items, but involves the more formal or tangible aspects of design, while the Taste Test consists of more familiar and representational items, but involves the less formal or tangible aspects of design.

DIRECTIONS FOR TAKING THE TEST

Following are a series of paired illustrations numbered 1A and 1B, 2A and 2B, etc. Compare each pair of illustrations, and decide which one of each pair you consider to be in better taste; that is, the better design. Write the numbers of your preferences on a sheet of paper. When you have completed the test, turn to page 184, and compute your score by comparing your choices with the correct answers.

1A 1B

170

2A

2B

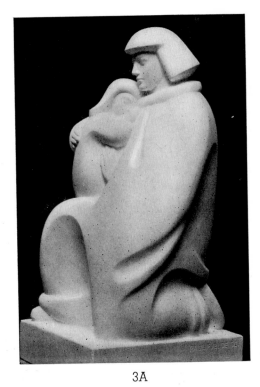

3A

3B

172

Here are four illustrations. Below them (A, B, C, D) the word "Design" is printed in different type faces. Each type face harmonizes with one of the four drawings. Decide which type face is most appropriate to each illustration. When you have made your choice, write on your answer sheet the key letter of each type face next to the number underneath the corresponding picture.

4

5

6

7

DESIGN

A

Design

C

Design

B

Design

D

173

8A

8B

9A **DESIGN**

9B **DESIGN**

10A **UNITED**

10B **UNITED**

Five Times faster

11A

Five times faster

11B

175

12A

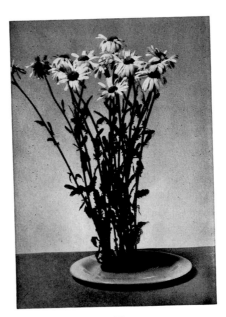

12B

176

13A

13B

14A

14B

178

15A

15B

16A 16B

180

17A

17B

181

18A

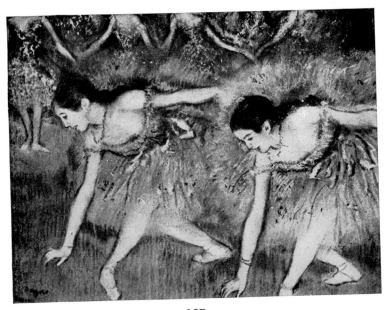

18B

182

19A

19B

183

1B	6A	11B	16A
2B	7D	12A	17B
3A	8B	13B	18B
4B	9A	14A	19A
5C	10A	15A	

Check the correct choices on your answer sheet. Your score is the number of correct choices multiplied by 5. The maximum, or highest possible, score is 95.

7. ANALYSIS OF THE TASTE TEST

1A, 1B. The clean, gracefully fluent contours of 1B are uncluttered by gaudily colored decorative relief. It was carefully designed for a manufacturer who specializes in products of high quality for discriminating customers. Squat, ornate, lumpy 1A was just as carefully designed—but for another manufacturer and for quite a different market. 1A was executed only after the designer had made a shrewd, intelligent analysis of the special taste (?) of this market as shown by a thorough study of its most popular items. One of our foremost ceramic designers, whose work has been exhibited in museums and featured in national magazines, created both teapots 1A and 1B, but wishes to remain anonymous. Although both designs are commercially successful, you can probably guess which one designer "X" considers in better taste.

2A, 2B. You probably used the National Tuberculosis Association's Seal 2B on your Christmas cards or packages in 1949. This seal, by Pratt student Herbert Meyers, "won first prize in a nationwide contest conducted by The Society of Illustrators among students of accredited art schools in every part of the country. Eighteen top-flight art schools submitted more than fifty drawings, every one of them good—for they

184

had to meet art school standards before they reached New York. Competition was really keen. The Society's judges, themselves nationally known illustrators and advertising men, unanimously chose '2B' as best in design and execution." Did your choice agree with that of the judges; or did you prefer 2A, one of the thousand rejected designs? If you chose 2A, can you justify your choice?

3A, 3B. Although both bas-reliefs were created by the well-known sculptor Paul Fjelde, they are, according to their designer, as far apart in concept, design, and execution as they are in time. Mr. Fjelde feels that his 3B was a competent, but strictly commercial, youthful job. He believes that his later work, 3A, a fine-arts commission with no commercial restrictions, is more mature and sensitive in concept, finer in design and execution. His colleagues agree.

4. Of the four type faces, Barnum or B, is the most appropriate for this gay-nineties design.

5. For this heavy, structural steel industrial subject, Stymie or Girder bold, C, is the most suitable.

6. This formal design calls for classic Caslon, or A.

7. Which of the four type faces could more fittingly express the adventurous connotations of an old map, ships, and the sea than D, the informal, calligraphic Legend?

8A, 8B. Advertising design 8B is more compact, and integrated, in better taste, and more original in concept.

9A, 9B. For over a century typographers have considered Caslon, or 9A, to be one of the most beautiful and legible of the classic type faces. Did you agree; or did you prefer 9B, a new, somewhat ostentatious and "arty" type face, aptly named Broadway, whose popularity was short-lived?

10A, 10B. This choice should have been an easy one for you.

It was simply a question of well designed versus poorly designed letter-spacing. 10A flows and forms a well integrated unit. 10B does not, but is broken into the four fragments U-NIT-E-D. It is only fair to tell you that in this, and in the following pairs of items, one item in each pair was deliberately designed to be as bad as possible without being too obvious. These were ten little plots hatched against you, but we hope you detected these traps and made all the right choices.

11A, 11B. Item 11A was deliberately made amateurish in execution, stiff, tight, turgid, and "corny." But 11B possesses the individuality and controlled fluency characteristic of the best brush calligraphy. Did you find this choice ridiculously obvious and easy?

12A, 12B. Each flower in 12A was carefully considered, cut, and thoughtfully placed by a designer skilled in the art, to compose an informal arrangement appropriate for daisies. 12B—it cannot be dignified by the name flower arrangement—was also carefully designed, but to be as bad as possible. It would be an impertinence to suggest that flowers can be in bad taste, but flower arrangements can be. Here is an example.

13A, 13B. We could have made 13A worse—it incorporates only a few of the many odious aspects of "borax." The name "borax"—the slang synonym for tawdry ornateness—originated in the practice of giving shoddy, showy, poorly built, and badly designed furniture as premiums to collectors of borax box tops. Examples of bad taste more offensive than 13A may be seen in thousands of shop windows and homes throughout the country. Some of this furniture—close competitors of that king of borax, the juke box—"is made out of not one, not two, but 16 different kinds of genuine wood veneer—16! And not only that but also contains many cute little gadgets rang-

ing from built-in lamps, to clocks, to ashtrays. Truly colossal bargains!"

14A, 14B. Each of the first 20 charts of the preceding Design Judgment Test presented a choice of two different arrangements of the same nonrepresentational items. Advertising lay outs 14A and 14B presented a choice of two different arrangements of the same representational items. In 14A and 14B the representational items used were chairs and type, although any other objects could have been used equally well. But the design principles discussed on the preceding pages—particularly in the Analysis of the Design Judgment Test—are valid, whether applied to nonrepresentational or representational design. Therefore, if you have studied the preceding pages, you should be able to explain why 14A is better designed than 14B.

15A, 15B. The well-known photographer-designer, Walter Civardi, cropped 15B to eliminate the superfluous, competing visual attractions; focus attention on the principal theme; and thus produce the stronger unity of 15A.

16A, 16B. If cropping enhanced 15B, why did not cropping also improve 16A? Because cropping 16A, as shown in 16B, did not remove superfluous, competing visual attractions. There were none. But cropping 16A did destroy the carefully designed space relationships shown in the analysis on page 268. 16B demonstrates the disastrous consequences of blindly following arbitrary rules, formulas, or recipes.

17A, 17B. Portrait 17B is the real Degas painting in the Metropolitan Museum of Art. 17A is an imitation Degas, a copy made by a young art student, in which the design has been deliberately damaged, as shown by the analysis of the original painting on page 265.

18A, 18B. Composition 18B is the genuine Degas. 18A is the

fake, a student copy in which the design has been calculatedly violated.

19A, 19B. The authentic painting is 19A—"Young Women" by Robert Brackman. In the student counterfeit, 19B, the composition has been carefully marred.

Acknowledgements

1A, 1B, Anonymous designer "X."—2A, 8A, Anonymous art students. —2B, H. Meyer,[12] and the National Tuberculosis Association.—3A, 3B, Paul Fjelde.—4[12] to 7[12].—8B, Adams.[12]—10A[12] to 12B[12].—13A, 13B, C. Balisado.[12]—14A,[12] 14B.[12]—15A, 15B, Walter Civardi.—16A, 16B, "Portrait of Miss Alexander," by James A. McNeill Whistler, Tate Gallery, Millbank, England.—17 A, M. Morris.[12]—17B, "Mme. Gobillard-Morisot," by Degas, Metropolitan Museum of Art.—18A, C. Yeiser.[12]—18B, "Ballet Girls," by Degas, Raymond and Raymond.—19A, "Young Women," by Robert Brackman.—19B, R. Bradbury.[12]—1A, 1B, 4 to 7, 12A to 13B, 17A, 17B, from the article, "Good Taste: Do You Have It?" prepared by Maitland Graves for *Parade Magazine*, pp. 19–21, July 24, 1949.

8. TASTE

Some like it hot,
Some like it cold,
Some like it in the pot,
Nine days old. (Old rhyme.)

Some like clam chowder with milk but no tomatoes—others like it better with tomatoes but no milk. Some appreciate and enjoy fine wines—others cannot taste or smell the difference between a Piesporter Goldtropfchen Beerenauslese, 1937, and a quickie wine bulk-produced for the slum trade and cheap spaghetti joints; but prefer a shot of rot-gut whiskey or a slug of bath-tub gin to either wine. There are those who like the subjective, highly emotional expressionist paintings—others consider this type of modern art a kind of repulsive, psychopathological catharsis. Some think that the polytonal compositions of Bela Bartók and Darius Milhaud are a peculiarly un-

[12] Pratt student.

188

pleasant and complicated kind of noise—while others enjoy hearing them. Few questions include so many subjects—food, drink, clothes, furniture, manners, aesthetics—are so controversial, and are so heatedly argued as the question of taste.

Our aesthetic judgment is constantly being challenged by problems of choice similar to those presented in the preceding Taste Test. Which dress? Which chair? Which tie? Which letterhead? We must make these or similar decisions of taste every day. And we must often justify our decisions, for we cannot always evade the issue with the old Latin proverb, *"De gustibus non disputandum."* Nor is it always possible to sidestep the situation as adroitly as did Lincoln who, when cornered and forced to express his judgment of some very controversial material, said, "For the sort of people who like this sort of thing this is just the sort of thing that those sort of people would like very much." But in some instances we might justly defend our choice by quoting the old proverb, "There is no disputing taste." For example, our preferring Notre Dame de Paris to either the Parthenon or the Taj Mahal may not, perhaps, be disputed; because each is superlative in its class, and our choice may be based purely on personal preference rather than aesthetic judgment. But a preference for Bach versus boogiewoogie or Cézanne versus calendar art should admit of a more valid dispute. If it does not, then aesthetic standards are meaningless.

For centuries artists and philosophers have been arguing over aesthetic standards. These disputes have sometimes been confused and futile, because aesthetic judgment or taste is often unconsciously influenced by many biasing or nonaesthetic factors such as racial, religious, moral, political, social, and nationalistic prejudices; personal predilections for the old and

familiar or the new and novel; and fashion, or the gregarious herd instinct, that is moulded by the above factors. Many persons, because they are afraid to stand alone or do not trust their aesthetic judgment, timidly affect the protective pose of fashionable taste. Even such a courageous and honest man as G. B. Shaw has said, "Even if I did not like Mozart, I should pretend to; for a taste for his music is a mark of caste among musicians, and should be worn, like a tall hat, by an amateur who wishes to pass for a true Brahmin."[13]

Fashion, that blind, unreasoning, and undiscriminating herd instinct, is exploited by hucksters of everything from whiskey to movies to political and medical nostrums. These merchants of mediocrity profitably spend millions of advertising dollars each year to assure us that millions of our gullible fellow sheep eat, drink, smoke, read, or wear their product, and that, therefore, it must, of course, be good. For many people this appeal to fashion seems to carry as much weight as the Ten Commandments or the Constitution. "To be in fashion, monkeys will even cut off their tails."[14]

But having the courage to resist mob propaganda and stand on one's aesthetic convictions should not be confused with stubborn, intolerant smugness. In matters of taste the self-satisfied, complacent person arbitrarily segregates others into the following three tidy categories:

1. The cultured, discerning, and intelligent people who think he has good taste.
2. The affected, haughty high-brows; the insolent, arrogant snobs; the insulting, supercilious stuffed shirts; the presumptuous poseurs; the pompous phonies; and the pretentious, precious prigs who think he has bad taste.

[13] "Music in London, 1890–1894."
[14] Negro proverb.

190

3. The moronic low-brows; the uncultured oafs; the stupid peasants; the vulgar boors; the ill-bred bumpkins; the ignorant, uncouth clowns; and the rude, crude louts who *he* thinks have bad taste.

So the smug person would not be interested in reading a discussion of taste unless he were desperately bored, and this the only literature in his ship's library on a slow boat to China or the only book in a snow-bound sod hut in Saskatchewan.

In addition to the personal prejudices and nonaesthetic biases previously mentioned, disputes about taste are often confused by disagreements on the following questions.

What, exactly, does aesthetic taste mean? According to Webster, one of the accepted authorities on definitions, aesthetic taste is the "Power of discerning and appreciating beauty, order, proportion, etc., in the fine arts and belles-lettres; critical judgment, discernment of what is pleasing, refined, or good usage; as a man of taste." Taste, therefore, means *good* taste, or the faculty of aesthetic appreciation and discernment possessed by both the observer and the creator of a fine design. Bad taste means a lack of taste or an absence of this critical faculty.

Or taste may also mean an inseparable property, quality, attribute, or aspect of the design, because the design inevitably exhibits or expresses the taste or lack of taste of the designer. This is what is meant when it is said that a design is in good (or in bad) taste. It would, therefore, be contradictory to say, "It is good design but in bad taste," or "It is bad design but in good taste," because good design *is* good taste, and bad design *is* bad taste.

Is taste purely personal? No, says W. C. Brownell in *Standards*—"Taste is essentially a matter of tradition. No one originates his own." But Pope, in "Imitations of Horace," retorts,

"Talk what you will of taste, my friend, you'll find two of a face as soon as of mind." George Wither agrees and rhymes

> Be she fairer than the day,
> Or the flowery meads in May;
> If she be not so to me,
> What care I how fair she be?

Is good taste an inherited ability, faculty, or talent? No, says Augustine Birrell, "You may as well expect to be born with a high silk hat on your head as with good taste." In *Patience*, W. S. Gilbert blithely echoes, "You can't get high aesthetic tastes like trousers, ready-made." Wordsworth agrees, and thinks, "An accurate taste in poetry, as in all the other arts, is an acquired talent, which can only be produced by severe thought and a long-continued intercourse with the best models of composition." But others believe that, although taste may be improved by education, practice, and experience, "You can't make a silk purse out of a sow's ear," and that superlatively fine taste is an innate talent that has merely been perfected by education, practice, and experience. Perhaps this question may eventually be decided by the psychologists.

Can good taste be taught by rules? Although principles of aesthetic order can be taught, no intelligent person believes that good taste can be taught by rules. "Could we teach taste or genius by rules, they would be no longer taste and genius," says Joshua Reynolds in *Discourses*.

How can you tell good from bad taste? There is, of course, no easy, infallible way for you to decide. For you, a thing is in good taste if you honestly consider that it can be justly characterized as integrated, well-proportioned, beautiful, original, fine, sincere, appropriate, clean, logical, direct, efficient. For you, a thing is in bad taste if you sincerely feel that it can be fairly described as chaotic, confused, illogical, badly propor-

192

tioned, ugly, inappropriate, shoddy, cheap, common, ordinary, trite, insincere, affected, ostentatious, showy, gaudy, garish, tawdry, vulgar, "cute," "corny," "borax," "schmaltz," "ham," etc. There are, of course, many degrees or levels of taste, ranging from the abysmally bad, to mediocre, to superlatively good. Although the arbiters of taste might disagree with your aesthetic judgment and classifications, these represent your honest, if personal, little aesthetic yardstick that you can develop and refine if you will. Our standards of taste are constantly changing, if we are growing, and as we develop finer discrimination, keener perception, maturer appreciation, we may discover that our old aesthetic yardsticks, tags, and labels have become ludicrously inadequate and must be revised or scrapped.

Who are the arbiters of taste? They may be critics or creators, amateurs or professionals, spectators or performers. They may be on all economic levels. They may be the collectors of expensive, autographed copies of limited editions, or they may be the buyers of cheap reprints. At the Metropolitan Opera House, they may relax in their private boxes, or they may stand in the peanut gallery. They may be articulate or inarticulate. They may be eminent critics on big newspapers who can express their opinions to millions, or they may be modest contributors to small avant-garde publications. They may be professors in obscure colleges, their ideas unknown beyond the campus. And they may be the quiet, anonymous but discerning little people whose approval or disapproval is perhaps expressed only by the tickets, books, music records, or art they buy—or do not buy. They may be of different races, religions, political beliefs.

But whatever else they may be, they are a brotherhood who have these in common: deep interest in, and appreciation of, a particular art; a conviction that it is an important part of living; mature, unbiased judgment based on knowledge of, and

wide experience with, the best work in their field; and severe, uncompromising standards of performance. These are the jury of the cognoscenti, the connoisseurs who establish our aesthetic criteria. These are the brotherhood of the elite, the arbiters of taste and the custodians of our cultural heritage.

Grand Rapids
Chippendale chair
bridge
lamp

His and Hers towels

Parlor
sculpture

Mail order
overstuffed
chair,
fringed
lamp

Balsam-stuffed pillow

Jukebox

QUESTIONS

1. Shown above are examples of bad taste, according to Russell Lynes, editor of *Harper's Magazine*.[15]

[15] The above drawings by Tom Funk in the April 11, 1949, issue of *Life Magazine* were based on an article by Russell Lynes in the February, 1949, issue of *Harper's Magazine*.

a. Do you agree? Why?

b. Is it your opinion that the examples are not so bad? Why?

c. Can you think of worse examples? If so, name them.

d. Do you consider that the examples are in good taste? Why?

2. The following are excerpts from a commentary on our American taste by Winthrop Sargeant.[16]

. . . the dominant feature of our mental and spiritual life is the overwhelming flood of cultural sewage that is manufactured especially for the tastes of the low-brow, and lower middle-brow. It is difficult even for a high-brow to escape its influence. Only eternal vigilance keeps it from converting us into 100 per cent low-brow people. This flood exists for only one reason. The oafish classes, being overwhelmingly numerous, are the biggest consumers of everything from salad to music, and an investment in their tastes is correspondingly profitable. They therefore dominate taste in nearly all our big industries where taste is a factor, the most horrible examples in point being the radio and the Hollywood movies. It is, of course, true that good things sometimes appear by accident even among the products of these industries. But this happens so seldom that high-brows are apt to assume that widespread commercial success is a sure sign of inferiority. Ninety per cent of the time they are right. . . . One fact about our contemporary environment is obvious. What culture and civilized living we have today is provided by the interaction of two groups—the esthetically radical high-brows and the somewhat more conservative and stable upper middle-brows. Beneath the upper middle-brows there yawns an awful chasm peopled by masses whose cultural life is so close to that of backward children that the difference is not worth arguing about. Lower middle-brows and low-brows may be bank presidents, pillars of the church, nice fellows, good providers or otherwise decent citizens, but, culturally speaking, they are oafs. Unfortunately these cultural oafs make up some 90 per cent of the population.

a. Do you agree completely with all of the above statements? Why?

b. Do you disagree with any of these statements? If so, which ones and why?

c. Do you think that all or most of the above statements are false or, at least, highly exaggerated and unnecessarily harsh? If so, why?

3. More than one foreign visitor, distinguished for his education and culture, has called our popular American taste adolescent, retarded,

[16] *Life Magazine*, April 11, 1949, p. 102.

crude, or barbaric. Do you consider that there are, or have been, valid grounds for this criticism? Why?

4. Do you believe that popular taste has always been poor or bad in all countries? That is, do you agree with R. L. Stevenson, who said, "I have always suspected public taste to be a mongrel product, out of affectation by dogmatism." If you agree, why?

5. Or do you think that in some countries there have been periods of high national culture, when the taste of the majority of the people was good or excellent? If so, where and when?

6. Do you think that there have been such periods in our American history? If so, when?

7. Judging from the clothing, homes, furniture, amusements, literature, music, and art of the two periods, do you believe that popular taste in America today is better or worse than it was when Thomas Jefferson was president in 1805? Why?

8. Do you think that American movies, radio, television, newspapers, magazines, and advertising are valid reflections of our popular taste today? If so, would you say that these reflections show that our standards of taste are rising or falling? Why?

9. If it is your opinion that our standards of public taste are rising, what agencies deserve the credit for raising them?

10. If you believe our standards are falling, what agencies do you think are to blame?

11. Is it your opinion that by patronizing or tolerating bad taste, we ourselves are at fault, and are only getting exactly what we deserve?

12. Some manufacturers, advertisers, and hucksters of ugly, badly designed products say that their job is to make money—not to raise the standards of public taste. Do you agree that their attitude is right and reasonable? Why?

13. Do you think that if they made, advertised, and sold only beautiful, finely designed products, they would make just as much money? Why?

14. In your judgment, is making, advertising, or selling an ugly, badly designed product as reprehensible as making, advertising, or selling a product of shoddy material and workmanship? Why?

15. Do you think that the legal dictum, *"caveat emptor"*—that is, let the buyer beware, for he buys at his own risk—is a justification for making, advertising, or selling poorly designed and ugly products? Why?

16. In past centuries the church—as the enlightened and cultured patron of the arts—encouraged, sponsored, or commissioned much of the

world's finest architecture, sculpture, painting, and music. A few of the many examples are the great Gothic cathedral of Notre Dame de Reims, Michelangelo's monumental "Moses," his heroic Sistine Chapel frescoes, and Bach's majestic B minor Mass. But most of the liturgical art of our modern materialistic and commercial period is hardly in this grand tradition. Today many of our churches contain, not monumental, majestic, heroic art, but pretty, sweetly sentimental pictures and gaudily gilded and painted figurines that cater safely to the lowest public taste. The efforts of The Liturgical Arts Society of New York, an organization dedicated to improving standards of ecclesiastical art, have been welcomed and encouraged by the churches.

The endeavors of this society to elevate aesthetic standards is paralleled in other professional fields by doctors, lawyers, dentists, psychologists, and architects who have formed societies—such as the American Medical Association—dedicated to maintaining and raising the ethical standards of their respective professions by exposing and suppressing the practices of unscrupulous fakers, hucksters, charlatans, quacks, and shysters. In the commercial field, The Motion Picture Producers and Distributors of America, Inc. imposes its code of censorship to police the moral standards of the movies.

a. Would it, in your opinion, also be desirable for the movie, radio, television, and advertising industries to set up councils or advisory boards that, like The Liturgical Arts Society, would be dedicated to elevating standards of taste in these industries? Why?

b. Do you think that the above idea is too idealistic or quixotic to be practical? Why?

c. Do you agree with Thomas Jefferson, who said, "Taste cannot be controlled by law?" Why?

d. Would you object to censorship of taste as being paternalistic regimentation and a denial of your desire to choose freely?

e. Do you believe that in matters of taste laissez faire is the best policy? Why?

SUGGESTED READING

Croce, Benedetto, *Aesthetic.*
Kant, Immanuel, *Critique of Aesthetic Judgment.*
Santayana, George, *The Sense of Beauty.*

Lines

Courtesy of Neenah Paper Co.

198

Part Three

ANALYSIS OF THE
DESIGN ELEMENTS

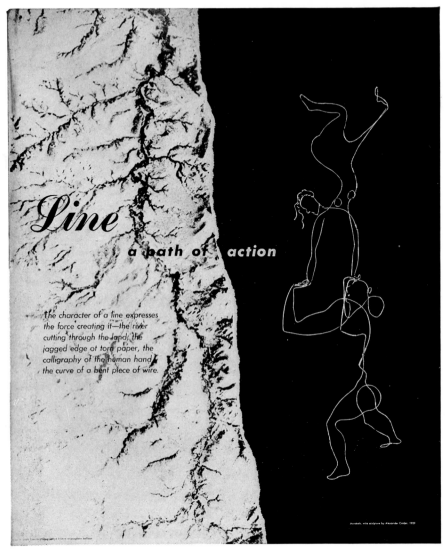

Line

a path of action

The character of a line expresses the force creating it—the river cutting through the land, the jagged edge of torn paper, the calligraphy of the human hand, the curve of a bent piece of wire.

Courtesy of The Museum of Modern Art.

200

CHAPTER VII

Line

Lɪɴᴇ is perhaps the most ancient of the art mediums. With line it is possible to synopsize the character and quality of forms with simplicity and with the utmost economy of means. Because of this subtle simplicity, it is perhaps the most difficult of the elements to analyze.

A line may be continuous, unbroken; or it may consist of isolated objects or points in space—like the constellations of the Big Dipper or Draco, the Dragon—that are connected by our eyes to form a linear path of vision.

A line may be two-dimensional, that is, drawn on a flat surface. Or a line may be three-dimensional, as in bent wire, the contour of an undulating surface, or the edge produced by the intersection of planes in sculpture and architecture. The architectural or geometrical line, drawn with the compass, triangle, T square, and other mechanical instruments, is precisely formal, impersonal, and Euclidean in character.

The hand-drawn or calligraphic line is more informal, personal, and variable; it may be weak or strong, delicate or bold, stiff or fluent, wavering or firm, thick or thin, soft and blurred or sharp. In handwriting or drawing, calligraphic line may be a symbol of emotion expressed in rhythmic movement—the

201

materialized essence of a personality, expressing innumerable moods and qualities. This rhythm may take the form of a powerful, tempestuous swirl, as the line of Hokusai's "The Wave" on page 92. Or the line may crawl painfully, stiffly, and slowly. Sometimes it scampers gaily. Sometimes it is restrained and austere. The abrupt and staccato line of el Greco is excitable and agitated. Suave, flowing brush strokes are characteristic of most Japanese paintings, with their smooth continuity.[1] The line is firm and sure. The Japanese, masters of line, have reduced it to a set of fixed conventions. Each line has a specific character and is employed as an expressive symbol.

To most people the straight line suggests rigidity and precision. It is positive, direct, tense, stiff, uncompromising, harsh, hard, unyielding.

The slightly curved or undulating line is loose and flexible. Because of harmonic transition in the change of direction, it has flowing continuity. Its slow, lazy movement is passive, gentle, feminine, soft, voluptuous. But the excessive use of this line creates an aimless, vague, or wandering effect.

The more vigorously curved line changes direction rapidly. This curve is active and forceful.

The arc or segment of a circle has an equal and constant change of direction. Because of this repetition, it is the most unified of curves but also the most monotonous and uninteresting, because of lack of variety. The spiraling curves seen in living, growing things are more dynamic.

The zigzag, jagged, or crooked line with its sudden, abrupt change of direction, is nervous and jerky. The rhythm is spasmodic and staccato. The line is excited, erratic; it suggests electrical energy or lightning, agitated activity or conflict, battle, violence, as in "Mob and Mountains," on page 135.

[1] See "Japanese Mother and Child," page 285.

202

FORMAL LINE EXERCISES BY PRATT STUDENTS

203

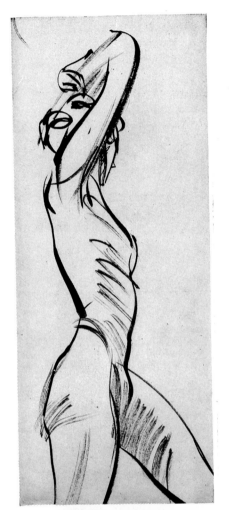

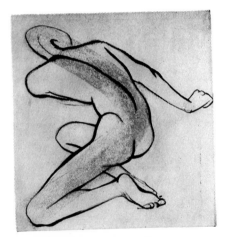

INFORMAL AND REPRESENTATIONAL LINE EXERCISES BY PRATT STUDENTS

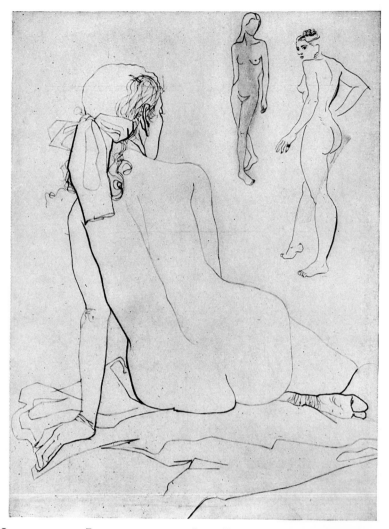

INFORMAL AND REPRESENTATIONAL LINE EXERCISES BY PRATT STUDENTS

INFORMAL AND REPRESENTATIONAL LINE EXERCISES BY PRATT STUDENTS

206

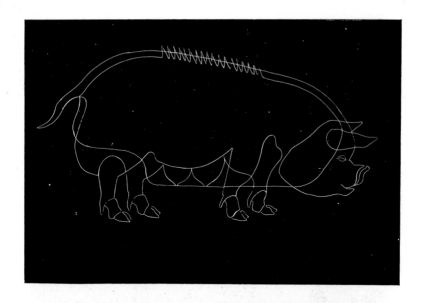

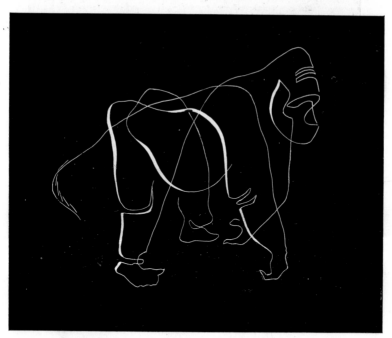

INFORMAL AND REPRESENTATIONAL LINE EXERCISES BY PRATT STUDENTS

207

THREE-DIMENSIONAL LINE EXERCISES IN BENT WIRE BY PRATT STUDENTS

208

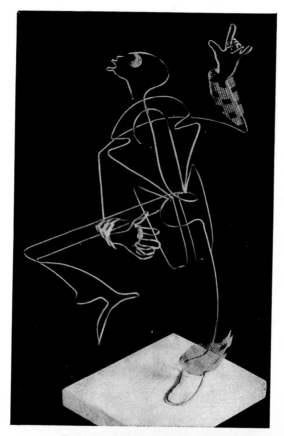

THREE-DIMENSIONAL LINE EXERCISES IN BENT WIRE BY PRATT STUDENT

CHAPTER VIII

Direction

ALL lines have direction—horizontal, vertical, or oblique. It is well known that each direction has a distinct and different effect upon the observer.

The horizontal is in harmony with the pull of gravity, that is, at rest. It is quiet, passive, calm; it suggests repose, the horizons of the seas and the plains.

The vertical is suggestive of poise, balance, and of strong, firm support. Vertical lines soar; they are severe and austere; they symbolize uprightness, honesty or integrity, dignity, aspiration, and exaltation.

The oblique or diagonal is the transitional, dynamic, or kinetic direction suggesting movement, as in wind-driven rain. Because it may seem incomplete and insecure by itself, a diagonal usually requires the support of an opposite diagonal at a right angle to it.

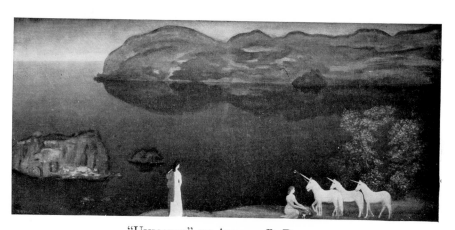

"UNICORNS" BY ARTHUR B. DAVIES

The romantic and dreamlike fantasy of this painting expresses the calm tranquility of the horizontal. (*Courtesy of the Metropolitan Museum of Art.*)

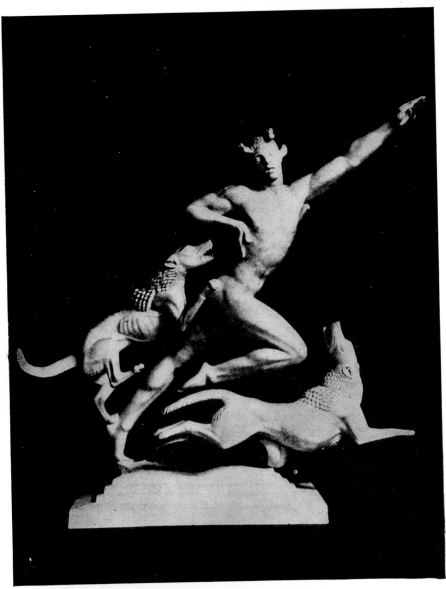

"ACTAEON" BY PAUL MANSHIP

The oblique or diagonal is the transitional, kinetic, or dynamic direction suggesting movement. Also see "Rain," page 57. (*Courtesy of the artist.*)

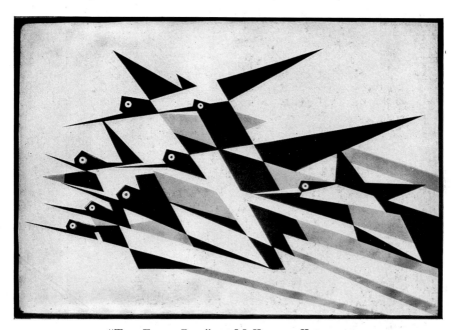

"The Early Bird" by McKnight Kauffer

The oblique direction is associated with action. (*Courtesy of The Museum of Modern Art.*)

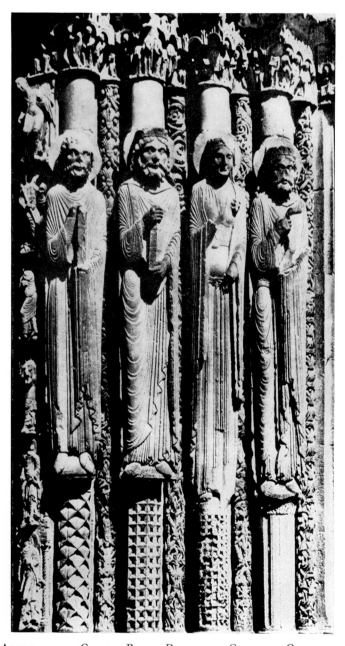

ANCESTORS OF CHRIST, ROYAL PORTAL OF CHARTRES CATHEDRAL

The vertical soars; it symbolizes austerity, dignity, aspiration, and exaltation. (*Courtesy of the Metropolitan Museum of Art.*)

214

"Verticality" by Clarence A. Brodeur
(*Courtesy of the artist.*)

215

"Mexican Frieze" by André Durenceau

Unlike some contemporary American wall paintings, this frieze is not merely an enlarged illustration or easel picture but is architectonic, as befits a true mural. "Mexican Frieze" demonstrates that a designer with originality can use the old, simple, and obvious plan of repetition and yet achieve freshness and distinction.

Although a few restless diagonals have been introduced for movement and variety, the principal directions are horizontal and vertical and suggest the formality and serene stability characteristic of classic architecture. The similarity is emphasized by the figures that are reminiscent of the caryatides on the Erechtheum and by the pleated skirts that are like fluted Greek columns.

The stripes on the skirts serve a triple function; they oppose contrasting horizontals to the vertical figures, tie them together, and provide a firm base that also forms an enclosing border or frame for the lower edge of the mural.

Indicative of the care with which the design is planned is the thoughtful choice of jars whose shapes harmonize with the contours of the human figures. Other harmonious patterns may also be discovered, such as the V-shaped hair braids and the V-shaped arms of the two girls in the front row.

216

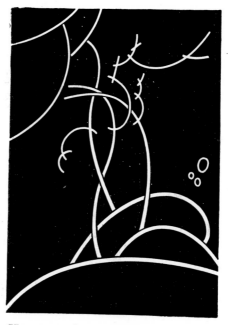

Contrast of straight and curved lines, straight lines dominant.

Contrast of measure, long and short, thick and thin.

Contrast of direction, the vertical dominating.

Harmony of curved lines.
Contrast of measure (long and short).
Contrast of direction.

Repetition of straight lines.
Contrast of measure (long and short).
Contrast of direction.

217

QUESTIONS

1. What qualities do straight lines suggest?
2. What are the characteristics of curved lines?
3. What are the characteristics of an arc or segment of a circle?
4. What are the attributes of the zigzag line?
5. What is the character of the horizontal?
6. What does the vertical suggest?
7. What are the characteristics of the diagonal?

EXERCISES

1. a. Execute informal, nonrepresentational line exercises as follows. On a sheet of heavy paper draw with a brush or with the side of a crayon straight, curved, wavy, and zigzag lines. Make some thick, others thinner, some long, others short. Cut these out, select six or eight, and experiment with various arrangements. These mobile, linear elements allow great freedom and flexibility of arrangement, because slight changes or subtle adjustments of position are quickly and easily made. When an especially interesting arrangement is created, lay a sheet of transparent paper over it and trace it. Then experiment with others. In these exercises it is advisable to avoid the limitations imposed by attempting to describe a specific object, since description tends to inhibit creative expression. A particular subject, however, may be the inspiration or motif of a design as it sometimes is in musical composition. Think simply in terms of contrasting straight and curved lines, thick and thin lines, long and short lines, and horizontal, vertical, and oblique lines. Keep in mind the principles of variety and dominance. Try to create interesting units.

 b. Execute with drawing instruments formal, nonrepresentational line exercises such as those shown on page 203.

2. Find and bring to class designs, such as those shown on the preceding pages, that illustrate horizontality, verticality, and obliquity.

218

TEXTURE

in nature—*it is where you find it*

in design—
it is sought
and planned

every surface has a texture
to be studied and enjoyed—
the room we live in,
the carpet we walk on,
the painting on the wall.

Courtesy of The Museum of Modern Art.

219

SEE *and* **TOUCH**

Much of our knowledge of what is around us depends on touch as well as sight. Our fingers react to rough and smooth, hard and soft, just as our eyes respond to form and color.

Courtesy of The Museum of Modern Art.

220

Texture

IT is generally accepted by psychologists that all complex cutaneous experiences, such as itch, burn, stickiness, vibration, wetness and dryness, roughness and smoothness, are due to simultaneous arousal of two or more of the primary skin senses. The four primary skin senses, referred to in combination as the sense of touch, are pain, pressure, cold, and warmth.

But texture is visual as well as tactile. That is, texture is perceived by our eyes as well as by our sense of touch, because wet or glossy surfaces reflect more light than dry, dull, or matt surfaces, and rough surfaces absorb light more unevenly and to a greater extent than smooth surfaces. Thus, by association of visual experiences with tactile experiences, things look, as well as feel, wet or dry, rough or smooth. Also, because texture affects light absorption and reflectance—that is, color— texture and color are directly related. For example, the same color may appear different when wet, dry, rough, and smooth.

Because of these visual aspects, texture is as important a design element as shape, size, and color in the visual arts. Mod-

ern designers can be credited with recognizing this importance, and with reviving the use of textural variety for its aesthetic value in painting,[1] architecture, interior design,[2] sculpture, and industrial design. With the introduction of new materials—such as glass block, corrugated sheet glass, chromium, plastics, sponge rubber, metallic paper, and cellulose fabrics—texture has become a richer, more versatile element that has expanded the scope of the designer. But whether the material be old or new, all surfaces in the visual arts are variations of one of the four basic textures—rough matt, rough glossy, smooth matt, smooth glossy.

In addition to the real textures, there are the simulated or artificial textures. These simulated textures, tints, or tones—an extension of the ancient wood-engraving technique[3] used prior to the invention of the modern halftone photoengraving process—have a wide and varied use in the graphic arts, because they can be reproduced by line cut, which is the least expensive photoengraving process. Simulated textures are either mechanical or hand-made.

The mechanical, or Ben-Day textured tints, may be applied by the engraver to the drawing as directed by the artist. (See page 246.) Or the artist may apply to his drawing transparent, adhesive films on which the tints have been printed. He may also draw on an especially prepared commercial paper on which invisible Ben-Day tints are rendered visible by applying washes of chemical developers with a brush. These materials, and directions for their use, are available in most art-supply stores.

Hand-made simulated textures, such as those shown on page

[1] See p. 223.
[2] See p. 58, 219.
[3] See pp. 51, 290.

227, are done by cross-hatching with a pen, stippling with a pen or a stiff, short-haired bristle brush, dabbing with a sponge or cotton wad, spattering with an old toothbrush, dragging a semidry brush over rough paper. Rubbing a pencil on thin paper placed over textured materials is another way of producing simulated textures, as shown on page 10.

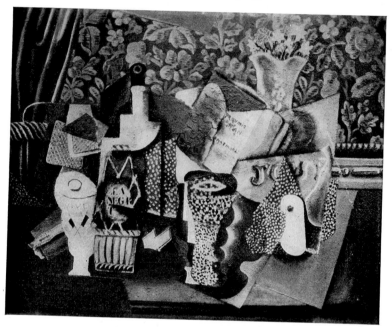

"VIVE LA" BY PICASSO

Textural Variety in Painting. The smooth, glossy, porcelainlike surface—consisting of paint liberally diluted with oil or varnish and applied with a soft sable or camel-hair brush—was popular with painters for many years. But today artists may also use thick, undiluted pigment—applied in rough impasto layers with the fingers, palette knife, comb, stiff-bristled brush, or other tools—to build textural variety that is used solely for its design value, as in the above painting. (*Courtesy of Sidney Janis Gallery, N.Y., and The Museum of Modern Art.*)

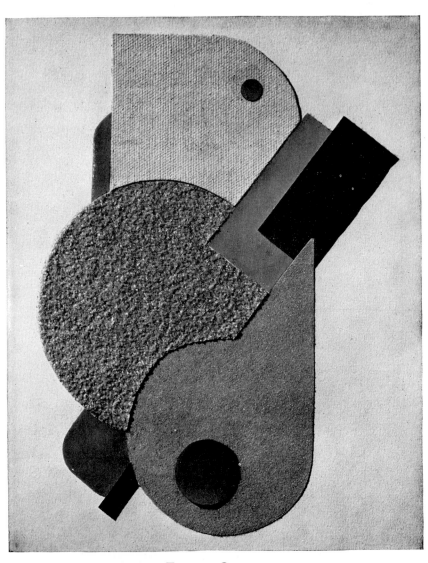

TEXTURE COLLAGE
(*Pratt student exercise* 1, *page* 230.)

224

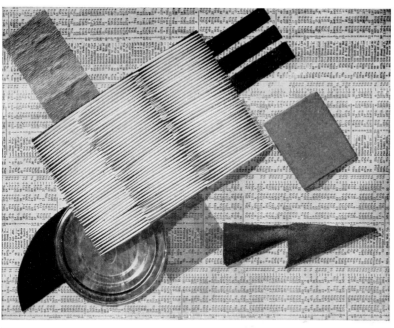

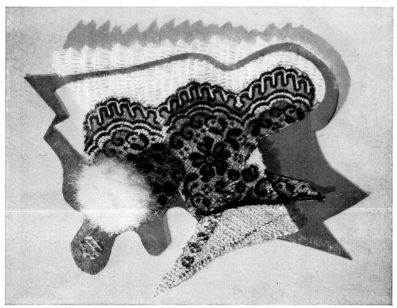

TEXTURE COLLAGES
(*Pratt student exercise 1, page 230.*)

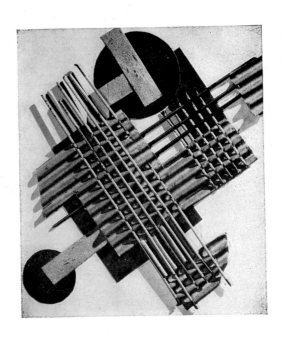

TEXTURE COLLAGES (*Pratt student exercise* 1, *page* 230.)

226

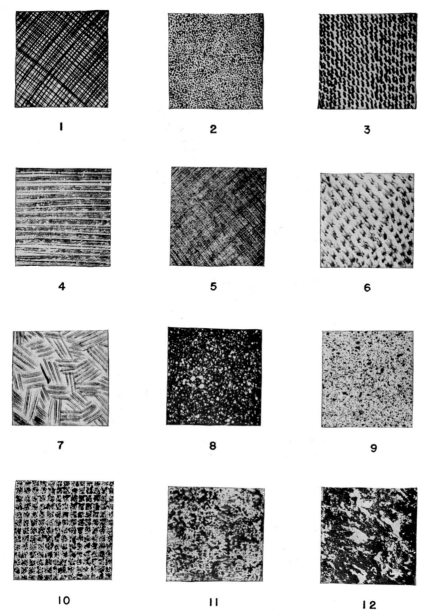

Simulated Textures. 1. Pen Cross-hatching. 2. Pen Stipple. 3. Pen Wiggle.
4. Dry Brush Dragged. 5. Dry-Brush Cross-hatching. 6. Dry Brush Dabbed. 7.
Dry Brush Irregular. 8. White Spattered on Black. 9. Black Spattered on White.
10. Black Spattered through Screen. 11. Black Dabbed with Sponge on White.
12. White Dabbed with Cotton Wad on Black. (*Pratt student exercise 2, page*
230.)

227

Designs in Simulated Textures.
(*Pratt student exercise 3, page* 230.)

Sequential Exercises in Shape, Shape Arrangement, and Texture. (*Pratt student exercise* 4, *page* 230.)

QUESTIONS

1. Texture is perceived visually because . . . ?
2. Texture affects the appearance of color because . . . ?
3. In modern design, textural variety is used for what purpose?
4. Name some new materials that have expanded the textural range of contemporary design.
5. Name the four basic textures used in the visual arts.
6. What is the origin of simulated textures?
7. Why are simulated textures extensively used in the graphic arts?
8. Name the two kinds of simulated textures.
9. Describe some of the ways in which the mechanical or Ben-Day textural tints may be applied to a drawing.
10. How are some hand-made simulated textures produced?

EXERCISES

1. Make collages, like those shown on page 224 to 226, from colored papers and materials of various textures, such as white and colored bath towels, sandpaper, corrugated cardboard, metallic papers or aluminum foil, sheet cork, sponge rubber, wood veneer, wire mesh, netting, clear and colored Cellophane.
2. Make a plate of simulated textures similar to the one on page 227. Use these textures in the following exercise.
3. Make nonrepresentational designs in simulated textures such as those shown on page 228.
4. Sequential exercises in shape, shape arrangement, and texture. See page 229.

 a. Divide a black paper unit into curvilinear elements that are repetitive in shape but contrasting in size, and rectangular elements that are also repetitive in shape but contrasting in size.
 b. Cut up the unit into these elements.
 c. Arrange these shape elements to form an integrated and interesting design.
 d. Trace this design on white paper, and execute it in real textures or in simulated textures.

230

CHAPTER X

Proportion

PROPORTION or ratio has fascinated man since ancient times, when he first began to count. The writings on the subject are encyclopedic, including writing in all the arts and sciences and even some religious and esoteric cults.

In the old civilizations some numerical ratios were mystical symbols. In Egypt, India, and Greece, the determination of the proportions of a building by means of manual arithmetic or the stretching of ropes was often accompanied by religious rites that persist today in the form of our cornerstone ceremonies.

Many canons of ideal proportion have been formulated in the past, some of them differing greatly. These systems are often considered unintelligently as a sort of magical recipe and applied as infallible methods, with little or no understanding of the underlying basic principles of design, unity, and variety.

It is generally admitted that classic design has unusually fine proportion, and many attempts have been made to analyze its secret. Of these analyses the best known today are Jay Hambidge's *Dynamic Symmetry* and *The Parthenon Naos* by the architect Ernest Flagg. Both these studies of proportion are fine, scholarly researches. However, they are perhaps a little too erudite and complex for the average young student.

For some years the author has made a study of ratios or proportion applied to surface division in design. Since this study has been checked and corroborated by surveys, he believes that the following pages will illustrate a new and simpler approach to the ancient and fascinating subject of proportion.

Although spatial dimensions, per se, are absolute, the conception of size or measure is relative, because it is impossible to comprehend one magnitude except in comparison with another. Comparison of size, measure, or magnitude is called *ratio* or *proportion*. In the fine arts, proportion means a designed relationship of measure. Proportion is a planned ratio of magnitudes or of intervals of the same kind, such as time, space, pitch, value, color, etc.

However, since the following chapter deals with surface division, we need consider only two-dimensional space—that is, magnitudes and intervals of length and area, which, of all dimensions, are easiest to measure and relate.

"Those damned dots!" is how a famous statesman once referred to decimals. If mathematics is not your forte either and decimals affect you in the same way, do not be disturbed by those on the following pages. These ratios are included merely to explain the mathematical relationships involved in applying the principles of design to the division of a line or surface. Application of the surface divisions requires absolutely no mathematical knowledge or arithmetical calculation, since these divisions may be made simply, easily, and rapidly with the triangles illustrated.

1. SURFACE DIVISION

Whether the problem is one of industrial, decorative, or architectural design, concerning cabinet, mural, or façade, the solution involves making a plan of surface division.

232

Design is the art of relating or unifying contrasting elements. From the standpoint of design, therefore, the best possible division of any surface is one that creates those two basic requisities of all fine design, unity and variety.

The most satisfactory surface division, therefore, is one in which interest and unity are produced by dividing the plane into parts that, although contrasting in shape or size, are related to each other and to the original surface. How this is done will be demonstrated by the diagrams on the following pages.

A continued proportion or a repeated ratio is the structural theme of the following rectangles with their divisions. This recurrent proportional motif, which is so strongly sensed as a rhythm underlying the interesting variations of shapes and sizes, creates the forceful impression of unity.

These plans of surface division might perhaps be compared with musical structure, that is, variations on a theme. According to Flagg, this was the plan of the Greek architect.[1] He says that the Parthenon and other Greek temples were designed in certain "keys" or particular ratios of proportion. This key ratio or proportional motif is supposed to have been repeated throughout the building, thereby creating a strongly integrated structure. This means that, although the dimensions changed, the relationship of the dimensions or the ratio remained constant. Hambidge's analysis of Greek vase proportions also seem to prove this theory. Vitruvius, also, confirms the supposition. He stated that the proportions of any of the ruined Greek temples or statuary could be calculated from the measurements of any remaining fragment, such as a column or triglyph.

All the following diagrams are based on a continued proportion or repeated ratio. They are theoretically the best and most

[1] This may be the reason why classic architecture has been called "frozen music."

233

satisfactory divisions of a surface. They are more. They are also the most pleasing and satisfying divisions to most people and the ones preferred by most.

This was conclusively proved by a survey made by the writer at the Pratt Institute School of Fine and Applied Arts. Sixteen classes in both the day and evening schools, comprising 463 students, were tested. The age range was from eighteen to thirty. The classes covered a wide field of specialized study, including architecture, illustration, advertising design, interior decoration, and industrial design. This represented a comprehensive cross section of the school. The perferences of the uninitiated laymen were considered by the inclusion of two classes from the Domestic Science School. The reactions of these two classes were more inconsistent and erratic, as was expected. The results here, though less conclusive, nevertheless corroborated the preferences of the trained groups.

The following is a typical example of the results of this experiment. Number 1, Diagram 4, page 240, was presented together with three other similar divisions. One was an equal division resulting in unrelieved, monotonous repetition or perfect unity. This example was least preferred, receiving 9 votes out of a total of 463. The second rectangle was divided halfway between the first and No. 1. This received 51 votes. Number 1, theoretically the best division, received 305 votes, more than the other three together. The remaining rectangle divided halfway between the top and No. 1 and, representing more extreme contrast, was the second choice. It received 98 votes. There were no neutral ballots; the students were instructed not to vote unless they had a very definite preference.

The foregoing is typical of the results obtained by the survey. In each instance, the diagrams on the following pages based on continued proportion were preferred by a large majority.

Proportions that appeal to so many different people must be of basic importance. The reactions of these persons were subconscious and the conclusions intuitive. This fact indicates that such reactions are common to everyone. The following diagrams, therefore, may be profitably studied by everyone engaged in art, architecture, industrial design, or advertising who desires to create the most forceful visual effects.

It is often necessary, as in the following diagrams, to divide a line into a number of proportionate parts. The following method is more rapid and simple than an arithmetical division. A decimal scale rule further simplifies the process. This method may be used when the proportional division triangles, described on the following pages, or a pair of proportional dividers are not available.

DIAGRAM 1

CONSTRUCTION

1. Draw AC of any convenient length and at any angle to AB.
2. On AC mark the desired proportionate division, AE and ED.
3. Draw DB.
4. Draw EF parallel to DB.

235

(*See Diagram* 2)

From a design standpoint, the most satisfactory division of a line is one that creates those two fundamental attributes of all fine design, unity and interest. Division of a line according to the Golden Mean Ratio or Proportion, as in Diagram 2, produces this desired result as follows. Variety is created by the contrast of size between CB and AC. Unity is created by relating these contrasting segments to each other and to the original line AB by a continued proportion or repetition of the Golden Mean Ratio as follows:

$$\frac{CB}{AC} = \frac{AC}{AB} = \frac{1}{1.618} = \text{Golden Mean}$$

Any line may be easily and quickly divided as below by the method shown in Diagram 1 or by the Golden Mean Triangle in Diagram 4.

DIAGRAM 2

The Golden Mean 1.618 is the geometric mean and also the constant factor in the geometrical progression 1, 1.618, 2.618, etc. 1.618 is also the approximate constant factor in the geometrical progression . . . 8, 13, 21, 34, 55, 89, 144 . . . etc.[2,3] This may be written 13/8, 21/13, 34/21, 55/34, 89/55, etc., and is called a "continued proportion." In this continued proportion the closest approximation to 1.618 is 89/55 = 1 34/55 = 1.6182. Therefore, a 55/89 ratio may be substituted for its

[2] Fibonacci Series, one of a summation series; see p. 237.

[3] The heights of the stories of the famous Peller House in Nuremberg, destroyed in World War II, also formed another, but different, geometrical progression in which 1.2 was the approximate constant factor.

equivalent, a 1/1.618 ratio, whenever it would be convenient to do so (see division of line into proportionate parts, Diagram 1, page 235).

The so-called "Golden Section" or "Golden Mean," 1.618, was known to the Egyptians and Greeks, and the ratio 1.618 to 1 appears frequently in their art and architecture.[4] This proportion also occurs in the *Elements* of Euclid.

Later, in 1509, Fra Luca Pacioli called it the "divine proportion." Other writers have also attributed a mystical significance to it. The scientist Kepler referred to it as a "precious jewel." The name "Golden Mean," commonly used at present, seems to have originated in 1830.

The Golden Mean is the structural motif of plant and animal life, as manifested by leaf arrangements, seed pods, sea shells, and cell growth. The pine cone and sunflower are notable examples of natural design based on this proportional ratio.

The Golden Mean, or 1.618, is the approximate constant factor in the Fibonacci Series . . . 8, 13, 21, 34, 55, 89, 144 . . . This series was named after the early thirteenth-century Italian mathematician Leonardo Pissano, or Fibonacci, who calculated this to be the rate of propagation of a pair of rabbits.

The logarithmic spiral of a discoid shell is an example of a natural growth curve also based on a continued proportion with this constant ratio. The name "logarithmic" spiral is attributed to Bernoulli (1691), who was so enamored of this spiral that he caused it to be engraved upon his tomb at Basel.

This spiral, also called the "constant angle" spiral, the proportional spiral, or the geometric spiral, together with the Golden Mean, has engaged the studious attention of many

[4] HAMBIDGE, JAY, *Dynamic Symmetry*, Yale University Press.

eminent mathematicians, scientists, and artists (see Dynamic Unity, page 91).

CONSTRUCTION OF THE GOLDEN MEAN RECTANGLE

DIAGRAM 3

The width of the Golden Mean Rectangle is one side of a square; its length is one-half the side of the square plus the diagonal of half the square.

1. Construct the square ABCD.
2. With M the mid-point of BC as the center and radius MA, draw arc AR.

" . . . The design of classic Greece was correlated by means of applied geometry."[5] The above rectangle is one of the two that " . . . furnish the correlating proportions of their great masterpieces such as the temple at Bassae, the Erectheum, and the Parthenon."[5]

The science of arithmetic as we now understand it was un-

[5] KANE, JAMES A., The Hambidge Theory of Symmetry and Proportion in Greek Architecture as Relating to Architectural Design, pp. 262, 264, *The American Architect,* Oct. 12, 1921.

known to the Greeks.[6] In the construction of the above rectangle, therefore, they had to rely on "manual arithmetic" or geometrical construction. That is the method used here. This construction was performed by Harpedonaptae, or rope stretchers, who learned their science from the Egyptians as early as the sixth century B.C.

It is interesting, therefore, that the above geometrical construction also produces the significant mathematical ratio or proportion discussed on these pages, as follows:

$$\frac{CD}{DG} = \frac{DG}{CD + DG} = \frac{GA}{AD} = \frac{AD}{DG} = \frac{\text{area GRBA}}{\text{area ABCD}} = \frac{\text{area ABCD}}{\text{area GRCD}}$$

$$= \frac{1}{1.618} = \text{or the Golden Mean}$$

In addition, GRBA is the same shape or proportion as GRCD or $\frac{1}{1.618}$.

CONSTRUCTION OF THE GOLDEN MEAN TRIANGLE

(Diagram 4 on page 240)

Golden Mean or 1/1.618 Rectangles of any size, such as ESCJ, may be quickly and easily constructed on the hypotenuse CG of the Golden Mean Triangle DCG, as demonstrated in No. 1, Diagram 4, page 240.

The Golden Mean Triangle may also be used to divide any line or any rectangle according to the Golden Mean Proportion of 1/1.618, as demonstrated in Nos. 1 and 2. This construction is more direct, rapid, and easier than the method shown in Diagram 1. It also eliminates the necessity of using a scale rule.

The Golden Mean Triangle is made by bisecting the Golden Mean Rectangle in Diagram 3 through its diagonal CG. This triangle may be enlarged to any desired size by extending CG, CA, CD and then drawing a line parallel to GD. The triangle

[6] Ibid.

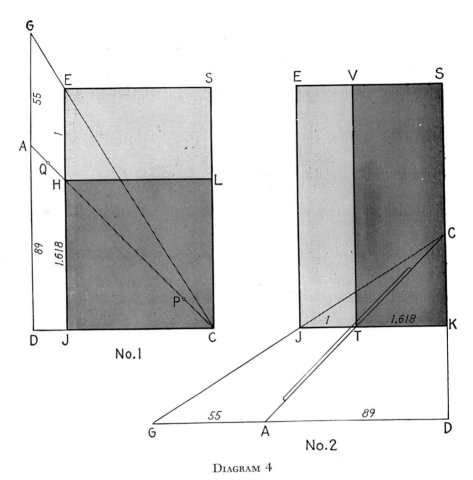

DIAGRAM 4

may then be cut from plastic. Line CA is scratched on the triangle with a knife. Two pinholes may be drilled through CA at convenient points such as Q and P, as shown in No. 1, or a narrow slit may be cut as shown in No. 2. If plastic is not available, the triangle may be drawn on tracing paper.

GOLDEN MEAN DIVISION OF A LINE OR RECTANGLE

To divide any line such as EJ, in No. 1, according to the Golden Mean Proportion so that $\dfrac{EH}{HJ} = \dfrac{HJ}{EJ} = \dfrac{1}{1.618}$:

240

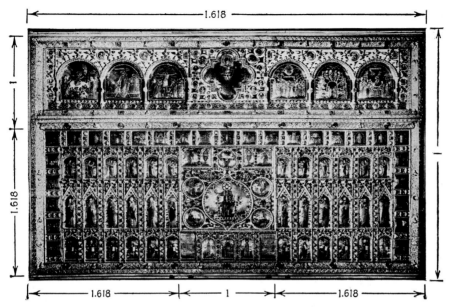

THE PALA D'ORO, OR THE GOLDEN ALTARPIECE IN THE
BASILICA OF SAN MARCO, VENICE

A famous example of Byzantine art, executed at Constantinople in A.D.
976.

Is it merely by chance that the Golden Mean Ratio 1/1.618 is repeated at
least three times in this example of Byzantine art?

1. Place the Golden Mean Triangle on EJ so that GD is
 parallel to EJ, point E is on the hypotenuse GC, and point
 J is on line DC.
2. Insert a pencil point in the holes and mark points P and
 Q.
3. Move the triangle and connect P and Q with a straight
 line intersecting EJ at H.

To divide horizontally any rectangle, such as ESCJ in No. 1,
according to the Golden Mean Proportion, locate H as ex-
plained above; then draw HL parallel to ES.

To divide vertically any rectangle, such as ESKJ in No. 2,
according to the Golden Mean Proportion, proceed as shown
in No. 2.

241

The foregoing divisions may be made even more easily and rapidly with a pair of proportional dividers set to a 1/1.618 or 55/89 ratio. These proportional dividers may be obtained at a drafting-instrument shop, or they may be made from thin strips of wood or metal.

The survey that I made at Pratt Institute indicates that the foregoing divisions produced by the vital, dynamic Golden Mean Ratio are the most pleasing divisions of a line or rectangle into two parts. It is logical that these divisions should be the most satisfactory because, from the standpoint of design, Nos. 1 and 2 are the best possible division of a line or rectangle into two parts. Variety and unity, those two essential requisites of all fine design, are created in No. 1 as follows:

Variety is produced by the contrast of shape and size of ESLH and HLCJ.

Unity is created by repetition of the Golden Mean Ratio 1/1.618. The two areas are related to each other and to the parent rectangle by the following continued proportion:

$$\frac{\text{Area ESLH}}{\text{Area HLCJ}} = \frac{\text{area HLCJ}}{\text{area ESCJ}} = \frac{1}{1.618}$$

The division in No. 1 is also used in MJ on Chart 2, page 69. MJ is also a Golden Mean Rectangle.

In No. 2, EVTJ and VSKT are also contrasting in shape and size (variety) and are also related to each other and to the original rectangle (unity) by the following repetitive or continued proportion:

$$\frac{\text{Area EVTJ}}{\text{Area VSKT}} = \frac{\text{area VSKT}}{\text{area ESKJ}} = \frac{1}{1.618}$$

Practical use of the foregoing divisions is illustrated on the following pages.

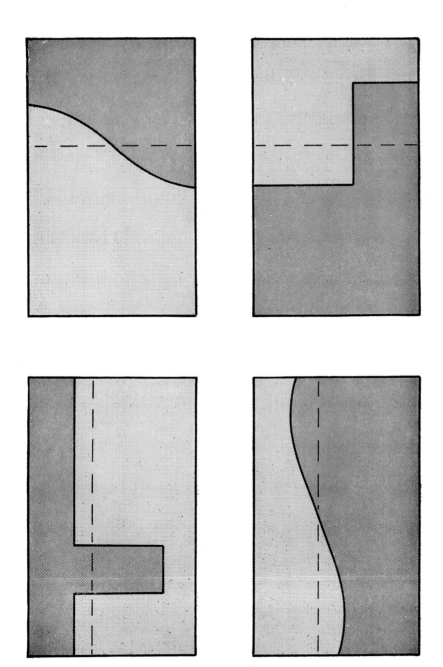

DIAGRAM 5

Variations on Diagram 4, maintaining the same proportions between the areas.

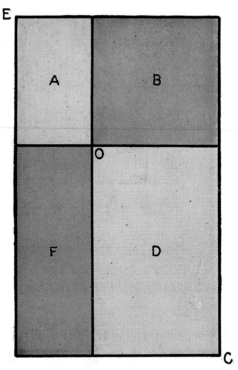

DIAGRAM 6

Diagram 6 is a combination of the divisions of Nos. 1 and 2, Diagram 4. In the survey this was preferred to any other similar division of a rectangle into four parts. From a design standpoint, it is probably the best possible division of a rectangle into four parts because maximum variety and unity are created as follows.

1. Variety of size, with unity of shape and direction. Although contrasting in size, A and D are the same shape and have the same vertical direction. They also repeat the shape and direction of the original or parent rectangle.
2. Variety of shape with unity of size. Although contrasting in shape, area B is the same size as area F.
3. Repetition of the Golden Mean Ratio. All the areas are related by the following continued proportion

$$\frac{A}{B} = \frac{B}{D} = \frac{A}{F} = \frac{F}{D} = \frac{1}{1.618}$$

The division of the diagonal EC also echoes the above ratio; that is,

$$\frac{EO}{OC} = \frac{OC}{EC} = \frac{1}{1.618}$$

244

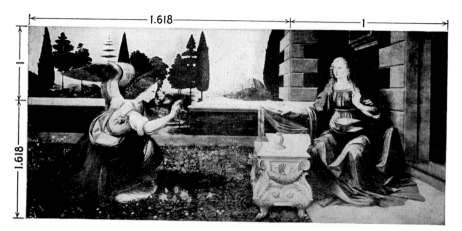

"Annunciation" by da Vinci

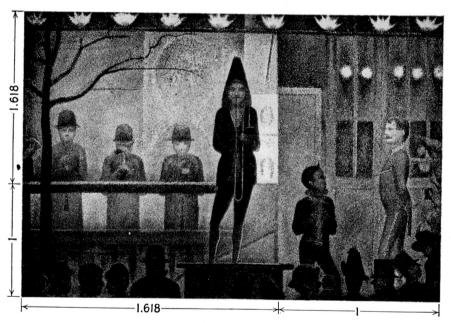

"Parade" by Seurat

(Collection of Stephen C. Clark. Courtesy of The Museum of Modern Art.)

245

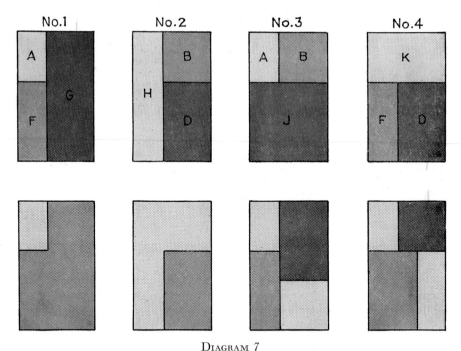

DIAGRAM 7

Variations on Diagram 6.

In the variations in Diagram 7 unity and interest are produced in the same way as in Diagram 6: that is, by repetition and contrast of shape, size, or direction.

In No. 1, for example, F and G are the same shape but contrasting in size. A and the original rectangle are also the same shape but unequal in size.

In No. 2, H and D are different in shape but the same size. Therefore,

$$\frac{B}{H} = \frac{B}{D} = \frac{1}{1.618}$$

D repeats the shape of the larger parent rectangle.

The small and large squares B and J, in No. 3, illustrate variety of size with a repetition of shape. As before, A and the parent rectangle are the same shape but contrasting in size.

In No. 4, K and D are identical in shape and size but opposite in direction. Therefore, $\frac{F}{K} = \frac{F}{D} = \frac{1}{1.618}$. Both K and D echo the shape of the larger original rectangle.

Similar relationships are produced by the divisions of the other rectangles.

246

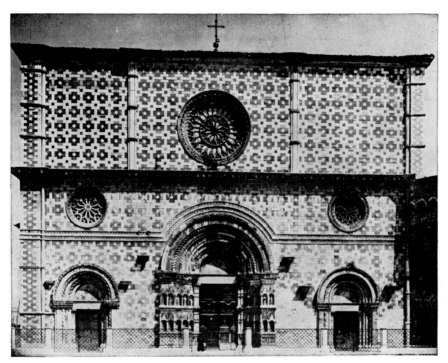

SANTA MARIA DI COLLEMAGGIO, AQUILA, A.D. 1287

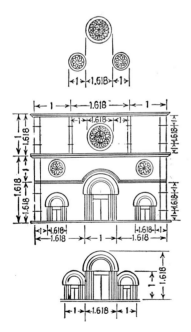

ANALYSIS OF FAÇADE, ILLUSTRATING REPETI-
TION OF 1 TO 1.618 RATIO (THE GOLDEN
MEAN)

Continued Proportion in Architecture. This
diagram is not intended as proof that the
façade was designed on the basis of the
Golden Mean used as the continued propor-
tion. Although the author has not measured
the building, many of the dimensions scaled
from the photograph roughly approximate a
1 to 1.6 ratio.

In the diagram, the façade has been re-
designed, slight adjustments having been
made so as to make it actually conform to
the repeated ratio of 1 to 1.618.

This example, together with the others
used in this book, is not intended to prove a
theory but rather to illustrate certain struc-
tural principles and to suggest their applica-
tion.

247

AESTHETIC-MATHEMATICAL SCULPTURE BASED ON HELICAL, AND PARABOLIC
THEMES, BY RUTHERFORD BOYD

The Golden Mean Ratio in Three-dimensional Design. Both the helical and
parabolic structures were kinetically developed by repetition of the Golden
Mean Ratio.

Rutherford Boyd, sculptor, mural painter, former advertising manager and
art director of six magazines, is perhaps the foremost contemporary protagonist
of the mathematics of art, or the art of mathematics. He has also produced the
nonrepresentational motion picture, *Parabola,* which is based on designs similar
to those shown above.

248

AESTHETIC-MATHEMATICAL SCULPTURE BASED ON AN ELLIPTICAL THEME
BY RUTHERFORD BOYD

The Golden Mean Ratio in Three-dimensional Design. This design was generated by one negative and one positive ellipse moving through three-dimensional space. The major and minor axes of each ellipse are in the Golden Mean Ratio of 1 to 1.618. The negative space, or void—partly bounded by the concave surface—was kinetically evolved by horizontally rotating the negative ellipse around the left edge of the structure as an axis, while moving the ellipse in vertical steps that are related by the Golden Mean Ratio. The positive space, or volume—enclosed by the convex surface—was also dynamically developed, but by horizontally revolving the positive ellipse about the central axis of the design, while raising the ellipse in tiers that are also integrated by the Golden Mean Ratio.

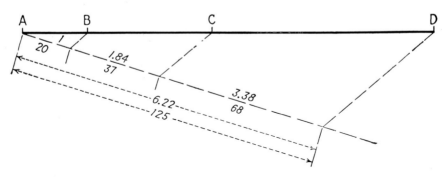

DIAGRAM 8

Division of any line into three parts, harmoniously related to each other and to the whole.

Result. Complete continued or repetitive proportion.

$$\frac{AB(1 \text{ or } 20)}{BC(1.84 \text{ or } 37)} = \frac{BC(1.84 \text{ or } 37)}{CD(3.38 \text{ or } 68)} = \frac{CD(3.38 \text{ or } 68)}{AD(6.22 \text{ or } 125)};$$

repetition of 1/1.84 ratio produces unity. Unity is reenforced by a dominant space interval *CD.** The segments are all of a different length, resulting in contrast of measure of variety.

Note. 1.84 is the constant factor in both of the following progressions, 1, 1.84, 3.38, 6.22, etc., or 20, 37, 68, 125. Therefore, the continued proportion $\dfrac{20}{37}, \dfrac{37}{68}, \dfrac{68}{125}$

is the same as and may be substituted for $\dfrac{1}{1.84}, \dfrac{1.84}{3.38}, \dfrac{3.38}{6.22}.$

The foregoing method of proportional division may be used when the proportional-division triangle, illustrated in Diagram 9, or a pair of proportional dividers are not available.

* See Dominance and Dominant Interval, p. 100.

250

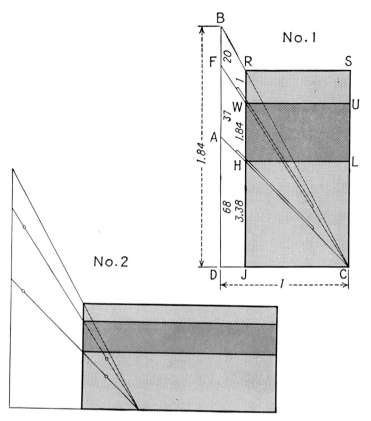

DIAGRAM 9

By means of the proportional-division triangle *DCB* any rectangle may be quickly and easily divided into three parts that will be related to each other and to the parent rectangle by the complete continued proportion or repetitive ratio $\frac{1}{1.84}$. This triangle may be enlarged to any desired size by extending *CB, CF, CA, CD* and then drawing a line parallel to *BD*. In the triangle slits may be cut as in No. 1 or holes may be drilled as in No. 2. The foregoing division may also be made with a pair of proportional dividers set to a 1/1.84 or 37/68 ratio.

In the survey, Nos. 1 and 2 were preferred to any other similar divisions. In No. 1, interest is produced by a variety of shapes of contrasting sizes, and unity is created by the repetitive ratio or continued proportion

$$\frac{RSUW}{WULH} = \frac{WULH}{HLCJ} = \frac{HLCJ}{RSCJ} = \frac{1}{1.84}.$$

The foregoing relationships also exist in No. 2 as well as in *JM* on Chart 14, page 72.

251

DIAGRAM 10

Variations on Diagram 9, maintaining same proportionate relationship of areas. *Note.* The surface division of the cover design of this book is based on Diagram *D*.

252

Design for a page built on a repetition of the 1 to 1.84 ratio. (*Courtesy of the Better Vision Institute, New York.*)

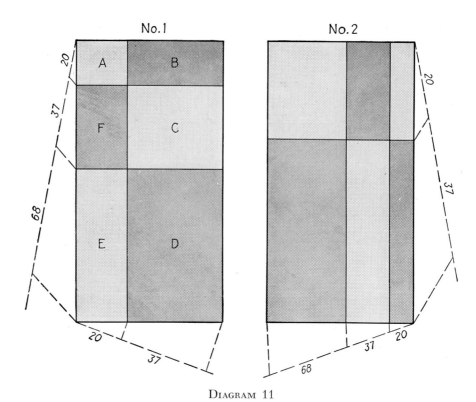

DIAGRAM 11

Division of any rectangle into six harmoniously related parts.

$$\frac{A}{B} = \frac{B}{C} = \frac{C}{D} = \frac{E}{D} = \frac{F}{E} = \frac{A}{F} = \frac{F}{C} = \frac{1}{1.84}, \text{ or } \frac{20}{37}, \frac{37}{68};$$

continued proportion or repetition of ratio creates unity.

A is the same shape as C, and F is the same shape as D; unity of shape, contrast of size.

Area B = area F, and area C = area E; unity of size, contrast of shape.

The above relationships are produced in No. 2, and also in the variations and combinations in Diagram 12.

Note. Although the above divisions were made by the method shown in Diagram 8, the divisions could have been made with the proportional-division triangle illustrated in Diagram 9 on page 251.

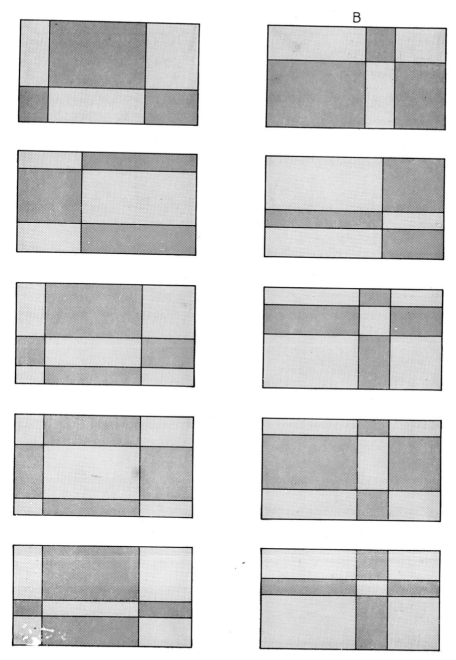

DIAGRAM 12

Variations and combinations of Diagram 11.

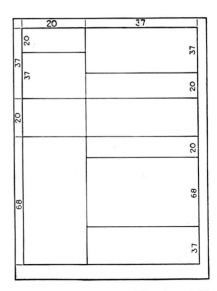

A design for an advertising layout, based on Diagram 12 B. The 1 to 1.84 ratio is repeated throughout.

The following are three of the preliminary page plans for a 15-page publication designed for the Better Vision Institute of New York. These designs demonstrate one of the ways in which unity and interest can be achieved in book design by variations of a repeated ratio. Almost all the principal surface divisions were based on the 1 to 1.618 ratio. Although occasional use was also made of the similar or harmonious 1 to 1.84 proportion, as on the vertical division of the first or cover design, the 1 to 1.618 proportion is the dominant ratio. The carrying through of this dominant ratio creates consistency or unity, and the varying dimensions provide the interest. This plan of repeating a key ratio or motif is the one supposedly used by the ancient Greek architects, according to Flagg, Hambidge, and Vitruvius (see page 233).

In looking through the above-mentioned publication it would be immediately evident that a red, black, and white

color scheme had been repeated throughout the book. Not so obvious, however, would be the repetition of the 1 to 1.618 proportion. Although it is more subtle, reiteration of this ratio is just as effective in integrating the book as is the reiteration of the color scheme.

Apropos of the color plan: although some of the pages are dominantly black, the majority are dominantly white, so that the booklet as a whole averages preponderantly white.

The plan of this publication might also be used in designing a series of posters, car cards, or labels for the different products of a food or drug manufacturer.

Surface division ratios must be used with discretion or they become a hindrance, a rigid strait jacket. Ratios are a means to an end, not an end in themselves. The design should not be forced to fit the ratios; the ratios should be used to fit the purpose.

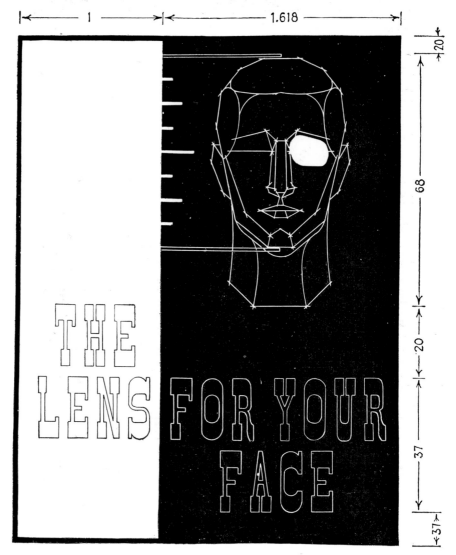

Courtesy of the Better Vision Institute, New York.

Type SBA
Short Blunt Angular

1.618

1.618

Courtesy of the Better Vision Institute, New York.

This design—like "Cats' Eyes," the *Fortune* cover design, "Give 'em Both Barrels," and the "Spirit of Mexico" previously shown—is also based on repetition with variation and dominance. (*Courtesy of the Better Vision Institute, New York.*)

260

"SARATOGA NINETIES"

Design for Overmantel Panel Built on the 1/1.84 Ratio. This composition evolved from a race horse. A galloping horse is most simply expressed in line by a leaping curve, arching upward. The design is built on repeated variations of this curving arch, which is the dominant linear motif. This characteristic line is echoed throughout the composition by the arches of the grandstand, the contours of the groups of spectators, the parasols, the bicycle, the trees, and the curved backs of the jockeys.

A comparison of this design and the photographic composition on page 138 will reveal an interesting parallel of plan. One evolves from a toothbrush; the other grows out of a racing horse.

261

AESTHETIC-MATHEMATICAL SCULPTURE BASED ON A SPIRAL THEME, BY
RUTHERFORD BOYD

Repetition of Ratio in Three-dimensional Design. Unity may be produced
by repetition of any ratio. This composition of three tangent spirals was
dynamically evolved from a continued proportion, or repeated ratio, of 1.3427.
(*From a design portfolio by Rutherford Boyd, published by Scripta Mathe-
matica, New York.*)

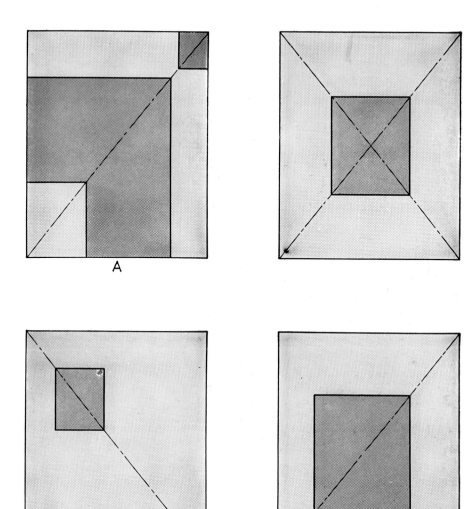

A

DIAGRAM 13

It is often necessary or desirable to enlarge or reduce a rectangle, maintaining the same proportions, or to construct within one rectangle a smaller of the same shape. Diagram 13 illustrates such construction.

DIAGRAM 14

In Diagram 13, the similar rectangles were constructed on the diagonals of the parent rectangles. If, however, it is desired to construct a similar rectangle not on either diagonal, the construction in Diagram 14 is used.

Any rectangle constructed on any line *CD* parallel to the diagonal *AB* will be the same proportion as the parent rectangle.

264

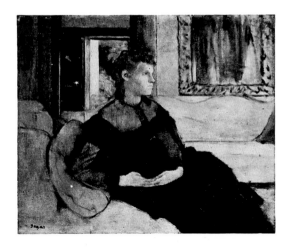

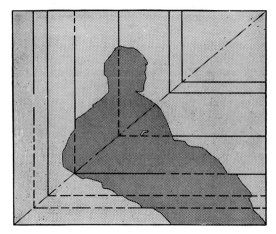

"MME. GOBILLARD-MORISOT" BY DEGAS

Repetition of Shape and Proportion. The underlying linear structure is based on subtle and partly hidden repetitions of the picture shape; unity of shape, variety of size or measure. This surface division is based on Diagram 13*A.* Contrast of direction, the diagonal dominant.

Color. The color plan is a harmony of warm reddish browns, with a cool green contrast, the warm hues preponderating.

The climax of strongest color is at the center of interest. The unifying power of a color climax is similarly employed in the living-room interior described on page 395. (*Courtesy of the Metropolitan Museum of Art.*)

265

DIAGRAM 15

Any rectangle whose diagonal is at right angles to the diagonal of the parent rectangle will have the same shape or proportion as the parent rectangle.

The two small rectangles in the diagram could have been made any length. However, just to demonstrate one possibility, AB was made equal to DE, creating the continued proportion or repeated ratio $\dfrac{AB}{CD} = \dfrac{CD}{FG}$.

266

Unity and variety are created in this architectural design as follows.

Repetition of shape creates unity. The rectangles, including the door and windows, are the same shape; they all belong to the same family. This family resemblance of shape or proportion unifies them. This shape relationship, used by the architects of the Renaissance, was termed *concinnitas* because of its similarity to skillfully composed music. (Construction of the rectangles is based on Diagrams 14 and 15.)

The contrasting sizes of these shapes produces variety or interest, and the one largest, major, or dominant shape D creates unity.

Repetition of the ratio $\dfrac{B}{C} = \dfrac{C}{D}$ also creates unity.

The contrasting directions of the shapes, horizontal versus vertical, produce variety or interest, the dominant horizontal direction creates unity.

The balance is asymmetrical or informal.

267

"PORTRAIT OF MISS ALEXANDER" BY JAMES A. MCNEILL WHISTLER

The picture shape or rectangle *ABCD* is repeated by rectangles *EBGF*, *KHGL*, *LGCD*, and *KOFL*. (Repetition produces unity.) Interest is maintained by varying the sizes of these rectangles. The diagram is a combination of Diagrams 13*A*, 14, and 15.

Other harmonious or repetitive elements include the bows on the slippers, the flowers, the four butterflies, Whistler's butterfly signature, the dark shape under the arm and the ovals of the head and hat. The position of the legs is arranged to harmonize with the directions of the sides of the skirt.

Although this diagram does not exactly fit the painting, it does closely coincide. We do not know whether or not the artists whose work is analyzed on these pages consciously organized their designs according to certain principles of composition. For the purposes of this book we do not consider that point important, nor are we concerned in proving it. The designs, diagrams, and analyses are intended only to illustrate various aspects of art structure and their application. Nevertheless, we do know that George Bellows studied dynamic symmetry and used it in some of his paintings. Also, in the above composition, it is possible that Whistler may have consciously used his knowledge of geometrical organization gained when he studied engineering at West Point Military Academy. (*Courtesy of Tate Gallery, Millbank.*)

268

2. PROPORTION OF RECTANGLES

A perfectly blank surface such as a sheet of paper or a canvas presents a relationship that can be pleasing or unsatisfactory. This relationship, that of length to width, is called its *proportion*.

Plato has defined what he termed the most beautifully proportioned shape. This shape is called by Hambidge a *root-three rectangle*, one whose long side is the square root of three (1.732), the short side being unity or 1 (Rectangle Y, page 270). Plato's contemporaries, however, apparently did not agree with him regarding the beauty of this proportion, inasmuch as it is seldom found in the art of that period.

Seeking to determine the rectangle whose proportions are most pleasing to the trained eye, I included Diagram 16, page 270, in the previously mentioned Pratt Survey. Rectangle X, whose sides are in the ratio of 1 to 1.618, the Golden Mean, which is a continued proportion, was most preferred. It is significant that this rectangle was so definitely preferred to rectangle Y, inasmuch as the proportions of these rectangles are so very similar. It seemed to be one of the most conclusive proofs of the mathematical basis of pleasing relationships and of the satisfactory qualities inherent in a continued proportion.

"I do not mean by beauty of form such beauty as that of animals or pictures, which the many would suppose to be my meaning; but, says the argument, understand me to mean straight lines and circles, and the plane or solid figures which are formed out of them by turning-lathes and rulers and measurers of angles; for these I affirm to be not only relatively beautiful, like other things, but they are eternally and absolutely beautiful."[7]

[7] Socrates, from Plato's *Philebus*.

DIAGRAM 16

PROPORTIONS OF RECTANGLES

$V = 1/1$, the least preferred shape, received 7 votes out of a total of 470.

$W = 1/1.31$, average proportion of books, magazines, newspapers, and standard-sized picture frames, third choice, 62 votes.

$X = 1/1.618$ (Golden Mean), most preferred, received 227 votes.

$Y = 1/1.732$, Plato's "most beautifully proportioned rectangle," second choice, 150 votes.

$Z = 1/2$, fourth choice, with 24 votes.

Acceptance of the Golden Mean Rectangle as the most pleasing in proportion does not imply that rectangles of all other proportions are to be discarded as useless. From the point of view of function that rectangle is best proportioned that best fits its purpose.

The proportion or shape of the picture space exerts a strong influence upon and to a certain extent arbitrarily pre-determines the composition and its treatment.

The proportion of the square V on page 270 is so emphatically unified that it would permit of more vigorous treatment and sharper contrast of value and color than would Z. The proportions of Z, on the other hand, present so much contrast to begin with that a fairly quiet treatment with more subdued contrasts would generally be indicated.

Although the foregoing statement would hold true in many cases, it is meant as a guiding principle rather than a rigid rule. In a complex subject like art, where exist so many factors, each capable of modifying the others, fixed rules are impossible. Ordinarily, the purpose of the work would be the major factor in determining the treatment.

QUESTIONS

1. From the standpoint of design, the most satisfactory division of a line or surface produces what results?
2. In dividing a surface, how may variety or interest be produced?
3. Repetition of shape creates what requisite of design?
4. What is a continued proportion?
5. How does a continued proportion or a repeated ratio create unity?
6. In the architecture of what ancient civilization was a "key" or repeated ratio supposed to have been used?
7. What is the Golden Mean?
8. In what living structures is the Golden Mean Proportion found?
9. Name one architectural masterpiece that was supposed to have been integrated by use of the Golden Mean Proportion.
10. In what example of Byzantine art is the Golden Mean Ratio repeated at least three times?
11. The Golden Mean Ratio is applied to the principal division of which painting by what famous artist of the Renaissance?
12. The Golden Mean is also used in the principal divisions of which painting by what well-known modern artist?

271

13. If the diagonals of two rectangles are parts of the same straight line, are the rectangles the same shape?

14. If the diagonals of three rectangles are parallel, are the rectangles in the same proportion?

15. If the diagonals of two rectangles are at right angles to each other are the rectangles the same shape?

16. How may the shape or proportion of a canvas influence and perhaps predetermine the character of a composition?

EXERCISES

1. Divide a line according to the Golden Mean Proportion by the methods shown in Diagrams 1 and 4.

2. Construct Golden Mean Rectangles by the methods shown in Diagrams 3 and 4.

3. Divide one rectangle horizontally in two parts and another rectangle vertically in two parts according to the Golden Mean Proportion. Use both methods as shown in Diagrams 1 and 4.

4. Divide a rectangle in four parts according to the Golden Mean Ratio by the method illustrated in Diagram 4.

5. Divide a line in three parts so that the segments and the total line will be related by a complete continued proportion or the repetitive ratio of 1/1.84. Use both the methods shown in Diagrams 8 and 9.

6. Divide one rectangle horizontally in three parts and another rectangle vertically in three parts according to the foregoing ratio. Employ both methods shown in Diagrams 8 and 9.

7. Enlarge and reduce a rectangle, maintaining the same proportion. Proceed as in Diagram 13.

8. Within one rectangle construct two smaller ones of the same shape. Make the diagonal of one of the small rectangles at right angles to the diagonal of the large one. Make the diagonal of the other small rectangle parallel to the diagonal of the parent rectangle.

9. With a pair of proportional dividers or the proportional-division triangles, analyze the divisions of examples of Greek architecture, Renaissance architecture, and paintings such as Leonardo da Vinci's "Annunciation." See if you can detect the presence of surface-division plans similar to those on the previous pages. When you find one, make a tracing illustrating the plan of surface division and write a short analysis explaining the design attributes created by the plan.

10. Plan the surface division for the following, using contrast of shape,

272

size, and direction, repetition of shape, and a continued proportion or a repeated ratio.

a. A cabinet or chest of drawers.
b. A book cover.
c. A page of printing such as those illustrated on page 253 and 256.
d. Three pages for an advertising booklet such as those shown on pages 258, 259, and 260, or a series of three related posters.
e. A simple modern architectural facade, such as the one illustrated on page 267.

Varying conditions of light will change the appearance of the simplest object—its size, its shape, its texture.

LIGHT reveals and transforms

Our moods and physical well-being may fluctuate with the quality of the daylight. It affects the whole character of our surroundings.

Courtesy of The Museum of Modern Art.

274

LIGHT

*creates the space, the figures, and
the dramatic power in this picture.*

Christ with the Sick around Him, Receiving Little Children. Etching by Rembrandt van Rijn, about 1648

To the photographer light is a medium
to work with, just as pigment is to the
painter. The camera records patterns of
light and dark in photographic images.

Photograph by George Knox

Photograph by William East

Artificial light, controllable at the
source, is the stage designer's most
effective instrument.

Courtesy of The Museum of Modern Art.

275

Value

Light is everything in the visual arts. Without it these arts could not exist. The artist controls light intensity with values, changes its color with pigments, and thereby creates his effects.

Like all animals, we are extremely sensitive to light, and any change in its intensity affects us strongly. Sunlight stimulates, twilight calms and makes pensive, and darkness depresses with fear and mystery. These are universal reactions to light and are as ancient as Adam.

1. VALUE KEYS

The *value key* or *tonality* of a painting is therefore of prime importance. It is the first impression received and immediately engenders an emotional reaction irrespective of the subject matter or composition. It must be remembered that we react to light in a very primitive manner, and this reaction would be the same whether we were viewing a painting or a blank canvas of the same value or tonality. In both instances the intensity of light reflected to the eye determines the primary

emotional response. White, gray, or black surfaces reflect varying amounts of light, each creating a distinctly different mood in the observer. The subsequent reactions to subject and composition may intensify or somewhat neutralize the first impression, but they cannot change it fundamentally. If anyone doubts this, let him transpose a Rembrandt painting into a higher key and note the distinct change in feeling, although the subject and composition remain the same. Or let him transpose a Monet into the lower key of el Greco.

The key of our painting should, therefore, receive our first consideration, since it will largely determine the other elements, color in particular. As will be seen later, we may use values without considering color, as in a lithograph or etching, but we cannot use color without considering values. Values are basic. Each subject requires a certain value key as well as a certain color key, which will best fit it and give scope for its fullest expression.

Oswald Spengler, writing of keys, says:

Plein-air and its new color scale stand for irreligion, hence the impossibility of achieving a genuinely religious painting on plein-air principles. . . . The whole of our great oil-painting, from Leonardo to the end of the 18th Century is not meant for the bright light of day. [Plein-air refers to the high-key paintings of the Impressionists.]

The matter of key has been more or less vaguely recognized by artists and has been discussed in rather loose and general terms. To my knowledge no one has yet clearly named or defined these keys that are so important in art. I shall try to clarify the subject by means of the diagram on page 283.

The terms are used according to their definition in Webster's Collegiate Dictionary, as follows:

Key: A system or series of tones or values based on their relation to a keynote, dominant value, or general tonality of the

painting, from which it is named. To regulate the pitch, such as to key to a high or low pitch.

Pitch: To fix at a certain level the acuteness or gravity of a value or tone.

Major: Large or greater interval. Strong contrast.

Minor: Small interval, closed up, muted. Subdued or muffled contrast.

In the diagram there are nine values or tones grading from black to white.[1] Values 1, 2, and 3 are in the low key; 4, 5, and 6 the intermediate key; 7, 8, and 9 the high key. If the darkest and lightest values in the design are three steps apart or less, such as 3 and 7, it may be called a *minor key.* If there is a greater interval between the darkest and lightest values and they are five, six, or seven steps apart, strong contrast results, and it may be called a *major key.*

Any painting or design may be thus classified. Some, like the examples used, are quite definite and are distinctly in a certain category. Others lie on the border line and are more difficult of classification. However, an exact classification is unimportant, except for the purpose of analysis or discussion. The value of this diagram is that it will help one to decide more quickly and easily in advance the key that will best fit the expression, eliminating the necessity of feeling around vaguely in all directions. Neither is there anything arbitrary about it, since it is intended only as a guide. Even after the key is tentatively decided, it may still be shifted up or down.

Each key in painting, like each key in music, has a distinctive emotional character. The luminous high major key is positive, stimulating, and cheerfully mundane. The high minor has a delicate, feminine quality and is more pensive. The intermediate major key is posteresque, strong, rich, with a some-

[1] The values on this chart are only approximate. The half-tone plate puts a gray tint over the white and somewhat modifies all tones.

278

what frank and masculine quality. The subdued intermediate minor suggests the timeless twilight of a dream world. The low major key is generally ponderous and dignified, as in a Rembrandt. With el Greco it becomes explosive, tortured, and queerly disturbing. The nocturnal low minor is funereal and macabre.

Many painters do not seem to be particularly versatile in the matter of key, sometimes because of training or habit. Others, perhaps, are temperamentally incapable of working in certain keys. Whistler is one exception, though he seems to have preferred the minor keys, as do also the Chinese. In European painting prior to the impressionists, the intermediate and low major keys were generally used.

The tendency in the past decade has been toward an increasing use of the intermediate and high keys in both painting and interior decoration. This is a natural expression of the modern temperament and is psychologically significant. The compact present-day apartment with its small rooms is undoubtedly a contributing factor. The higher keyed walls, ceilings, and furnishings together with the cool receding colors often used create a feeling of airy spaciousness. This is in interesting contrast with the stuffy and cluttered Victorian room, with its somber, low-keyed reds and liverish browns.

At present, painting tends to reflect the serious aspect of contemporary life, resulting in an increasing use of the lower major keys. This applies particularly to propagandist painting, with its sinister note of foreboding and world revolution. This restless modern school of painting is also partial to the other agitated major keys and to astringent or acrid color.

Sir Joshua Reynolds was keenly interested in the value key of paintings, although he did not call it by that name. He tells us that, as a result of his analyses of many of the Venetian and

279

Dutch masters, he concluded that the best proportion of values was one-half gray, one-quarter light, and one-quarter black. This is the intermediate major key, the one most used prior to the advent of the high-keyed canvases of the impressionists. More important, however, is that his observations indicate that these painters keyed their pictures to a dominant value and did not use equal amounts of each. This bears out the generally accepted theory that it is unwise to have color or value areas equal. This equality tends to destroy unity. One color and value should be dominant.

2. CHIAROSCURO AND NOTAN

There are two principal ways of using light and shade or values. These are the naturalistic and the pattern treatments. The realistic method is called by the Italians *chiaroscuro*, literally *chiaro* (light) plus *oscuro* (dark). The Japanese distinguish between the lights and shadows occurring in nature (realistic modeling) and artificial value patterns by naming the latter *notan*,[2] in contradistinction to the former. These two methods are sometimes combined, as in the murals by Cornwell and Savage on pages 288 and 289.

3. THE NATURALISTIC TECHNIQUE

With this technique, values are used to convey an illusion of illuminated bulk and mass. The third dimension is emphasized. (See portrait sketch, page 291.) This method, extensively developed by the Italian painters of the Renaissance, was perfected in the canvases of Rembrandt, Vermeer, and Velasquez.

[2] Japanese prints, particularly the Actor Prints by Sharaku, illustrate notan especially well. The print on page 285, the Greek vase painting on page 287, and the print by Landacre on page 290 are also good examples. Nearly all ancient painting is in this category, that is, flat pattern. Well-known specimens are the Egyptian wall paintings and the art of the primitive American Indian of the Southwest. It is interesting that most children instinctively tend to work in this manner.

A further development, accenting one aspect of this naturalistic trend, was effected by the French impressionists Monet and Pissarro. In this phase of painting, light and especially color were stressed, and three-dimensional mass was subordinated. This preoccupation with the problems of broken color resulted in a neglect of bulk and volume. It was this, plus the influence of Cézanne, that was in part responsible in precipitating a counterreaction known as *cubism*. From this point, a series of "isms" followed that comprise the modern movement. Matisse and Gauguin, both reactionaries, complete the cycle. One harks back to the Persians; the other resurrects the primitives.

The foregoing is a generalized classification for the purpose of a consideration of technique. It is not intended to imply that literal description is the end and aim of a naturalistic technique. Photographic reproduction should not be confused with creation. A naturalistic style may also be employed as an expressive form, as it was by Rembrandt, and is not always merely realistic and descriptive.

4. PATTERN (MURALS AND POSTERS)

In this treatment, forms are usually considered to be illuminated equally all over by a wide source of light coming from the front. This tends to flatten the bulk and consequently emphasizes the two-dimensional surface pattern. This type of lighting also simplifies matters, since it eliminates all cast shadows (see "Recessional"). In this method the shapes are developed decoratively and are often treated somewhat as a colored bas-relief. The murals of Jan Dupas and Eugene Savage are examples of this style. The emphasis is on two-dimensional pattern rather than on solidity. Local values, such as the black, white, and grays of the costumes, are pre-determined arbi-

trarily in the interest of pattern. All modeling is kept subordinate to the dark-and-light pattern; that is, the values within any shape are kept very close to the value of the enclosing pattern. The effect is posteresque. This is the usual mural and poster technique. This technique, considered from the point of view of expressive pattern or decorative design, has, in the opinion of many critics, reached its highest stage of development in the Near East and the Orient, principally in Persia, China, and Japan. Many Occidental artists, notably Whistler and Matisse, have been influenced by Oriental art. Perhaps the earliest and best-known examples of the Eastern attitude reflected in European art are the Byzantine mosaics.

The purpose of a pattern technique is often decoration. Certain Chinese landscape and religious paintings and also some of the canvases of Cézanne, Davies, Picasso, and others are exceptions. In these paintings, although the treatment is patternesque and often highly decorative in effect, the intent primarily was not decoration but expression. The decorative quality is a by-product and was not the main concern of the artist.

Value Key Chart
The Value Key Chart and Variety of Value Intervals

It will be noticed on the Value Key Chart that the intermediate keys do not conform to the principle of variety of intervals, which states that the middle position between two extremes should be avoided if maximum interest is desired.* The reason for this seeming discrepancy follows.

Consider the intermediate major key. There are numerous possible variations of this key that avoid the middle position between two extremes and that produce dominant and subordinate intervals. A few of these are values 9-6-1, 9-4-1, 9-5-2, 8-5-1, and 8-6-1. There are similar variations of the other keys. If all these variations had been included, the chart would be complicated and confusing. Therefore, each key is typified by a generalized example. In actual practice, of course, the exact middle position between any two extremes need not be used.

The chart is intended to illustrate only the idea of Value Keys, to suggest variations and as an aid in planning them. It need not be conformed to rigidly.

* Variety of contrasts or intervals, p. 62.

VALUE KEYS.

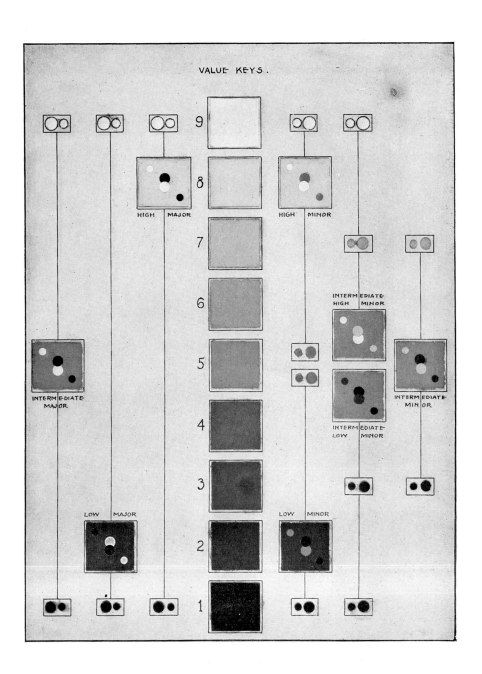

283

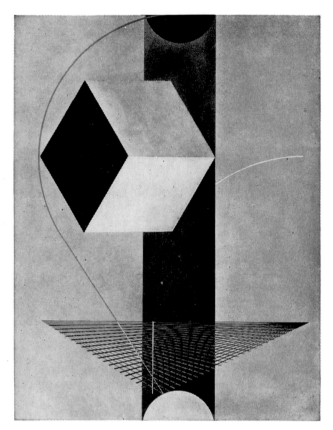

CONSTRUCTION BY EL LISSITZKY (*Courtesy of The Museum of Modern Art.*)

HIGH MAJOR KEY

The luminous high major key is positive, stimulating, and cheerfully mundane. Both the fine old Japanese print opposite and the modern painting by Lissitzky are rendered in this key.

284

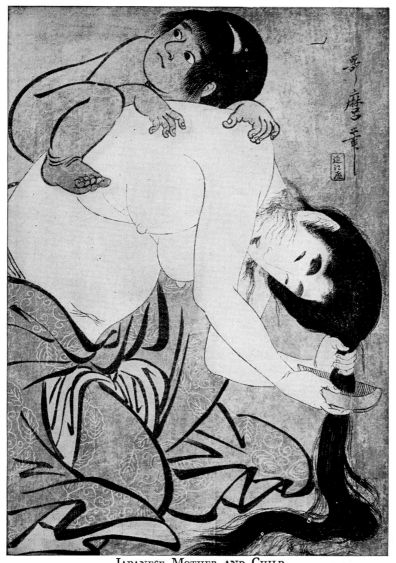

JAPANESE MOTHER AND CHILD
(*Courtesy of the Metropolitan Museum of Art.*)

285

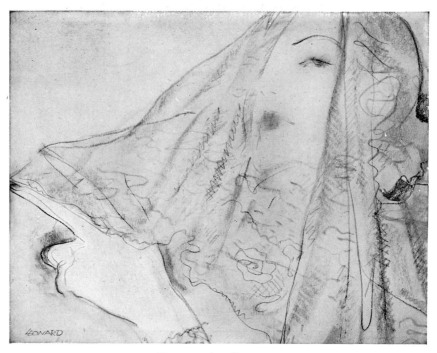

DRAWING BY LEONARD

Typical of his distinctive style is this drawing by Leonard, advertising artist
and designer, who is known through his work in various class publications such
as *Vogue* and *Harper's Bazaar*. The sophisticated whimsy of conception to-
gether with the sensitive line are fused in a style admirably fitted to the subject.

HIGH MINOR KEY

The high minor key has a delicate feminine
quality and is somewhat pensive.

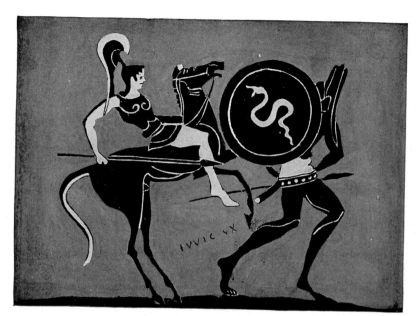

VASE PAINTING—GREEK

INTERMEDIATE MAJOR KEY

The intermediate major key as illustrated by the Greek vase painting, is posteresque, strong, rich, with a somewhat frank and masculine quality.

287

"Recessional" by Eugene Savage

The minor keys have been the ones most preferred by mural painters because these keys create a quiet, restful background for the life within a room. Architects, too, have favored them, for these subdued keys conform to the classic role of decoration that is subordinate to that of the building. They do not disturb the unity of a wall surface; neither do they blast holes in these planes that form the architectural design.

On the other hand, places of transient, turbulent activity, such as night clubs, demand the more stimulating major keys for their decorative panels. (*Courtesy of Grand Central Art Galleries, New York.*)

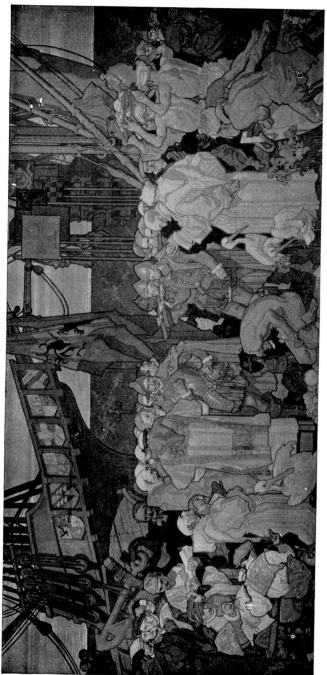

MURAL BY DEAN CORNWELL FOR THE LOS
ANGELES LIBRARY

INTERMEDIATE MINOR KEY

The subdued intermediate minor key suggests the timeless twilight of a dream world. It is often found in mural paintings where strong contrasts of tone and color would be inappropriate.

Mr. Cornwell states that he used for the lowest notes in this mural no paint darker than yellow ocher, or approximately No. 5 value. The original, therefore, is in a high minor key. Photography and engraving have transposed it into an intermediate minor key.

"Forest Girl" by Paul Landacre

(*Courtesy of American Artists Group, Inc.*)

Low Major Key

The portrait sketch by Maitland Graves on page 291 and the wood cut by Paul Landacre are good examples of this low major key.

PORTRAIT SKETCH BY MAITLAND GRAVES
(*Collection of National Arts Club.*)

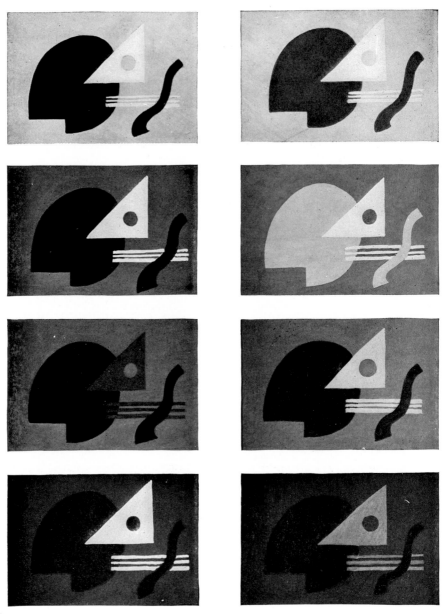

Transposition of a nonrepresentational design into different value keys. Also see pages 361, 369. (*Pratt student exercise 3, page 295.*)

292

QUESTIONS

1. What is the value key of a composition?
2. Why is the value key of a composition important?
3. How may the Value Key Chart be helpful in planning a composition?
4. What is meant by a major value interval?
5. What does a minor value interval mean?
6. If the dominant value or general tonality of a composition is quite dark, low in value, or about value 2, is the composition in a low key, intermediate, or high value key?
7. If the dominant value of a composition is approximately value 5, is the composition in a low, intermediate, or high value key?
8. If the largest areas of a composition are about value 8, is the composition in a low, intermediate, or high key?
9. If there is a minor or small value interval or weak contrast between the darkest and lightest values of a design, is the design in a minor or major value key?
10. If there is strong contrast between the extreme values of a composition, is the composition in a minor or major key?
11. In what value key is a design in which the dominant value or general tonality is quite dark or low in value and in which there is a minor interval or weak contrast between the darkest and lightest values?
12. In what value key is a composition in which the dominant value is about value 2 and in which the extreme values are about six steps apart? Name one example.
13. What is the key of a quiet, subdued design consisting chiefly of intermediate values? Name an example.
14. In what key is a design in which the largest areas are value 5 and in which there is strong value contrast? Name an example.
15. What is the key of a composition in which value 8 is dominant and in which there is a minor interval between the extreme values? Give one example.
16. In what value key is a composition which is mostly light or high in value and in which there is strong value contrast? Name an example.
17. What, to you, seem to be the characteristics of

 a. The high major key?
 b. The low minor key?
 c. The high minor key?
 d. The low major key?

293

e. The intermediate minor key?

f. The intermediate major key?

18. In European painting prior to the impressionists, which value key was most frequently used?

19. In contemporary interiors, which value key would you say is most generally employed?

20. Judging from the modern paintings that you have seen, would you say that the minor value keys or the major value keys are most characteristic of contemporary art?

21. What proportion of values did Sir Joshua Reynolds conclude was the best as a result of his analyses of Venetian and Dutch paintings?

22. What value key would this proportion produce?

23. What are the two principal ways of using darks and lights or values, and what are they called?

24. What does chiaroscuro mean?

25. What is notan, and how does it differ from chiaroscuro?

26. Who was one master of chiaroscuro or the naturalistic technique?

27. Where did notan or expressive and decorative pattern reach a high stage of development?

28. Name a master of notan.

29. Name one example of notan.

30. If a mural is to function as a quiet, restful, and decorative background, which would create the desired effect, a major or a minor value key?

31. If a mural is to be subordinate to the architectural design, which would function better, a mural in a major key or a mural in a minor key? Why?

32. In a decorative painting for a night club or bar, which would be the more appropriate, a major key or a minor key? Why?

33. Describe the mural or poster technique, explaining

a. Direction and kind of lighting with which the forms are illuminated.

b. The effect of this kind of lighting on

(1) Volume or mass.

(2) Two-dimensional surface pattern.

(3) Cast shadows.

c. The treatment or development of shapes.

d. Local values or the values of each part of the subject matter.

e. The modeling or shading of the subject matter.

294

EXERCISES

1. Find reproductions of paintings or designs that are good examples of
 a. Chiaroscuro or the naturalistic technique.
 b. Notan or flat, arbitrary pattern.
 c. Examples that combine both chiaroscuro and notan.
2. Find reproductions which, like those on the previous pages, illustrate the various value keys. If possible, mount these in your notebook and bring them to class for discussion.
3. Take the Greek vase painting on page 287 or some other simple design and transpose it into
 a. The high minor key.
 b. The low major key.
 c. The high major key.
 d. The low minor key.
 e. The intermediate minor key. (See student exercise 3 on page 292).

5. VALUE ORGANIZATION

In working out a composition you may, of course, experiment with numerous value combinations and evolve a more or less successful value plan by trial and error. Success depends upon much experience and practice. But if you have not had much experience and practice, how will you start? And even if you are experienced, is there not a more direct, rapid, and orderly approach to value organization that will ensure more consistent success? There is, and the following pages will explain it. First, however, we must decide what constitutes a satisfactory value plan.

A good value plan is a value combination that

1. Is appropriate for its purpose.
2. Possesses unity.
3. Has variety or interest.

The first requirement, suitability, has been discussed in the previous section on Value Keys. As it was stated, the choice of a value combination is determined by the character of the de-

sign and its function. Some designs are best expressed by a quiet, subdued minor key. For others the richer, more stimulating effect produced by a strongly contrasting major key is more appropriate.

But what of requisites 2 and 3, unity and interest? What exactly is meant by unified and interesting value combinations, and how are they planned? Compositions II and III, pages 299 and 307, will be used to illustrate what is meant by unified and interesting value combinations and to show how values are organized according to these basic principles of design.

VALUE RHYTHM

Rhythm means measured, proportioned intervals. *Value rhythm*, therefore, means measured, proportioned value intervals. The value rhythm consists of a series of planned value intervals or contrasts such as those illustrated on pages 298 and 306. These value intervals are designed to produce the results stated on the following pages.

THE VALUE CHORDS

I use the term *value chord* to specify a value combination in which the values and the intervals between the values, or the value rhythm, is planned according to the principles of design. This term is used to distinguish such an organized value relationship from a value combination in which the value rhythm is not so planned.

Each of the 30 value chords on pages 302 and 308 is a different variation of the basic value rhythm. Two of these value chords are illustrated on pages 298 and 306. Every one of these 30 value chords is so designed that the values and the value intervals will produce the results stated below.

Each value chord is composed of four values, A, D, W, Z. A is the lightest value, D the next lightest, W the next, and Z is

the darkest value. The pattern consists of A and D; the background consists of W and Z or vice versa. Since these letters will later be used in connection with color, initials have been chosen that will not be the same as the color initials such as B for blue, Y for yellow, etc.

Inasmuch as all 30 value chords are planned on the same principles, analysis of value chord 11 D, illustrated on page 298, will be sufficient to explain the reasons for the choice of the values that are used.

D VALUE CHORDS

The aim of composition is to create an interesting unit. Interest is the result of variety. Unity is created by dominance. The value chords, therefore, are organized to produce these two results which are created as follows:

1. *Interest.* Interest is created by the variety of value intervals. Equal intervals make a monotonous rhythm. Unequal intervals or a variety of intervals create an interesting rhythm. Therefore, the four values A, D, W, and Z are not equidistant, which makes the value intervals or value contrasts between them unequal. These four values are so planned that when they come into contact, in a composition, six different-sized intervals or value contrasts of various intensities, grading from small or weak to great or strong, will be produced. Six is the maximum number of intervals or the greatest possible variety of contrasts that can be obtained from four values.

The weakest value contrast in the D value chords is between W and Z. WZ is, therefore, the smallest or minor value interval. The strongest value contrast is between A and Z. AZ is, therefore, the major, greatest, or dominant value interval. The intermediate value intervals AD, DW, DZ, and AW complete the graduation from minor to major (page 298).

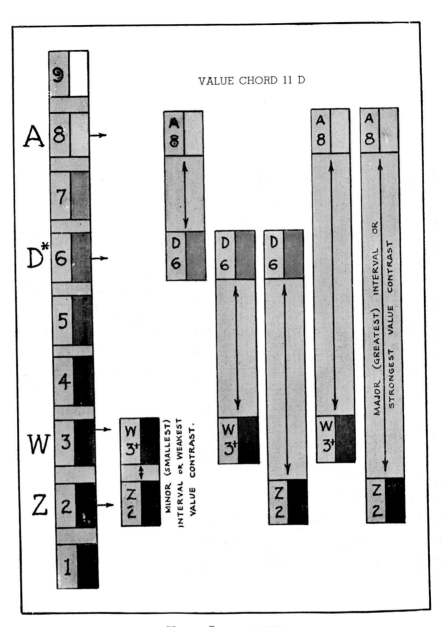

VALUE CHORD 11 D

This diagram illustrates the order of sizes of the six unequal value intervals that form a value rhythm or value chord 11 D. This value chord is used in Composition II on page 299.

COMPOSITION II

D^* or light pattern dominant in area against
the dark background W.

Plan of approximate value
areas or quantities.

299

Although the sizes of the six value intervals vary in each D value chord, the order of sizes of the intervals or the value rhythm does not change but is always as shown on page 298 in every D value chord. There are always six unequal value intervals, with AZ greatest or dominant.

In addition to interest, the value chords are designed to produce

2. *Unity*, which is created by a dominant pattern. The pattern is the picture. Unity is created when the pattern dominates. In order to assure a strong, coherent pattern, therefore, value interval or contrast DW is always greater or stronger than intervals AD and WZ in every value chord. This makes the contrast between the pattern and the background greater than the contrast between the pattern and the detail within the pattern. It allows the pattern to dominate and thus prevents a spotty, vague, and confused composition. The pattern and background are thereby made dominant and primary; the detail is subordinate and secondary. As a result, the first impression is one of strong, unified pattern against a quiet background. The statement is simple, clear, direct, and forceful.

THE PLAN OF VALUE AREAS OR QUANTITIES

The plan of value areas illustrated on page 299 is an essential part of value organization. In planning the values for a composition, it is just as important to plan the value areas or quantities as it is to plan the value intervals or rhythm. Successful value organization depends equally on both; each is a vital part of the complete plan. The plan of value areas, therefore, is also designed to produce interest and unity, which are created as follows:

1. *Interest*. This is created by making the values unequal in

300

area or quantity. Variety of size is interesting. In addition, the variety of major and minor contrasts of quantity or intervals of size between the small and large areas results in an interesting rhythm of size or measure that enhances a composition.

2. *Unity*. In any combination, unity is impossible unless there is a dominant. In any composition, therefore, unity necessitates that one value be dominant or largest in area. The dominant value partly determines the value key of the composition. This may be high, intermediate, or low. The emotional quality of a composition is modified considerably by its value key.

In Composition II, the value areas are so planned that the largest areas, which are the pattern and the background, consist chiefly of the two intermediate values D and W. But we could change the plan of value areas so that the largest areas, or the pattern and background, consist chiefly of the two extreme values A and Z. Upon trying this second value plan, however, we immediately see that the pattern becomes so sharply cut out against the background, so strong and insistent, that the composition looks like a bare dark-and-light silhouette. The design looks hard, stark, and blank because the contrast between the pattern and background is so extremely strong that it overwhelms and fades out the detail in the background as well as the detail within the pattern. Although this effect might be suitable for certain special purposes, it is too harsh and empty for general use.

But the plan of value areas on page 299, in which the pattern and background consist of the intermediate values D and W, produces a softer, richer, less glaring effect that is more desirable for most purposes. It is advisable, therefore, to use this plan of value areas with all the D value chords.

301

D VALUE CHORDS

for D or light pattern dominant in area against a dark background W (such as composition II)

Weak value contrast, minor or small value intervals — 4-value-step contrast between the extremes or the lightest and darkest values A and Z

	A	D	W	Z
1 D	A · 5	D * 3.7	W · 2	Z · 1
2 D	A · 6	D * 4.7	W · 3	Z · 2
3 D	A · 7	D * 5.7	W · 4	Z · 3
4 D	A · 8	D * 6.7	W · 5	Z · 4
5 D	A · 9	D * 7.7	W · 6	Z · 5

Moderate value contrast, medium value intervals — 5-value-step contrast between A and Z

	A	D	W	Z
6 D	A · 6	D * 4.4	W · 2+	Z · 1
7 D	A · 7	D * 5.4	W · 3+	Z · 2
8 D	A · 8	D * 6.4	W · 4+	Z · 3
9 D	A · 9	D * 7.4	W · 5+	Z · 4

Strong value contrast, major or great value intervals

6-value-step contrast between A and Z

	A	D	W	Z
10 D	A · 7	D * 5	W · 2+	Z · 1
11 D	A · 8	D * 6	W · 3+	Z · 2
12 D	A · 9	D * 7	W · 4+	Z · 3

7-value-step contrast between A and Z

	A	D	W	Z
13 D	A · 8	D * 5.5	W · 2.5	Z · 1
14 D	A · 9	D * 6.5	W · 3.5	Z · 2

8-value-step contrast between A and Z

	A	D	W	Z
15 D	A · 9	D * 6.3	W · 3	Z · 1

Note. + (Plus) means slightly lighter. For example, 2+ is approximately 2.2

MIXING PAINT FOR A VALUE CHORD

The values in the original value scale on page 298 are absolutely accurate. Nevertheless, because of the limitations of printing and photoengraving, this value scale may not be reproduced with absolute accuracy. In mixing gray paint for the values of a value chord, therefore, it might be better to mix the paint to match the accurately graded gray papers furnished by the Munsell Color Company, Inc., 10 East Franklin Street, Baltimore, Md., or the Allcolor Company, 527 Fifth Avenue, New York.

Do not be worried by the fractional values; close approximations can easily be made as follows. If, for example, value 3+ (approximately 3.2) is wanted, a value is mixed to match value 3 and then made slightly lighter. If value 5.5 is wanted, a value is mixed that is halfway between values 5 and 6. Value 5.7 is, of course, about halfway between values 5.5 and 6. Value 5.4 is very slightly darker than value 5.5. The other fractional values are approximated in the same way.

MIXING A D VALUE CHORD BY EYE

For a Light Pattern Against a Dark Background
Like That of Composition II

The Munsell gray papers, although very useful and convenient, are not absolutely necessary. You can make any D value chord you wish by mixing any grays by hand and comparing the intervals by eye. Proceed as follows:

1. Refer to the value scale on page 298, and select any one of the six values from 3 to 8 that you wish for D, the dominant value of the pattern. Mix a gray that approximately matches this value.

2. Select any darker gray that you wish for W, the back-

ground. Mix a gray that approximately matches this value.

3. Select A, the lightest value that you wish to have in your composition, remembering that interval AD should be a little smaller than interval DW. Mix a gray that approximates this value.

4. At this point a comparison between intervals AD and DW may be necessary, because the value scale might not be reproduced with absolute accuracy. Check by comparing the contrast between A and D with the contrast between D and W. If the contrast between A and D is not less than the contrast between D and W, make it so by making A darker.

5. Mix the darkest value Z so that the contrast between Z and W is a little less than the contrast between A and D.

W VALUE CHORDS

For W or Dark Pattern Dominant in Area Against
a Light Background D

The 15 W value chords on page 308 are for compositions in which a dark pattern is dominant in area against a light background such as that of Composition III on page 307. The W value chords are based on the same principles as the D value chords and possess the same attributes of good design.

Although the sizes of the six value intervals vary in each W value chord, the order of sizes of the intervals or the value rhythm does not change but is always as shown on page 306 in every W value chord. There are always six unequal value intervals, with AZ greatest or dominant.

In all the W value chords the plan of value areas or quantities on page 307 is used in which W is the largest value area.

This plan of value areas is best for most purposes because, for reasons already explained, it is generally preferable to have the largest area intermediate in value rather than extreme. However, the largest area could consist of Z, an extreme, if desired.

MIXING A W VALUE CHORD BY EYE

For a Dark Pattern Against a Light Background
Like Composition III

The W value chords may be mixed either by comparison with the Munsell gray papers or by eye, as follows:

1. Select any one of the six values from 2 to 7 that you wish for W, the dominant value of the pattern. Match it approximately.

2. Choose any lighter gray that you wish for D, the background. Match it approximately.

3. Select Z, the darkest value that you wish to have in your composition, remembering that interval WZ should be a little smaller than DW. Match this value approximately.

4. Check by comparing the contrast between W and Z with the contrast between D and W. If the contrast between W and Z is not less than the contrast between D and W, make it so by making Z lighter.

5. Mix the lightest value A so that the contrast between A and D is a little less than the contrast between W and Z.

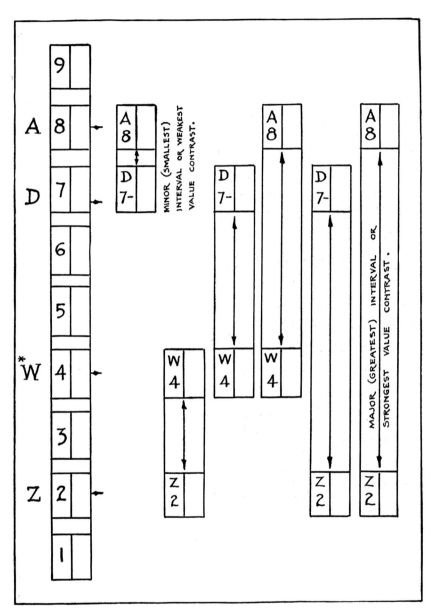

VALUE CHORD 11 W

This diagram illustrates the order of sizes of the six unequal value intervals that form a value rhythm or value chord 11 W. This value chord is used in Composition III on page 307.

| A |
| Z |
| D |
| * W |

Plan of approximate value
areas or quantities.

COMPOSITION III

* W or dark pattern dominant in area
against the light background D.

307

W VALUE CHORDS

for W or dark pattern dominant in area against a light background D
(such as composition III)

	Weak value contrast, minor or small value intervals					Moderate value contrast, medium value intervals				Strong value contrast, major or great value intervals					
	4-value-step contrast between the extremes or the lightest and darkest values A and Z					5-value-step contrast between A and Z				6-value-step contrast between A and Z			7-value-step contrast between A and Z		8-value-step contrast between A and Z
	1 W	2 W	3 W	4 W	5 W	6 W	7 W	8 W	9 W	10 W	11 W	12 W	13 W	14 W	15 W
A	A · 5	A · 6	A · 7	A · 8	A · 9	A · 6	A · 7	A · 8	A · 9	A · 7	A · 8	A · 9	A · 8	A · 9	A · 9
D	D · 4	D · 5	D · 6	D · 7	D · 8	D · 5—	D · 6—	D · 7—	D · 8—	D · 6—	D · 7—	D · 8—	D : 6.5	D : 7.5	D : 7
W	W * 2.3	W * 3.3	W * 4.3	W * 5.3	W * 6.3	W * 2.6	W * 3.6	W * 4.6	W * 5.6	W * 3	W * 4	W * 5	W * 3.5	W * 4.5	W * 3.7
Z	Z · 1	Z · 2	Z · 3	Z · 4	Z · 5	Z · 1	Z · 2	Z · 3	Z · 4	Z · 1	Z · 2	Z · 3	Z · 1	Z · 2	Z · 1

Note. — (Minus) means slightly darker. For example, 5— is approximately 4.8

The purpose of the two charts on pages 302 and 308 is to offer you a choice of 30 value chords that are planned according to the basic principles of design. These charts will help you find easily and rapidly the value chord you want. But you must first decide the effect you wish to create. The choice of a value chord is determined by the character of the design and the purpose for which it is intended. Character and function, therefore, decide the questions that may be considered in the following order.

1. Do you want a light pattern against a dark background, such as that of Composition II, or a dark pattern against a light background, such as that of Composition III? Let us assume that you want a light pattern. In that case, the Chart of D Value Chords will be used.

2. Do you wish
 a. The weak value contrast produced by value chords 1 D to 5 D? or
 b. The moderate contrast of value chords 6 D to 9 D? or
 c. The strong contrast of value chords 10 D to 15 D?

3. If you decide on weak value contrast, you have a choice of the five value chords 1 D to 5 D. Although each of these value chords has weak contrast, the effect produced by each is different, ranging from 1 D, which encompasses the lower or darker half of the value scale, with value 3.7 as the largest area, to 5 D, which spans the upper or lighter half, with value 7.7 as the largest area. After a little practice you will become familiar with the distinctive character of each value chord and will know in advance the effect each will produce. In the meantime, the various effects can be seen and studied as follows.

309

In a sheet of cardboard cut or punch four sets of holes corresponding to the positions of A, D, W, and Z in value chords 1 D, 6 D, 10 D, and 13 D. Paint the cardboard with value 5 or middle gray. By laying this perforated mask on the value scale and shifting it up and down, any one of the D value chords may be isolated and studied. By turning the mask upside down, any one of the W value chords may be framed and considered.

Modeling or Shading. In modeling or shading subject matter and detail, slightly lighter and darker values than A, D, W, and Z may also be used. If these values are kept close to A, D, W, and Z, the composition will not become spotty or confused. Neither will the value chord be disturbed, since the average values of the areas will be as shown in the value chord. The subject of modeling introduces the question of which value chords are most flexible.

The Most Flexible Value Chords. The 12 value chords 2 D, 3 D, 4 D, 7 D, 8 D, 11 D and 2 W, 3 W, 4 W, 7 W, 8 W, 11 W are the most flexible because they permit greater freedom or scope for modeling than do the other value chords. This is because the first-mentioned value chords do not include value 1 (black) or value 9 (white), which leaves sufficient reserve with which to model darker in the Z areas and lighter in the A areas.

The other value chords are a little more restrictive, either because Z is value 1 (black), as in value chord 1 D, or because A is value 9 (white), as in value chord 5 D. In value chord 1 D, therefore, it is impossible to model darker in the Z areas, and in value chord 5 D it is not possible to model lighter in the A areas. In short, value chords such as these are less flexible because there is no reserve at either one end or the other with which to model. Nevertheless, these value chords are included so that you may have entire freedom to choose any value chord that exists in the complete value scale.

COMPOSITION VII, ASTRONOMICAL ELEMENTS

COMPOSITION I, VIGNETTE

COMPOSITION VI, GRECIAN
ELEMENTS

311

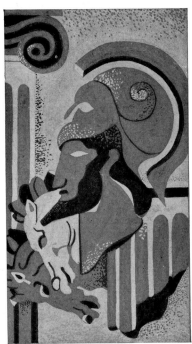

Experimental Value Patterns. (*Pratt student exercise* 1, *page* 316.)

Experimental Value Patterns. (*Pratt student exercise 2, page* 316.)

Composition II is a simple exercise in value pattern. The following procedure shows how it was evolved.

1. The first step is illustrated by Composition I on page 311. On a sheet of transparent tracing paper is drawn a group of harmoniously associated objects: apples, pears, grapes, grape leaves and vine tendrils, a wine bottle, and wineglasses. These provide an interesting variety of straight and curved lines. The objects are drawn as directly as possible in simple line, the drawings being superimposed or overlapped.

2. This vignette is enclosed within a rectangular boundary or frame. A circular, oval, or irregular pear-shaped frame may be used if desired.

3. Several tracings of the drawing are made on dark-gray charcoal paper.

4. Various experimental or trial value patterns, like that in Composition II, are then made. Only four values are used at first. The trial patterns are done in white, light-gray, dark-gray, and black chalks or pastels. These chalks permit quick, direct work and also make changes and erasures quite easy. The light-gray pattern D is first massed in against the dark-gray background W. This pattern is, at first, an empty light-gray silhouette. The shapes within the pattern are afterwards developed with the lightest value A. The shapes in the background are done with the darkest value Z.

5. The best trial pattern is chosen, one of the D value chords selected, and the final composition done in tempera or oil.

6. The contrast of crisp, sharp, hard edges opposed to softly graded edges contributes greatly to the interest of a com-

position. The Neenah design on page 104 is an excellent example of this important design factor. If a composition is done in oil, edges are easily softened by blending. If tempera is used, edges may be graded by stippling with a short, stiff bristle brush; or an air-brush may be used.

7. Variety of textures, smooth, rough, mat, and glossy, may also be utilized to heighten interest. Rough textures can be built up with the fast-drying Japan coach color. Tempera naturally dries flat or nonglossy. Oil colors may be made to dry with a mat surface by first squeezing the paint on blotting paper and working out the excess oil with a palette knife. The paint is then mixed with turpentine. Glossy surfaces or textures are produced with shellac or retouching varnish.

In planning a composition consisting of a dark pattern against a light background, such as that of Composition III, the procedure is similar to the foregoing, except that the drawing is traced on light-gray charcoal paper.

Compositions I, II, and III are not intended to illustrate a quick and easy short cut or recipe for design. They are merely simple exercises in value pattern.

Compositions II and III suggest the many possibilities for effective pattern produced by treating overlapping or superimposed objects as transparent forms. Some of the interesting contours and shapes that result are filled in alternately like an irregular checkerboard. This was a favorite device of some of the cubist painters, such as Picasso and Juan Gris.[3] Much can be learned from a study of the paintings of that great pattern-maker Georges Braque. Study, too, the patterns of McKnight-Kauffer's superb posters.

[3] Many of these irregular "checkerboard" or cubist designs may be found in *You Can Design* by Reiss and Schweizer, published by McGraw-Hill.

315

QUESTIONS

1. What are the three requisites of a good value plan?
2. What is value rhythm?
3. What is a value chord?
4. The value chords are organized to produce what two results?
5. How does a value chord produce interest?
6. Why are equidistant values not used in the value chords?
7. How does a value chord create unity?
8. Why is value interval or contrast DW always made greater than AD and WZ?
9. On which two design principles are the plans of value areas based?
10. How is interest created by the plans of value areas?
11. How do the plans of value areas create unity?
12. Why is it generally more desirable to have the largest value areas, that is, the pattern and background, consist of the intermediate values D and W rather than the extreme values A and Z?
13. How are grays mixed that will be approximately value 3.2? Value 5.5? Value 5.7? Value 5.4? Value 4.3?
14. How is a D value chord mixed by eye?
15. How is a W value chord mixed by eye?
16. What is the purpose of the two charts showing the 30 value chords?
17. What two considerations determine the choice of a value chord?
18. How may a value chord be isolated for study?
19. Why are value chords that include either value 1 or value 9 less flexible than value chords that do not include black or white?
20. What is the procedure in planning a value pattern for a composition consisting of a light pattern against a dark background?
21. How do you intend to treat the edges in your compositions? Why?

EXERCISES

1. Trace Composition VI, "Grecian Elements," on light-gray charcoal paper. Make several experimental patterns; select the best one and do it, using value chord 3 W. See student exercise 1, p. 312.
2. Trace Composition VII, "Astronomical Elements," on dark-gray charcoal paper. Make several trial patterns; select the best one and do it, using value chord 2 D. See exercise 2, p. 313.
3. Draw in line seven vignettes like Composition 1 on page 311, using
 a. Steer skull, sombrero, cactus, and lariat.
 b. Sheet music, musical instruments such as violins and horns.
 c. Fish and vegetables.

316

d. Palette, paintbrushes, and paint tubes.

e. Chessmen.

f. High-magnification microscope, test tubes, and slides of bacteria cultures.

g. The zodiac.

h. Drawing instruments, such as a slide rule, compass, triangles, T square, and French curves.

i. Playing cards.

j. African Negro masks and sculpture.

4. Enclose these vignettes within rectangular, oval, circular, or irregular pear-shaped boundaries and execute them in the value chord you think is most appropriate to the subject. Proceed as suggested in Planning a Value Pattern on page 314. Remember that gradation of value and a variety of contrasting hard and soft edges will make your compositions more interesting. You might also experiment with smooth, rough, mat, and glossy textures.

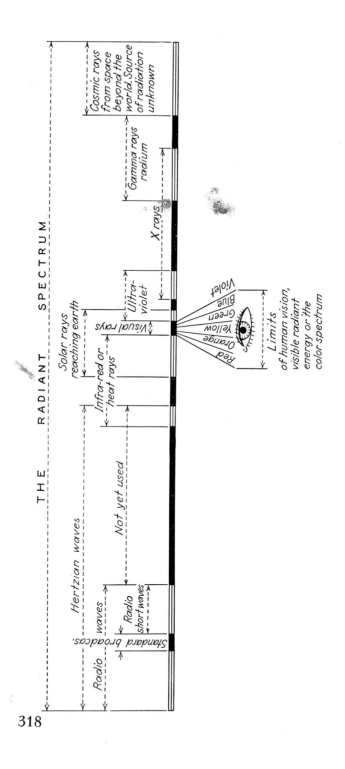

THE RADIANT SPECTRUM

Cosmic rays from space beyond the world. Source of radiation unknown

Gamma rays radium

X rays

Ultra-violet

Solar rays reaching earth

Visual rays

Infra-red or heat rays

Red
Orange
Yellow
Green
Blue
Violet

Limits of human vision, visible radiant energy or the color spectrum

Hertzian waves

Not yet used

Radio waves

Radio short waves

Standard broadcast

Radio

318

CHAPTER XII

Color

1. THE NATURE OF COLOR: THE SPECTRUM

Color, like sound, is a vibratory phenomenon. Each color is like a musical note. Red,[1] at one end of the spectrum, has the lowest frequency (number of vibrations per second) and the longest wave length. It is analogous to a deep sound of low pitch. The frequency increases in passing through the spectrum. Violet,[2] at the other end, has the highest frequency and the shortest wave length. Violet corresponds to a shrill note of high pitch. Beyond the ends of the spectrum are the invisible "colors," infrared and ultraviolet. Like extremely low- or high-frequency sound waves, which are inaudible to us (but which a dog can hear), infrared and ultraviolet are also beyond the threshold of the human sensory range; their presence can be detected only by means of special instruments.

Color or light is only one of the forms of radiant energy and is only a very small section of the electromagnetic spectrum. Beyond the infrared are the longer Hertzian rays and radio

[1] This is 2R on the hue circuit on page 350.
[2] This is PB-P on the hue circuit.

waves. At the other end of the electromagnetic spectrum are rays shorter than those of color. Beyond the ultraviolet are the shorter X rays and beyond them, the still shorter gamma rays. At the extreme end are the mysterious cosmic rays.

Sir James Jeans, in his book *Through Time and Space*, says,

Just as different colours of light are produced by light waves of different lengths, so sounds of different pitch are produced by sound waves of different lengths. For instance, middle C on the piano has a wave length of four feet, while treble C has a wave length of two feet. When one sound has just half the wave length of another, we say it is an octave higher in pitch. In the same way when one colour of light has just half the wave length of another, we may say by analogy that it is an octave higher in pitch. Thus, as violet light has just half the wave length of red light, we may say that violet light is an octave higher in pitch than red light. Indeed, we shall not go far wrong if we think of the seven colours of the spectrum as the seven notes of a scale, red being C, orange D, yellow E, green F, and so on. We have already seen that all the visible spectrum lies within one octave. Our ears can hear eleven octaves of sound, but our eyes can see only one octave of light.

White is a balanced mixture of all wave lengths of the visible spectrum.

Gray is the same as white, but the amplitude is less. Black is an absence of light.

WARM AND COOL COLOR

Artists have long referred to yellow, orange, and red as warm colors and blue-green, blue, and violet as cool colors. Few of them are aware that this is literally true, as may be demonstrated by placing a thermopile (a very sensitive thermometer) in different parts of the spectrum. The red end is always warmer, the blue end cooler. Green and red-purple are between the warm and cool halves of the spectrum and are relatively neither warm nor cold. The purples and red-purples do not exist in the solar spectrum but are made by mixing the extremes, red and violet.

320

2. CAUSES OF COLOR SENSATION

Physiological

Color, like sound, is subjective; its existence depends upon the sensory apparatus of humans and animals. It is the name given to a sensation produced by excitation of the eye by visible radiant energy or light of a particular wave length. Without the eye, color, properly speaking, would not exist. Some persons are like the dog[3] and the bull[4] that are totally color-blind; some, like the bee, perceive only yellow and blue.

Sensation of color may, however, be produced by means other than light stimulus, just as sensation of sweetness may be produced by the two chemically different stimuli, sugar and saccharin. Drugs, pressure on the eye, and electricity also produce color sensation. Another kind of color sensation that we all have experienced is called the *afterimage*. This can be produced by staring intently at a brilliant color for a minute. Then, when the eyes are closed, the complement of the color will be seen. For example, an intense red will induce an afterimage of green.

PIGMENT

The color of a painted object is the result of the chemical or molecular character of the pigment or dye. A pigment absorbs light of certain wave lengths and reflects light of all other wave lengths. Thus, in the case of an absolutely pure-red pigment, all the colors except red are absorbed. The red is filtered out of the white light and reflected to the eye. Pigments of absolutely pure color are rare. Most pigmentary colors are composed of a mixture of different wave lengths. The dominant wave length determines the color.

[3] According to the Yerkes-Watson discrimination apparatus for testing color blindness in animals.

[4] Contrary to popular belief, the bull is not enraged by red but charges any moving object regardless of its color.

If a white or gray pigment is illuminated by a colored light, it will reflect and appear to be the color of the light. It would, for example, appear red in a red light. But if we place a brilliant green pigment in the red light, it would appear black, since green completely absorbs red light.

It has been demonstrated that a bright blue seen in the light of a kerosene lamp matches a brown seen in daylight; and white illuminated by the lamp appears the same color as dark orange seen in daylight. One type of sweet pea also exhibits a striking hue change. This flower, which is purple blue-purple in daylight, appears red-purple in electric light—a change of approximately 15 hue steps. The light in which a painting is seen is, therefore, all-important, since it will change not only its color but also its value key. For this reason, paintings should be executed, whenever possible, in the same light in which they will be exhibited.

IRIDESCENCE

Color may be created by mechanical means other than pigment. Color may be seen where no pigment is present, as in soap bubbles, oil films on water, sea shells, ceramic glazes, bird feathers, crystals, and gas. The opalescent color of these things is the result of the structure of the reflecting surface, which causes refraction or diffraction of the light rays.

COLOR STIMULUS VERSUS COLOR SENSATION

Light, or the color stimulus, is the cause; color sensation is the effect. Cause and effect are, obviously, distinctly different; they should not be confused. Light, the stimulus or cause of color sensation, can be measured precisely by photometer and spectrophotometer. Measurement of the effect or color sensa-

tion, however, must be psychological—in terms of what we see, not in terms of wave-length stimulus. Specification of wave length expresses no more the sensation of color than does the chemical formula $C_{12}H_{22}O_{11}$ (sugar) convey the taste sensation of sweetness.

For example, No. 5 or middle gray appears to the eye to be half as brilliant as white or twice as brilliant as black. This gray seems to reflect about 50 per cent of the light. Actually, however, according to precise photometric measurement, it reflects only 18 per cent of the light.

Conversion of spectrophotometric tristimulus data into the psychological terms of hue, value, and chroma, which are specified according to the Munsell notation, has been made by Hardy, Glenn, and Killian in the Color Measurements Laboratory of the Massachusetts Institute of Technology and by the Colorimetry Section of the National Bureau of Standards at Washington, D.C. This important work is being coordinated by the Colorimetry Committee of the Optical Society of America.

QUESTIONS

1. What "invisible colors" are beyond the threshold of the human sensory range?
2. What is white light?
3. What is black?
4. What are the warm hues?
5. Which hues are cool?
6. What hue is not in the spectrum?
7. What is the usual cause of color sensation?
8. Can a sensation of color be caused by means other than the stimulus by light of a particular wave length?
9. What is one other cause of color sensation?
10. What is the afterimage?
11. Why does red pigment or paint appear red?
12. Does white paper look white in a red light? What color does it appear to be? Why?

13. What would brilliant green paint look like in a red light? Why?
14. Why should a painting be done in the same kind of light in which it will be exhibited?
15. Color may be produced by what mechanical means other than pigment?
16. Where may iridescent color be seen?

3. COLOR NOTATION

Centuries ago people said, "Unless musical sounds be retained in the memory, they perish, for they cannot be written." But the seemingly impossible was accomplished, and by 1700 a complete system of musical notation had been perfected that made it possible to write scales, key, pitch, intensity, measured interval, and duration. Without this system, musicians would be severely handicapped, symphonic composition utterly impossible; and we would know the great musical geniuses of the past only by hearsay. It is significant that the world's greatest music has been composed since the perfection of a system of musical notation.

Until recently the composer of color was in the same predicament as the medieval minstrel. In the matter of notation, the painter has lagged centuries behind the musician.[5] Although earlier and somewhat similar attempts had been made by others, it was not until 1912 that Albert H. Munsell, of Boston, Mass., perfected a satisfactory system of color notation and terminology. Today the colorist may avail himself of the advantages and freedom that this system offers and that have long been denied him.

This system fulfills a long-felt need, as in the past our color vocabulary has been vague and poor. All languages have been weak in this respect. The languages of some primitive peoples

[5] In this respect dancers have been even slower than painters. It is only lately that a practical method of dance notation has been developed by Rudolph von Laban.

324

contained no color names; many others had no name for blue and green. In the Bible, although there are over four hundred references to the sky or heaven, the color blue is not named. The same is true of the early Hindu writings. Such names as mustard yellow, Nile green, mouse gray, peacock blue, and baby blue may serve the purposes of the casual layman, but they are inadequate for the professional. Imagine the chagrin of a composer attempting to cope with musical notes called "siren," "baby whimper," "mouse," or "nightingale."

The Munsell system, described in the following pages, is a scale precisely defining color qualities and their measured intervals. This scale makes possible the rational discussion of color, and the planning and notation of color schemes.

The Munsell system is basic and practical. It is used and recommended by the U.S. Department of Agriculture, the Encyclopaedia Britannica, the International Printing Ink Corporation, the Lakeside Press, *Fortune* magazine, the Walt Disney Productions, and also by many artists, decorators, architects, and industrial designers. In this country the Munsell notation of color is rapidly becoming standard.[6]

If we would intelligently relate colors, we must consider all their qualities or dimensions. It is not sufficient to describe a color as dark red or light green. Such a description, as Munsell says, is equivalent to a map of Switzerland with the mountains left out. It is like describing a box by saying that it is 2 feet wide and 9 feet long. The box has still another dimension, depth, which, if not specified, might be imagined to be anything from 1 inch to 30 or more feet. Like the box, color also has three

[6] Charts and color cabinets containing 362 different colored papers arranged according to the Munsell system may be obtained from the Allcolor Company, New York. The Munsell "Book of Color," charts, colored papers, and colorimetric equipment are supplied by the Munsell Color Company, Inc., Baltimore, Md.

qualities, attributes, or dimensions. These three dimensions are hue, value, and chroma. Before color can be rationally organized, these three color dimensions must be thoroughly comprehended.

<div align="center">HUE</div>

Hue is the quality or characteristic by which we distinguish one color from another, a red from a yellow or a green from a purple. Hue specifies the position of a color on the following hue circuit. The hue circuit illustrates the position of 20 equidistant hues. Reading clockwise, the five principal hues are red, yellow, green, blue, and purple. Halfway between these are the five intermediate hues, yellow-red, green-yellow, blue-green, purple-blue, and red-purple. Where more precise defini-

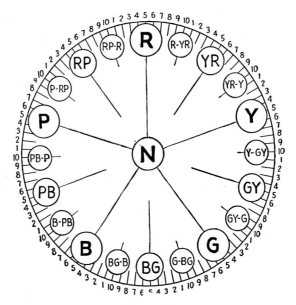

<div align="center">FIGURE 1</div>

Diagram showing the 5 principal hues, the 5 intermediate hues, the 10 second intermediate hues, and the 80 special intermediate hues (indicated by the numerals, 1, 2, 3, 4, and 6, 7, 8, 9), in the 100-hue circuit. (*Courtesy of the Munsell Color Company.*)

326

tion is necessary, color is designated by means of the 10 second intermediate hues red-yellow red, yellow red-yellow, yellow-green yellow, etc., which are placed halfway between the principal hues and the intermediate hues. The 80 special intermediate hues, indicated by the numerals 1, 2, 3, 4, 6, 7, 8, 9, are for very precise color specification. In notating a color, its hue is indicated by the initial letter or letters of the color; R for red, YR for yellow-red, etc.

Adjacent hues are similar or harmonious, such as blue-green, green, and green-yellow. The "Portrait of a Young Man" by van Gogh[7] illustrates exactly the use of this particular triad of harmonious hues.

Hues opposite or nearly opposite on the hue circuit, such as red and blue-green or green, are contrasting hues. In van Gogh's "La Berceuse"[7] these contrasting hues of strong chroma form the color scheme. The hue key or dominant hue of the painting is green.

Therefore, hues that are closest together on the hue circuit are most similar or harmonious; the closer they are, the more alike they are. Hues that are farthest apart on the hue circuit are most different or contrasting; the greater the distance, the greater the contrast. For example, complementary hues such as red and blue-green or yellow and purple-blue, which are diametrically opposite on the hue circuit, are most radically different and represent a maximum hue interval or contrast.

VALUE

Value is the degree of luminosity of a color. It is, for example, the quality that differentiates a dark red from a light red. In the diagram are 10 visually equidistant values or neutrals,

[7] Small, inexpensive color prints of both these paintings may be obtained from Raymond and Raymond, New York.

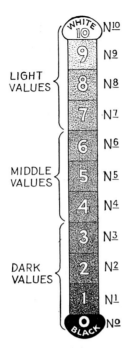

FIGURE 2

Diagram of the value scale. Note on the left the indication of the three zones, light, middle, and dark, and on the right the notation of neutral at the various levels of value. (*Courtesy of the Munsell Color Company.*)

from black to white. The intervals between these 10 principal value steps may also be divided into 10 equidistant value steps, which are specified decimally as 1.1, 1.2, 1.3, etc. A value halfway between value 1 and value 2 would, for example, be designated as value 1.5.

Any pure gray is called a neutral and is designated by N. Its degree of brightness or luminosity and its position in the value scale are indicated by a numeral set above a line to its right, such as N 2/, N 3/, etc. N 0/ is a perfect black that reflects absolutely no light. A perfect black is a hole in a box lined with black velvet. However, any surface painted with the purest black paint obtainable will reflect a certain amount of light. The usual black, therefore, is value 1 and is notated as N 1/. A perfect white would reflect all the light it receives, but a perfect white is practically unobtainable. Our most perfect

328

white is magnesium oxide, which is 9.8 in value. The usual white paint is value 9 and is notated at N 9/. Therefore, for all practical purposes, our luminosity scale consists of nine value steps as illustrated on page 328.

The value of any color is determined by comparing it with the grays of the value scale, which will indicate how light or dark the particular color is. For example, a red as dark as N 2/ would be specified by placing its value above a line to the right of the hue, thus, R 2/. A lighter red would be notated as R 3/, a still lighter red as R 4/, etc. The value of a color, therefore, specifies its position on the value scale, that is, whether the color is dark, light, or intermediate.

Colors are more alike or harmonious when their values are adjacent or similar, such as value 3 and value 4, or when their values are the same.

Colors are more contrasting when their values are widely separated or contrasting, such as value 3 and value 8.

CHROMA

"Two colors may be the same in Hue (for instance, both Red) and the same in Value (that is, neither is lighter or darker than the other), and yet be different in color strength. One may be a strong Red and the other a weak, grayish Red. The difference is in the dimension of Chroma, by which the degree of color strength (intensity) is measured and indicated."[8]

Hue is the name of a color. Value is the brightness or luminosity of a color. *Chroma* is the strength, intensity, or purity of a color.

A step of chroma is the unit of measure of change in a hue between neutral gray and the maximum intensity of the hue.

[8] F. G. Cooper in the Munsell "Manual of Color."

As shown in Figs. 3 and 4, these steps are numbered outward from the neutral-gray axis to the strongest obtainable chroma of any hue at the various value levels. Although Fig. 3, for the

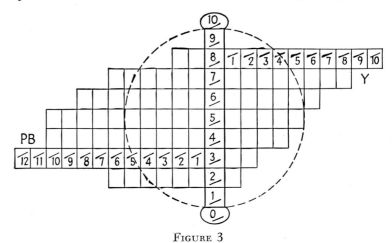

FIGURE 3

Diagram showing characteristic chromas extending beyond the surface of the color sphere, the yellow reaching its strongest chroma at the eighth level of value, while its opposite, purple-blue, reaches its strongest chroma at value 3.

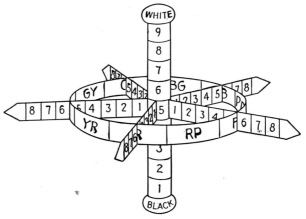

FIGURE 4

Diagram showing hue, value, and chroma in their relation to one another. The circular band represents the hues in their proper sequence. The upright center axis is the scale of value. The paths pointing outward from the center show the steps of chroma, increasing in strength as indicated by the numerals. (*Courtesy of the Munsell Color Company.*)

330

sake of clarity, shows the relationship of hue, value, and chroma only at value 5, the same relationship exists at all value levels from 2 to 8, as suggested by Fig. 3.

Colors are not shown at value levels 1 and 9 because the values of the darkest colors are lighter than black (value 1), and the values of the lightest colors are darker than white (value 9).

The chroma of any color is specified by a number placed under the value number of the color. For example, a red halfway between black and white in value and eight steps out in chroma would be written R 5/8.

Any color, therefore, may be precisely described and its relation to any other color stated thus:

$$\text{Hue} \frac{\text{Value}}{\text{Chroma}}$$

A light grayish green, for example, would be written G 8/1. This would mean

$$\text{G (Hue)} \frac{8 \text{ (Value)}}{1 \text{ (Chroma)}}$$

Thus G 8/1 and G 5/1 would indicate that these two colors had the same hue and chroma but that their values were different, whereas G 5/4 and G 5/1 would mean two colors of the same hue and value but of different chromas. Y 3/2 and P 3/2 indicate different hues but identical value and chroma.

Some hues extend farther from the center and have more steps of chroma than other hues. This is due to the nature of pigment. The chroma of the purest red pigment, for example, is stronger than the chroma of the purest green pigment available at present. Then, too, pigments by their nature are strong in chroma at certain values and weak at others. For example, the maximum chroma of yellow is stronger at value 8 than at

value 3. On the other hand, the purest purple-blue is low in value, and its maximum chroma is, therefore, stronger at value 3 than it is at value 8, as shown in Fig. 3. The value level at which the strongest possible chroma of a particular hue is reached is called its "home" value level. As was explained, this level varies with different hues (see Table of Maximum Chromas on page 342).

Hues are more similar or harmonious when their chromas are weak or moderate, such as chroma 4.

Hues are more different or contrasting when their chromas are strong, such as chroma 10.

Similarity and difference of chroma affect color relationships as much as do similarity and difference of hue and value. When hue and value differences are constant, colors whose chromas are similar or close together, such as chromas 4 and 6, are more alike than colors whose chromas are contrasting or far apart, such as chromas 2 and 8. For example, G 7/4 and R 5/6 are more alike, similar, or harmonious than G 7/2 and R 5/8.

THE COLOR SOLID

The color sphere illustrated, together with Fig. 4, helps us to visualize the simple, orderly arrangement of all colors, in which hue, value, and chroma are separately identified and yet comprehended together. The color sphere does not contain all colors compressed into a perfectly spherical solid but merely symbolizes the basic concept of the three-dimensional nature of colors and the relationship between colors.

The real shape of the color solid is more irregular than a sphere. The actual shape is that of a tree with many closely packed horizontal branches of different lengths. The vertical trunk of the color tree corresponds to the vertical value-scale

332

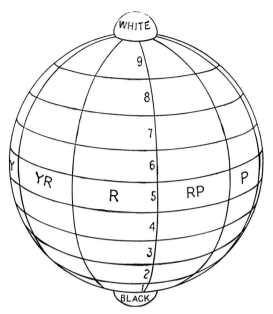

FIGURE 5. THE COLOR SPHERE

The hues are placed in sequence around the neutral axis. The axis and all
the hues surrounding it are all of the same value (lightness or darkness) at
any given level, increasingly lighter to white at the top and increasingly
darker to black at the bottom. From neutral gray at the center axis the hues
increase in color strength or intensity (chroma) as the distance outward from
the axis is increased. (*Courtesy of the Munsell Color Company.*)

axis of the sphere. Each horizontal branch is a series of colors
that have the same hue and value but that increase in chroma
as the distance from the neutral gray trunk becomes greater.
Any two branches at the same height consist of colors of the
same value but of different hues. A horizontal cross section cut
through the color solid would be like an irregularly shaped
wheel with many long and short spokes placed equidistantly
around the hub. Figure 3 illustrates a vertical cross section
bisecting the color solid.

A color tree may be built by fastening semicircular Lucite
or celluloid disks vertically around an upright cylindrical pipe
set in a wooden base. The Munsell color chips are then pasted

on the disks. The disks may be cut with L-shaped pieces projecting from the inside or straight edges by means of which the disks are hooked into equidistant vertical slots cut in the pipe. A simpler color tree may also be made by inserting the Munsell Student Charts vertically in deep, equidistant, radial slits cut in a circular wooden base.

This system of color notation, together with the charts, enables us to think clearly and to plan color schemes in accordance with the principles on the following pages. They make it possible to plan innumerable color combinations that would not occur to us if we fussed about aimlessly on the palette. Left to himself, the artist sometimes falls into a narrow rut and forms restricted color habits. By the haphazard process of fiddling about he evolves certain color formulas that he has a tendency to repeat. The charts and the color organization—explained on the following pages—should enable him considerably to extend his color range.

COLOR CHARTS AND THE COLOR CABINET

I have devised a color chart that contains the hue, value, and chroma plans illustrated on the following pages. Color chords are easily and rapidly planned with it, and the color chords are then selected from a color cabinet containing indexed Munsell colors. This color cabinet is to the artist what the piano is to the musician; it enables the artist to select quickly and accurately any color chord he desires.

A color cabinet may be made inexpensively with the Munsell student-set color chips. Each color chip may be pasted vertically on the projecting tab of an index card and its notation written alongside it. These color cards may then be arranged in sequence and inserted in a small filing cabinet or box, as will be explained. Color cabinets are also supplied by the All-

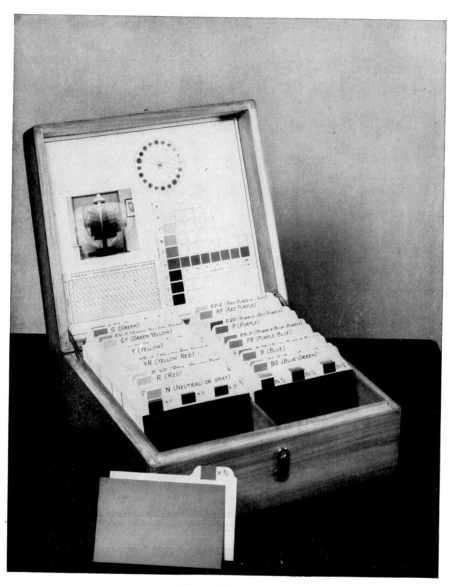

Color Cabinet

335

color Company, New York. The Allcolor cabinet may be supplemented with second intermediate colors obtainable from the Munsell Color Company, Baltimore, Md.

There are several great advantages in using the color plans on the following pages and selecting the color chords from a color cabinet.

First, these plans considerably expand the artist's color range by offering him a choice of hundreds of unusual and interesting color chords that could be created in no other way.

In addition, the color cabinet saves the time and labor wasted in mixing paint. Several different color chords can be taken from the cabinet, compared, and a selection made in far less time than it takes to mix the colors by hand. Freed from this needless manual labor, the artist has the time and the energy to make a more thorough study of his color problem and its various possible solutions.

Saving of time and effort is a very practical advantage, but more important to the artist is that this saving of time and effort means that his sensitivity to color relationships will not be blunted by boredom and fatigue. In order to understand why, we must consider what happens when the color cabinet is not used. In that case, many colors must be mixed slowly one at a time before several different color combinations can be assembled and compared. This tends to dull sensitivity to color relationships, because, after each color has been thus isolated and concentrated upon separately, it becomes difficult to sense the total effect produced when the colors are combined. Also, the tedious process of mixing many colors tires the eye and makes color comparison still more difficult. Judgment of sound relationships would likewise tend to be dulled for similar reasons if the strings of a guitar had to be tuned before each

336

chord could be struck. Therefore, in addition to the time and effort saved, the use of a color cabinet helps the artist to a truer color judgment because he is made aware of a color combination as a color relationship or total effect and not piecemeal as a collection of separate colors. Looking at the color combination with a fresh eye, he thus sees it more naturally and can sense its immediate impact.

Add to these advantages the fact that the color chords can be written in terms of Munsell notation. This notation is a more permanent, imperishable record than color samples that may fade. Like sheet music, these notated color chords can be conveniently and compactly filed for future reference and, when needed, be quickly and accurately reproduced. They may also be transmitted by telephone, cable, or radiogram.

The color chords may also be specified in terms of their printing-ink numbers. On the back of each Allcolor sheet is its I.P.I. ink number in addition to its Munsell color notation. This is very helpful to advertising men and printers, since specification of the ink numbers ensures accurate color reproduction in the printed product. For example, the I.P.I. ink numbers of the colors in Composition IX on page 364 are A(305 + 355) D(347) and W(421) Z(7).

A color cabinet is very helpful, rapid, and convenient but not absolutely necessary. Even without it you can create color chords such as the two illustrated on pages 351 and 365. After a color chord is planned, the colors may be mixed by hand and the intervals compared by eye. One of the small Munsell Student Charts shows all the principal and intermediate hues, all the values, and all the even steps of chroma of red at value 4. When mixing a color, you will find this chart a great help in determining its hue, value, and chroma.

MATERIALS

Munsell Student Color Set. The set contains a color manual, 11 charts, and 253 Munsell color chips.

Cards (a). Get 255 three-by-five index separator cards or guides with tabs not less than 1½ inches wide. White cards are preferable. If you cannot get white cards, get the light cream or buff cards.

Advantages. (1) Cards are stiff and substantial. (2) They come already cut and ready to use.

Disadvantages. (1) These cards are expensive. They cost about ten times as much as the ordinary thin, white tabless index cards. (2) As these cards are thicker than the other cards, they take up more space and require a deeper and somewhat more expensive cabinet. (3) White separator cards, which are preferable, are difficult to obtain.

Cards (b). Get 255 three-by-five ordinary, thin, white, index cards which may be cut as shown.

Use 170 of these if the cards are not ruled on the back (85 in this position and 85 with the color tab on the right, or this card reversed).

If the cards are ruled on the back, reverse this card and trace it on the white sides of 85 cards.

Use 85 of these cards.

338

Advantages. (1) These cards are inexpensive. (2) These cards are thin and fit into a shallower cabinet, which is less expensive. (3) White cards are standard and easy to obtain.

Disadvantages. (1) The cards are not as stiff and substantial as the other cards. (2) The tabs must be cut by hand, which requires time and work.

Cabinet. (a) Three-by-five cabinet 5½ inches deep if the thick cards are used. See a. (The cabinet may be cardboard, wood, or metal.) (b) Three-by-five cabinet 3 inches deep if the ordinary, thin, white index cards are used. See b.

PROCEDURE

Arrange the cards in the cabinet in the following order: first card on left, second in the middle, third on the right, then fourth on the left, fifth in the middle, sixth on the right, etc.

Take the envelope marked HVC and dump the colors on the Hue $\frac{\text{Value}}{\text{Chroma}}$ Chart.

Select the neutrals or grays and place them on their proper squares on the vertical value scale at the left of the chart. The color chips may more easily be moved about and placed in position by sliding or pushing them with the rubber at the end of a pencil.

Replace all the other color chips in the envelope.

Take nine index cards from the front of the cabinet and on the *right* half of the tab write, in black waterproof ink, N 1/, N 2/, N 3/, etc., to N 9/.

Paste the N 1/ chip on the N 1/ card. Paste the chip on the left half of the tab flush with the top edge. This is so that colors may touch for comparison in planning a color scheme. Put cement on both the card and the chip for permanent attachment. Handling the chip with tweezers and applying the cement with a small, stiff brush makes the job both easier and cleaner. Place the card in the front of the color cabinet.

Paste the N 2/ chip on the N 2/ card, and place this card behind the N 1/ card in the color cabinet.

Repeat with the other neutrals.

Take the envelope marked R and pour the red color chips on any color chart. Arrange the colors according to the directions printed on the bottom of the chart.

After the colors are arranged, compare the red color chart with the black diagram of the red chart (marked R-32) to see if the arangement is correct.

Colors will be more quickly and easily found in your color cabinet if all index guides of the same chroma are always in the same row (see page 339). Thus, a color of chroma /2, /8, or /14 is always found in the left row. A color of chroma /4, /10, or /16 is always found in the middle row. A color of chroma /6 or /12 is always found in the right row.

Take 32 cards and, referring to the chart for the maximum chromas at each value level, write R 2/2, R 2/4, R 2/6; then R 3/2, R 3/4, etc. After each card is notated, replace it in the cabinet.

After the 32 red cards are notated, paste the R 2/2 color chip on the R 2/2 card and replace the card in the cabinet following N 9/.

Paste the R 2/4 color chip on the R 2/4 card and replace this card in the cabinet following R 2/2.

Repeat as above with all the other red color chips and cards.

When all the red cards are done, repeat as before with the YR color chips.

When all the YR color chips are done, follow with Y, GY, G, BG, B, etc.

Take the envelope marked HVC and dump the colors on the Hue $\frac{\text{Value}}{\text{Chroma}}$ Chart.

Paste the colors on the Hue Circuit and the Chroma Scale.

With tempera, match the nine neutrals or grays in the color cabinet and paint them on the Value Scale.

Paste this HVC Chart and a Table of Maximum Chromas on the inside of the cabinet lid as a guide to help you decide the hue, value, and chroma of any color which you may wish to select from the cabinet.

The color cabinet is now complete. If desired, the large 3-by-5 Munsell or Allcolor sheets may be inserted later.

SUMMARY OF MATERIALS

Munsell Student Color Set.
255 3-by-5 index card separators or index cards with tabs cut by yourself.
3-by-5 index card cabinet, 5½ inches deep.
Black waterproof ink.
Pen.
Pencil with an eraser attached to its end.
Rubber cement.
Small, stiff brush.
Tweezers.

A photographic contact printing frame makes a convenient holder for a color scheme that has been selected from the color cabinet. The color cards are inserted under the glass of the frame which serves as a palette and also keeps the colors clean when paints are being mixed to match. The frame has a snap-spring back quick and easy insertion of the colors.

TABLE OF MAXIMUM CHROMAS

The choice of any color combination, whether or not it is organized according to the following color plans, is naturally limited by the maximum or strongest possible chromas that are available in the desired hues. What these maximum chromas are is shown by the Table of Maximum Chromas on page 342. Suppose we wish to know the strongest possible red obtainable at value 2. Referring to the table, we find this to be chroma 6. (This R 2/6 cannot be made stronger in chroma by the addition of pure brilliant red because its value would be thus raised and it would no longer be value 2.) If we want to know the strongest possible blue of value 8, we discover this to be chroma 6. And so on with other colors.

TABLE OF MAXIMUM CHROMAS

This table shows the strongest chroma attained by each hue at each value level.

VALUE	R	R-YR	YR	YR-Y	Y	Y-GY	GY	GY-G	G	G-BG	BG	BG-B	B	B-PB	PB	PB-P	P	P-RP	RP	RP-R
8	8/	8/6	8/4	8/8	8/12	8/10	8/8	8/6	8/6	8/6	8/2	8/4	8/2	8/6	8/2	8/4	8/2	8/6	8/4	8/6
7	7/	7/8	7/8	7/12	7/10	7/16	7/8	7/14	7/8	7/6	7/4	7/6	7/4	7/8	7/6	7/6	7/6	7/8	7/10	7/8
6	6/	6/12	6/12	6/14	6/10	6/12	6/6	6/12	6/12	6/8	6/8	6/6	6/8	6/6	6/10	6/8	6/12	6/8	6/16	6/10
5	5/	5/14	5/10	5/10	5/8	5/6	5/6	5/10	5/8	5/8	5/8	5/8	5/8	5/6	5/12	5/10	5/12	5/10	5/16	5/10
4	4/	4/14	4/10	4/8	4/4	4/4	4/4	4/6	4/6	4/6	4/4	4/6	4/6	4/10	4/8	4/12	4/12	4/10	4/12	4/10
3	3/	3/10	3/6	3/6	3/2	3/4	3/2	3/4	3/4	3/6	3/4	3/6	3/6	3/8	3/12	3/12	3/10	3/10	3/10	3/10
2	2/	2/6	2/2	2/2	2/2	2/2	2/2	2/2	2/2	2/2	2/2	2/4	2/2	2/2	2/2	2/6	2/6	2/6	2/6	2/6

Note. The Allcolor Cabinet does not contain all the second intermediate colors, red-yellow red, yellow red-yellow, etc., which are supplied by the Munsell Color Comapny. In the above table, therefore, the chromas of all the second intermediate hues except R-YR 6/12, Y-GY 8/10, GY-G 6/12, G-BG 6/8, and 5/8, BG-B 5/8, PB-P 4/12 and 3/12 are the maximum chromas of these hues as furnished by the Munsell Color Company.

The chromas of the principal and intermediate hues, red, yellow-red, yellow, green-yellow, etc., are the maximum chromas of these hues in the Allcolor Cabinet. Some of these hues are supplied in stronger chromas by the Allcolor Company than by the Munsell Company. For example, blue-green is supplied as strong as chroma 4 at value 8 by the Allcolor Company but only as strong as chroma 2 at value 8 by the Munsell Company. This accounts for such seeming inconsistencies as that the maximum chroma of green-blue green is only chroma 2 at value 8, whereas the maximum chroma of green is chroma 6, and the maximum chroma of blue-green is chroma 4.

Briefly, each color in the above table is the maximum chroma in a complete chroma sequence of constant hue and value that is obtainable in either Munsell or Allcolor papers.

342

QUESTIONS

1. What is the purpose of the Munsell System of Color Notation?
2. What are its advantages?
3. What are the three qualities, attributes, or dimensions of a color?
4. Define hue.
5. How is the hue of a color designated or notated?
6. Describe the hue circuit.
7. Name the five principal and the five intermediate hues in order, starting with red and proceeding clockwise around the hue circuit.
8. What are complementary hues? Name an example.
9. Are adjacent hues more alike, similar, or harmonious than complementary hues?
10. Are BG 5/4 and GY 5/4 more or less contrasting than BG 5/4 and R 5/4? Why?
11. What is a maximum hue interval or contrast? Give an example.
12. Define value.
13. Describe the value scale.
14. How is a pure gray written, designated, or notated?
15. Define black.
16. What is white?
17. How may the value of a color be determined?
18. How is the value of a color written or notated?
19. Which are more similar or harmonious, N 8/ and N 7/ or N 8/ and N 5/?
20. Are R 8/4 and R 7/4 more or less contrasting than R 8/4 and R 3/4? Why?
21. Which are more contrasting, R 8/4 and BG 7/4 or R 8/4 and BG 3/4? Why?
22. Define chroma.
23. How is the chroma of a color written or notated?
24. Why are there no colors at value levels 1 and 9?
25. What is the "home" value level of a hue?
26. Which are more similar or harmonious, R 5/2 and R 5/4 or R 5/2 and R 5/10? Why?
27. Which are more contrasting, G 7/4 and R 5/6 or G 7/2 and R 5/8? Why?
28. Describe the color solid.
29. What purpose does the color solid serve?

EXERCISES

Described below are nine paths through the color solid. These paths are circular, vertical, horizontal, diagonal, and spiral movements through color space. They are color scales. These scales may be painted or made with Munsell or Allcolor papers. Making these scales should give one a thorough understanding of color dimensions and color relationships.

1. A circular, clockwise path in a horizontal plane or cross section of the color solid. This is a gradation of hue with constant value and chroma, such as R 5/6, YR 5/6, Y 5/6, GY 5/6, G 5/6, BG 5/6, B 5/6, PB 5/6, P 5/6, RP 5/6. This path is illustrated by Fig. 1 and Fig. 4. Arrange the color scale in a circle, as illustrated.

2. An ascending, vertical path through a vertical plane or cross section cut through the center of the color solid. This is a gradation of value with constant hue and chroma, such as PB 2/2, PB 3/2, PB 4/2, PB 5/2, PB 6/2, PB 7/2, PB 8/2. Plot or trace this path on Fig. 3 and arrange the colors in that way.

3. A straight, horizontal path starting from the neutral center axis outward. This is a gradation of chroma with constant hue and value such as PB 5/1, PB 5/2, PB 5/4, PB 5/6, PB 5/8, PB 5/10. This path is illustrated in both Figs. 3 and 4. Arrange the colors accordingly.

4. An ascending, diagonal path in a vertical plane or cross section bisecting the color solid. This path starts near the bottom of the neutral center axis and proceeds obliquely upward and outward. It is a gradation of both value and chroma with constant hue, such as Y 2/1, Y 3/2, Y 4/3, Y 5/4, Y 6/5, Y 7/6, Y 8/7. Plot or trace this diagonal path on Fig. 3 and arrange the colors accordingly.

5. A flat, clockwise, spiral path in a horizontal plane or cross section of the color solid. The path starts at the center or neutral axis, winds around it in a clockwise direction, and gradually recedes outward. It is a gradation of both hue and chroma with constant value, such as R 5/1, YR 5/2, Y 5/3, GY 5/4, G 5/5, BG 5/6, B 5/7, PB 5/8, P 5/9, RP 5/10, R 5/11. Another spiral gradation is G 5/2, BG 5/4, B 5/6, PB 5/8, P 5/10, RP 5/12, R 5/14. Plot these spiral paths on Fig. 1 and arrange the colors accordingly.

6. A helical path or a segment of an ascending, clockwise, cylindrical spiral. This color scale is a spiral movement partly around a vertical cylinder or core whose center is the axis of the color solid. It is a gradation of both hue and value with constant chroma, such as R 2/4, YR 3/4, Y 4/4, GY 5/4, G 6/4, BG 7/4, B 8/4. Arranging these colors clockwise in a flat semicircular arc will illustrate the

top view of this helical path. But a better and more interesting illustration can be made by actually building this three-dimensional path or helix. This may easily be done in any of the six following ways.

a. Cut out the flat color arc described above. With it make a semicircular ramp by pasting the red end to the edge of a circular cardboard base and lifting the blue end and attaching it to the top of a vertical piece of cardboard fastened to the opposite edge of the base, or

b. Wind this color arc a little more than halfway around a cylinder from bottom to top like a clockwise spiral ramp or staircase around a lighthouse. It can then be fastened to the cylinder by tabs projecting from the inside edge of the arc. The entire color scale will be visible from any position if it is mounted on a celluloid or glass cylinder, a clear bottle, or a drinking glass.

c. Paste or paint the colors on a straight strip of paper. Wrap the strip partly around and paste flat against the cylinder. If a transparent cylinder is used, paint the colors on both sides of the strip.

d. Paint or paste the colors on a sheet of paper or celluloid diagonally from the lower right corner to the center of the top edge. Roll the sheet into a cylinder and fasten the edges together.

e. This color helix may be painted or pasted directly on a cylinder. The positions of the colors may be plotted from the intersections of ten equidistant vertical lines and seven equidistant circles drawn on the cylinder.

f. The helical path, color scale, or gradation may also be represented by a three-dimensional or perspective drawing.

7. An ascending, clockwise, conical spiral path through the color solid. This path or scale combines the movements of paths 5 and 6. It is a gradation of all three color dimensions, hue, value, and chroma, such as B 2/1, PB 3/2, P 4/4, RP 5/6, R 6/8, YR 7/10, and Y 8/12. Arranging these colors clockwise in a flat spiral that can be plotted on Fig. 1 will show how this inverted conical, spiral path looks from the top. But this path will be more clear and interesting if actually built as follows:

a. Cut out the flat color spiral described above. With it make a spiral ramp by pasting the blue end to the center of a circular cardboard base and lifting the yellow end, which is then attached to the top of a vertical support fastened to the edge of the base, or

b. Wind this color spiral a little more than halfway around a cone

so that it forms a spiral ramp from base to apex. It can be pasted to the cone by tabs projecting from the inside edge of the spiral. Conical paper drinking cups or an ordinary kitchen funnel make adequate cones. If a glass funnel is used, the entire color spiral will be visible from any position.

 c. Paste or paint the colors on a flat paper arc. Wrap this arc partly around and paste flat against the cone. If a transparent cone is used, paint the colors on both sides of the paper arc.

 d. Cut a semicircular disk from paper or celluloid. On it paint or paste the color gradation in the form of an arc. Roll the sheet into a cone and fasten the edges together.

 e. The color spiral may also be painted or pasted directly on a cone. The positions of the colors may be plotted approximately from the intersections of 10 equidistant lines radiating from the apex of the cone and 7 equidistant horizontal circles.

 f. This spiral path, gradation, or scale may also be illustrated by a three-dimensional or perspective drawing in color.

8. A straight horizontal path completely piercing the color solid. This path starts inward from one surface, passes through the neutral axis, and emerges on the opposite side. It is a gradation of chroma between two complementary hues of constant value, such as Y 6/6, Y 6/4, Y 6/2, Y 6/1, N 6/, PB 6/1, PB 6/2, PB 6/4, PB 6/6, PB 6/8. This horizontal path is shown on Fig. 3. Arrange the colors accordingly.

9. An ascending diagonal path completely piercing the color solid. This path starts from the bottom surface, proceeds obliquely inward and upward, passing through the center of the neutral axis, and emerges on the opposite side or top surface. It is a gradation of value and chroma between two complementary hues, such as PB 2/6, PB 3/4, PB 4/2, N 5/, Y 6/2, Y 7/4, Y 8/6. This oblique patch may be plotted on Fig. 3, and the colors arranged that way.

4. COLOR ORGANIZATION

The previous chapters have helped us to a better understanding of the nature of color and explained a simple and logical system of color notation. These chapters are important and necessary because intelligent control of color is not possible unless we first comprehend the tridimensional nature of

color. Now, therefore, we are prepared to apply this knowledge practically to color organization.

Two important questions have tremendously interested artists for centuries. The search for the solution has been to artists as fascinating as the medieval alchemists' quest for the philosophers' stone. In 1349 a group of Florentine artists formed a society for the study of these questions and the mathematics of composition.

These two questions are

1. What is a good color scheme?
2. What are the principles of color organization that will help one to plan a good color scheme?

In the answer to the first question is hidden the secret to the solution of the second. Let us first define a good color scheme.

A good color scheme is any color combination that

1. Pleases the artist.
2. Is appropriate for its purpose.
3. Possesses unity.
4. Has variety or interest.

The first requirement must be entirely a personal decision. It is a matter of taste . . . and regarding taste there is no disputing. There is no one color combination that will please all persons. Some detest any color scheme that includes strong orange or violet. Others like both these colors. To some persons certain colors, like certain flavors, although pleasant separately, are unpleasant when combined . . . like chocolate ice cream on roast beef. The same is true of sound. To some, certain modern compositions are music; to others, noise. Whether one color combination is more pleasing to him than

another, the artist and no one but the artist can decide. The responsibility for decision 1 is, therefore, squarely up to the artist; only his taste and experience can help him to a sensitive selection, a fine discrimination.

Attribute 2, or whether the color scheme fits its purpose, can be decided either emotionally or practically and rationally. If it is for a poster, billboard, or magazine advertisement, complementary or strongly contrasting hues of strong chroma and a major value key will be a practical choice. If the color scheme is for a young girl's bedroom, the delicate high minor key with light pastel colors of weak or moderate chroma might be appropriate. If, in an illustration, the color combination is intended to express the sinister, the weird, the somber low minor key or the explosive low major, with strong metallic greens, yellow-browns, and cold, steely grays, might suggest this mood.

Keenly sensitive to color and aware of its possibilities as a powerful instrument of emotional expression, van Gogh wrote to his brother Theo:

> In my picture of the "Night Café" I have tried to express the idea that the café is a place where one can ruin one's self, run mad, or commit a crime. So I have tried to express as it were the powers of darkness in a low drink shop, by soft Louis XV green and malachite, contrasting with yellow green and hard blue greens, and all this in an atmosphere like a devil's furnace, of pale sulphur.

Suppose, then, we have tentatively picked two similar color combinations, both of which please us and fit our purpose. Which shall we choose? If we knew which possessed the more unity and interest (the other attributes of all good color combinations) we could decide with more confidence. But what, exactly, is meant by unified and interesting color schemes, and on what color principles are they based? Compositions

348

VIII and IX, pages 350 and 364, will be used to illustrate what is meant by unified and interesting color combinations and to demonstrate the principles of color organization on which they were planned.

You may happen to dislike strong colors in general and particularly dislike the strong colors in Composition VIII. These colors were chosen only to illustrate the planning of a color combination consisting of strongly contrasting hues and values. However, color will here be considered impersonally and discussion limited to a rational analysis of color organization.

COLOR RHYTHM

Rhythm means measured, proportioned intervals. *Color rhythm*, therefore, means measured, proportioned color intervals. The color rhythm illustrated on page 351 is the logical extension of the value rhythm on page 298. Both are based on the same principles and are organized to produce the same results, unity and interest. The color rhythm consists of a series of planned color intervals or contrasts such as those illustrated on pages 351 and 365. These color intervals are designed to produce the results stated on the following pages. The color chords illustrated on pages 351 and 365 are two of the hundreds of variations of the basic color rhythm.

THE COLOR CHORDS

I use the term *color chord* to specify a color combination in which the colors and the intervals between the colors, or the color rhythm, are planned according to the principles of design. This term is used to distinguish such an organized color relationship from a color combination in which the color rhythm is not so planned. The color chords are designed so

349

D COLOR CHORD FOR COMPOSITION VIII

D or light pattern dominant in area against a dark background W

PLAN OF COLOR AREAS

Z PB 2/6	
A Y 8/8	
W B-PB 3½/6	
D* GY 6½/2	

HUE PLAN VII D

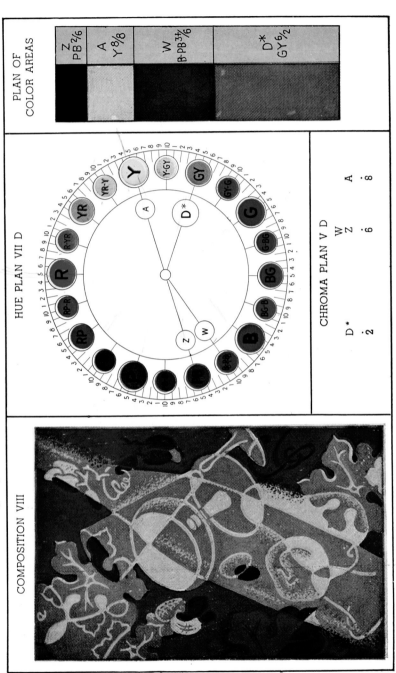

CHROMA PLAN V D

	W		
	Z	A	
	.6	.8	
D*			
.2			

COMPOSITION VIII

350

D COLOR CHORD FOR COMPOSITION VIII

The hue, value, and chroma plans when combined produce the total color intervals or contrasts. This diagram illustrates the order of sizes of the six un-equal color intervals that form the D color chord for Composition VIII.

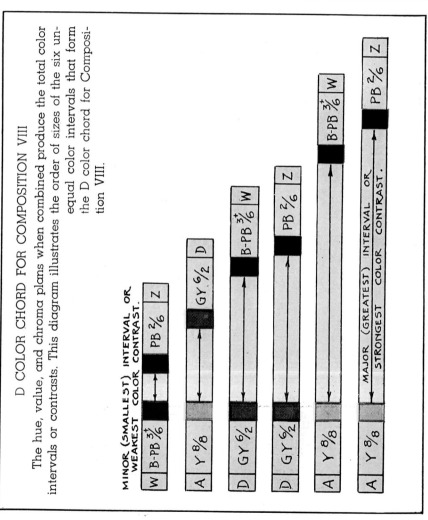

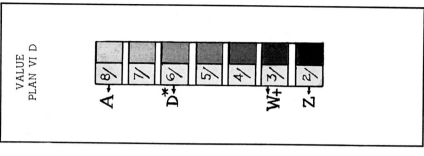

VALUE
PLAN VI D

351

that the colors and the color intervals will produce the results stated below. The color chords are made by combining the value, chroma, and hue plans in various ways.

The Value, Chroma, and Hue Plans

The value, chroma, and hue plans illustrated on pages 355, 356, and 358 can be combined in hundreds of different ways, as will be shown. Each different combination produces a different D color chord. The value, chroma, and hue plans are organized so that every one of these hundreds of D color chords will be a variation of the basic color rhythm. This means that every D color chord will possess all the following attributes of good design.

1. Unity, which is created by

 a. Dominant pattern. As was explained on page 300, a strong, coherent pattern is assured when the other intervals or contrasts are greater or stronger than AD and WZ.

 b. Dominant interval. One color interval is greatest, that is, the color contrast AZ is strongest or dominant.

 c. Dominant color. One color area is largest or dominant.

2. Interest, which is created by

 a. Variety of hue.

 b. Variety of value.

 c. Variety of chroma.

 d. Variety of color intervals.

Equal intervals make a monotonous rhythm. Unequal intervals or a variety of intervals create an interesting rhythm. The color rhythm, therefore, is planned to create the greatest

352

possible variety, or six unequal color intervals or contrasts, grading from small and weak to great and strong, with one interval, AZ, greatest or dominant. Six unequal color intervals is the maximum or greatest possible number of unequal color intervals that can be obtained from four colors. Although the sizes of these intervals will vary in each D color chord, depending upon which D hue, value, and chroma plans are used, the order of sizes of the intervals or the color rhythm will not vary, but will always be as illustrated on page 351 in every D color chord. There will always be six unequal color intervals, with AZ greatest or dominant.

THE PLAN OF COLOR QUANTITIES OR AREAS

The plan of color areas of Composition VIII is similar to the plan of value areas of Composition II on page 299. Both plans are based on the same principles and are designed to produce the same results explained on page 300 which are briefly:

1. Unity by dominance of area or quantity.
2. Interest by variety of contrast between areas of different sizes.
3. Color balance that is produced by making the largest color area of weak or moderate chroma balanced by smaller color areas of stronger chroma.

The hue of largest area determines the hue key of the design, which may be either warm, temperate, or cool (see the description of van Gogh's "La Berceuse," page 327, and the analysis of the color scheme of the living room by Allan Walton on page 395).

The following pages will show how hundreds of color chords can be planned. Every one of these hundreds of color chords

will be a perfect color combination, because each one will possess all the foregoing attributes of good design. However, you alone can decide which of the color chords please you most and which best suit your purpose.

Although these color chords are designed primarily for paintings, posters, murals, and illustrations, they can also be used for other purposes, such as industrial design, interior decoration, architectural exteriors, textiles, or ceramics. One hundred of these color chords are shown in a book now being prepared by the author.

By combining the following value, chroma, and hue plans in various ways, you can create many variations of the color rhythm on page 351. By proceeding as follows, you will be able to plan more than a thousand different color chords.

SUBSTITUTING VALUE PLANS

In the color chord for Composition VIII on page 351, value plan VI D is used. Any one of the other five D value plans shown on page 355 can be substituted for value plan VI D. Combining each of these D value plans with the hue plan VII D and the chroma plan V D will produce five new color chords. Each color chord will be a variation of the basic color rhythm. For example, substituting value plan II D produces A(Y 7/8) *D(GY 6 — /2) W(B-PB 4/6) Z(PB 3/6).

In all D color chords the plan of color quantities on page 350 is used in which *D is the largest color area. For most purposes this plan of color areas is best because it is usually more satisfactory to have the largest color area consist of D, which is always intermediate in hue and value and weak or moderate in chroma. However, if desired, the largest color area could be made A, which is always extreme in hue and value and strongest in chroma.

354

D VALUE PLANS

for D or light pattern dominant in area against a dark background W

Weak value contrast, minor or small value intervals			Moderate value contrast, medium value intervals		Strong value contrast, major or great value intervals
I D	II D	III D	IV D	V D	VI D
·	·	A · 8	A · 8	·	A · 8
·	A · 7	D 7—	·	A · 7	·
A · 6	D * 6—	·	D * 6.5	·	D * 6
D * 5—	·	W · 5	·	D * 5.5	·
·	W · 4	Z · 4	W · 4 +	·	·
W · 3	Z · 3	·	Z · 3	W · 3 +	W · 3 +
Z · 2	·	·	·	Z · 2	Z · 2

NOTE. — (Minus) means slightly darker. For example, 5 — is approximately 4.8. + (Plus) means slightly lighter. For example, 3 + is approximately 3.2.

SUBSTITUTING CHROMA PLANS

Chroma plan V D is used in the color chord for Composition VIII, although one of the other D chroma plans on page 356 could have been used. Combining some of these D chroma plans with the D value plans and hue plan VII D will produce more than thirty new color chords. For example, combining chroma plan IV D and value plan I D with hue plan VII D produces A(Y 6/6) *D(GY 5 — /2) W(B-PB 3/4) Z(PB 2/4). This color chord is distinctly different from the color chord of Composition VIII. It is quieter, more subdued, because it consists of

D CHROMA PLANS

for D or light pattern dominant in area against a dark background W

Weak contrast of chroma and hue

I D

D	
W	
Z	A
1	2

II D

	W	
D	Z	A
1	2	4

III D

D	
W	
Z	A
2	4

Moderate contrast of chroma and hue

IV D

		W	
D	D	Z	A
1	or 2	4	6

V D

			W	
D	D	D	Z	A
1	or 2	or 4	6	8

Strong contrast of chroma and hue

VI D

				W	
D	D	D	D	Z	A
1	or 2	or 4	or 6	8	10

VII D

					W	
D	D	D	D	D	Z	A
1	or 2	or 4	or 6	or 8	10	12

VIII D

						W	
D	D	D	D	D	D	Z	A
1	or 2	or 4	or 6	or 8	or 10	12	14

356

weaker value contrast, that is, minor or small value intervals in addition to weaker contrast of chroma and hue.[9]

ROTATING THE HUE PLAN

So far, the variations of the color rhythm have been made by various alterations of two of its three dimensions, that is, its chroma and value plans. The color rhythm can be altered in still another or third way, that is, by altering its other dimension or its hue plan as follows. Rotate hue plan VII D on page 350 around the hue circuit while maintaining exactly the same intervals between the hues. For example, one of the 19 hue combinations (produced by rotating hue plan VII D halfway around the circuit) would be A(PB) D(P) W(YR-Y) Z(Y). This is the position of hue plan VII D illustrated on page 358. Combining each one of these 19 hue combinations with the D value and chroma plans will produce at least 100 new and distinctly different color chords. One of these color chords resulting from combining one of the 19 hue combinations with value plan I D and chroma plan IV D is A(BG 6/6) *D(B 5 — /2) W(RP-R 3/4) Z(R 2/4).

SUBSTITUTING HUE PLANS

All the previous color chords were created by combining hue plan VII D with the D value and chroma plans. Any of the D hue plans on page 358 can be substituted for hue plan VII D and combined with any D value and chroma plan.

Each of these hue plans can be rotated around the hue circuit,

[9] The D chroma plans on page 356 and the W chroma plans on page 367 show only chromas 1, 2, 4, 6, 8, 10, 12, 14. That is, with the exception of chroma 1, all the chromas are even numbers. This is because these chroma plans are designed for use with Munsell and Allcolor papers, which are supplied only in the even-numbered chroma steps in addition to chroma 1. This, however, is not a disadvantage inasmuch as even-numbered chroma steps are sufficiently close for most purposes.

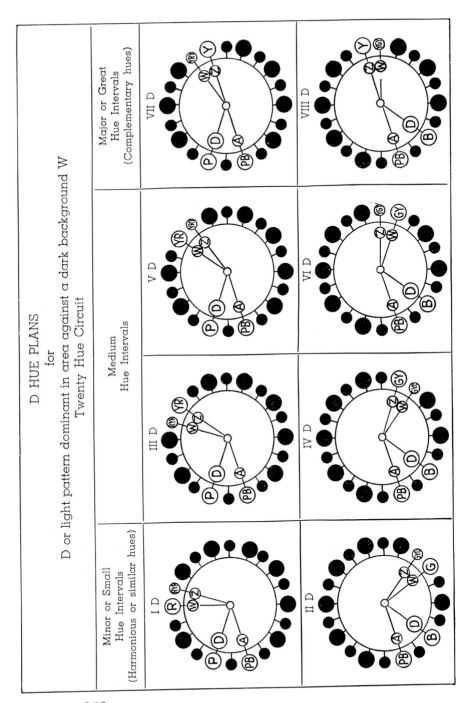

D HUE PLANS
for
D or light pattern dominant in area against a dark background W
Twenty Hue Circuit

Minor or Small Hue Intervals (Harmonious or similar hues)

Medium Hue Intervals

Major or Great Hue Intervals (Complementary hues)

I D

II D

III D

IV D

V D

VI D

VII D

VIII D

and each will produce 20 different hue combinations. Since there are 8 hue plans, there will be 160 different D hue combinations. One of these hue combinations, produced by rotating hue plan II D, is A(G) *D(GY) W(YR) Z(R-YR).

Combining these 160 D hue combinations with the D value and chroma plans produces a choice of more than 500 D color chords.

The wide scope offered by these color plans is illustrated by the fact that if we wished to use the foregoing hue combination, we would have a choice of at least six distinctively different color chords, each one being a variation of the foregoing hue combination. One of these, made by uniting value plan I D and chroma plan III D, is A(G 6/4) *D(GY 5 — /2) W(YR 3/2) Z(R-YR 2/2). Another variation produced by a union of value plan III D with chroma plan IV D is A(G 8/6) *D(GY 7 — /2) W(YR 5/4) Z(R-YR 4/4). Similar variations are, of course, also possible with any of the other hue combinations.

Note that hue plan I D proceeds clockwise around the hue circuit from A to Z. Hue plan II D has exactly the same hue intervals but is the reverse of hue plan I D, as it proceeds counterclockwise around the hue circuit from A to Z. Therefore, the 20 hue combinations produced by rotating hue plan II D around the circuit will be different from the 20 hue combinations produced by rotating hue plan I D, although the relative hue interval will be the same in all 40 hue combinations. The foregoing is also true of hue plans III D and IV D, V D and VI D, and VII D and VIII D.

THE D COLOR CHART (WITH DISKS)

To make the selection of the color chords simple, easy, and rapid, draw on a cardboard chart eight hue circuits like the one

359

illustrated on page 350. Fasten a stiff paper disk to the centers of the hue circuits with a roundheaded paper fastener or staple so that the disks may be rotated. On these disks draw the eight D hue plans. Include the D value and chroma plans and the Table of Maximum Chromas on this color chart.

<div align="center">THE D COLOR CHART (WITH SLIDE)</div>

A better D color chart, which may be made from cardboard, is shown on page 361. Beneath the chart is a 12-inch rule that may be copied and used to determine the dimensions of the chart. As shown, the chart contains the D hue, value, and chroma plans, the D plan of color areas, the Table of Maximum Chromas, and a copy of D Composition VIII on page 350. The chart also includes a simple nonrepresentational design executed in each of the six D value plans. These six designs help one decide which D value plan to use in planning a D color chord.

On this chart the D hue plans are stationary. Each hue plan consists of four holes, lettered A, D, W, Z, arranged in a straight horizontal line. The hue circuit is movable and is also arranged in a straight horizontal line. The hue circuit is made of vertical hue strips on a rectangular cardboard panel. In the illustration this hue circuit panel, bearing notated hue strips, is shown removed and placed beneath the color chart. The hue circuit panel slides horizontally in a slot and is directly under the holes of the hue plans. The notated hue strips are visible through these holes.

Each hue is typified by a vertical color strip that shows the hue at its middle value 5/, and the chroma at value 5/ which is closest to its middle chroma. For example, the middle chroma of yellow is /8 or half its maximum chroma /16. But at value 5/, yellow reaches only chroma /6. Yellow is therefore typified

D Color Chart (with slide)

by a color strip of yellow 5/6. But it is necessary that each color strip be notated only with its hue letters as shown. These letters are repeated vertically on the strip in line with the eight D holes of the hue plans. The color strips may either be painted on the hue circuit slide or they may be strips of Allcolor paper pasted on the slide.

On the hue circuit slide are hue strips of the 20-hue circuit which has been cut and extended in a straight horizontal line. Starting at the left of the slide with B, the hues follow the circuit clockwise to BGB and then continue through B again part way round the circuit to GYG. Operation of the slide has

361

shown that this duplication of part of the circuit is necessary. Thus there are 36 hue strips.

Hue plans I D and II D, on the chart, are the same as hue plans I D and II D for the 20-hue circuit, shown on page 358. Hue plans III D to VIII D, on the chart, are also the same as hue plans III D to VIII D, shown on the same page 358, except that W has been moved one step nearer D. This change makes it possible to use the hue plans on the chart with either a 20-hue color cabinet or a 10-hue color cabinet. Although the change will slightly modify the sizes of some of the color intervals, the order of sizes of the color intervals—that is, the color rhythm—will remain unchanged.

This color chart with the slide is quicker and easier to operate than the chart with the disks previously described. For example, instead of separately rotating D on each of the eight hue plan disks to a particular dominant hue on each of the eight hue circuits, we simply slide the hue circuit panel until the desired hue appears under the D hole of any hue plan. This sets all the other hue plans to the same dominant hue.

USING THE TABLE OF MAXIMUM CHROMAS IN PLANNING COLOR CHORDS

In organizing color chords, the table is used as follows. Suppose, for example, we have tentatively planned the following color chord by combining hue plan V D, value plan II D, and chroma plan V D. This color chord is A(RP 7/8) *D(R 6 — /2) W(GY 4/6) Z(GY-G 3/6). Before selecting this from the color cabinet or attempting to mix it, we refer to the table to see if all the colors exist. We discover that all the colors are available except Z(GY-G 3/6), which does not exist because the maximum chroma of GY-G at value 3 is only chroma 4. In a case such as this, we can do one of the following three things.

362

1. Change the hue plan slightly. If we do not wish to change the value and chroma plans of our original color chord above, we can keep them if we change the hue plan slightly by using hue plan VII D instead, which gives us A(RP 7/8) *D(R 6 — /2) W(GY-G 4/6) Z(G 3/6). All these colors exist and are available.

2. Change the value plan. We can maintain the hue and chroma plans of our original color chord if we change our value plan II D to value plan III D, which produces A(RP) 8/8) *D(R 7 — /2) W(GY 5/6) Z(GY-G 4/6). All these colors are also obtainable.

3. Change the chroma plan. The original hue and value plans can be kept if our chroma plan V D is changed to chroma plan IV D, which gives us A(RP 7/6) *D(R 6 — /2) W(GY4/4). Z(GY-G3/4). Our first reference to the table has shown us that all these colors are available.

W COLOR CHORDS

For W or Dark Pattern Dominant in Area Against a Light Background D

The W color chords are for compositions in which a dark pattern is dominant in area against a light background, such as Composition IX on page 364. The W color chords are based on the same principles as the D color chords and possess the same attributes of good design summarized on pages 352 and 353.

The W value, chroma, and hue plans on the following pages can also be combined in various ways to produce more than 500 W color chords.

One of these W color chords, illustrated by Composition IX, was created by uniting value plan II W, chroma plan IV W, and hue plan I W.

W COLOR CHORD FOR COMPOSITION IX

W or dark pattern dominant in area against a light background D

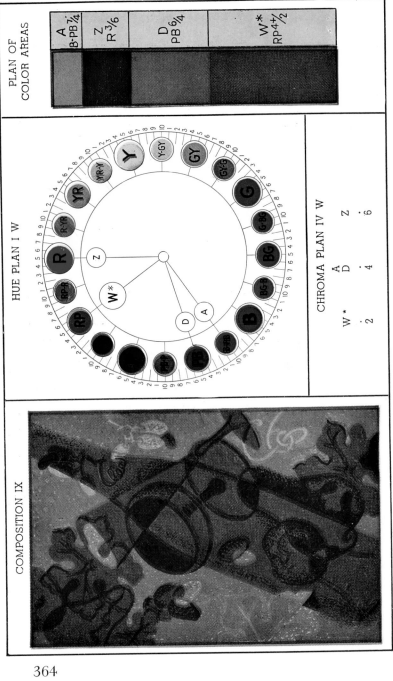

PLAN OF COLOR AREAS

A B·PB 7/4	
Z R 3/6	
D PB 6/4	
W* RP 4+/2	

HUE PLAN I W

CHROMA PLAN IV W

W*	A D	Z
·2	·4	·6

COMPOSITION IX

W CHROMA PLANS

for W or dark pattern dominant in area against a light background D

Weak contrast of chroma and hue				

I W

```
W
A
D        Z
.        .
1        2
```

II W

```
        A
W       D        Z
.       .        .
1       2        4
```

III W

```
        W
        A
        D        Z
                 .
        .        4
        2
```

Moderate contrast of chroma and hue				

IV W

```
                A
W       W       D           Z
.  or   .       .           .
1       2       4           6
```

V W

```
                        A
W       W       W       D           Z
.  or   .  or   .       .           .
1       2       4       6           8
```

Strong contrast of chroma and hue				

VI W

```
                                A
W       W       W       W       D       Z
.  or   .  or   .  or   .       .       .
1       2       4       6       8       10
```

VII W

```
                                        A
W       W       W       W       W       D       Z
.  or   .  or   .  or   .  or   .       .       .
1       2       4       6       8       10      12
```

367

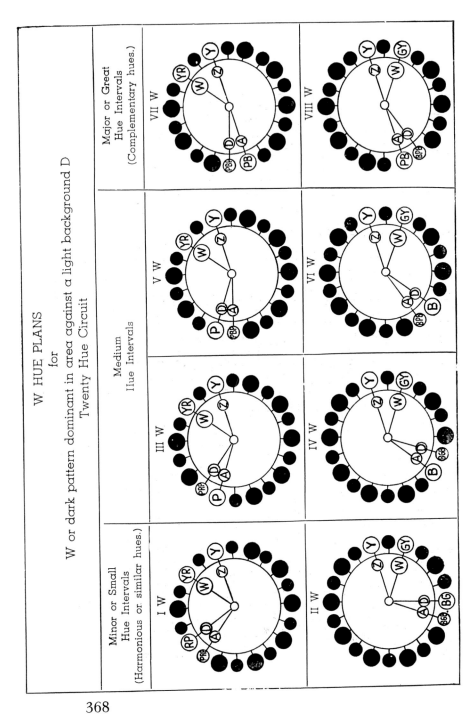

W HUE PLANS
for
W or dark pattern dominant in area against a light background D
Twenty Hue Circuit

Minor or Small Hue Intervals (Harmonious or similar hues.)

Medium Hue Intervals

Major or Great Hue Intervals (Complementary hues.)

I W

II W

III W

IV W

V W

VI W

VII W

VIII W

W Color Chart (with slide)

The W Color Chart with slide includes the W Hue, Value, and Chroma Plans, the W Plan of Color Areas, a copy of W Composition IX on page 364, and a nonrepresentational design executed in each of the six W Value Plans. The remainder of the chart—the Table of Maximum Chromas, the positions of the holes on the Hue Plans, the 36 notated hue strips, and the Hue Circuit sliding panel—is exactly the same as the D Color Chart previously described.

369

also be mounted on a cardboard chart, similar to the one described on page 359, or the one shown on page 361.

Although the sizes of the six color intervals will vary in each W color chord, depending upon which W hue, value, and chroma plans are used, the order of sizes of the intervals or the color rhythm will not vary but will always be as shown on page 365 in every W color chord. There will always be six unequal color intervals, with AZ greatest or dominant.

PLANNING A COLOR CHORD

The purpose of the color plans is to offer us a choice of hundreds of planned color combinations or color chords and to help us find easily and rapidly the one we want. But we must first decide the effect we wish to create. The choice of a color chord is determined by the purpose for which the colors are intended. Function and, of course, our personal color preferences decide the questions that may be considered in the following order.

1. Do we want a light pattern against a dark background, such as that of Composition VIII, or a dark pattern against a light background, such as that of Composition IX? Let us assume that we want a dark pattern. In that case, only the W value, chroma, and hue plans will be used.
2. Choosing the value plan, do we wish

 a. The weak value contrast produced by value plans I W, II W, and III W? or

 b. The moderate value contrast of value plans IV W and V W? or

 c. The strong value contrast of value plan VI W?

If value plan II W is chosen, we write A(7/) D(6/) *W(4 +/) Z(3/).

370

3. Choosing the hue plan, do we want to use

 a. Small hue intervals, harmonious, or similar hues, as in hue plans I W and II W? or

 b. Medium hue intervals, as in hue plans III W, IV W, V W, and VI W? or

 c. Large hue intervals, including a pair of complementary hues, as in hue plans VII W and VIII W?

Suppose we decide to use either hue plan I W or II W.

4. Choosing the dominant hue, do we want the pattern or largest area to be

 a. Warm, such as red, yellow-red, yellow, or green yellow? or

 b. Temperate, such as green or red-purple? or

 c. Cool, such as blue-green, blue, purple-blue, or purple?

Suppose that we decide to make *W red-purple. In that case, hue plans I W and II W are rotated until *W is on RP. This gives us a choice of the two following hue combinations: A(B-PB) D(PB) *W(RP) Z(R) or A(YR-Y) D(YR) *W(RP) Z(P). If the first combination is chosen, we combine with it the value plan II W, already selected, and write: A(B-PB 7/) D(PB 6/) *W(RP 4 + /) Z(R 3/).

5. Choosing the chroma plan, do we wish to have

 a. Weak contrast of chroma and hue such as produced by chroma plans I W, II W, and III W? or

 b. Moderate contrast of chroma and hue as produced by chroma plans IV W and V W? or

 c. Strong contrast of chroma and hue such as chroma plans VI W and VII W?

If chroma plan IV W is chosen, we combine with it value

371

plan II W and the hue combination already selected and write: A(B-PB 7/4) D(PB 6/4) *W(RP 4 + /2) Z(R 3/6). This is the W color chord for Composition IX and is illustrated on page 365.

There are, of course, other ways of planning a color chord. For example, a color chord for a room or a painting can be built up around any specified dominant color such as R 4.5/2, for instance. We could then proceed to plan our color chord as follows.

1. Referring to the W value plans on page 366, we see that we can use value plan IV W because value 4.5, which is the value of the specified color, is the dominant value in this value plan. We then write A(8/) D(7 — /) *W(R 4.5/2) Z(3/).

2. All the W hue plans are then rotated until the W in each hue plan is on the specified hue, which is R in this instance. This gives us a choice of eight hue combinations, and we choose the one produced by hue plan IV W. We then write A(GY 8/) D(Y-GY 7— /) *W(R 4.5/2) Z(RP 3/).

3. Upon consulting the Table of Maximum Chromas, we find that these hues are available in strong chromas in the foregoing value levels and therefore permit a wide choice of chroma plans. So just to try the effect of a smashing contrast of chroma and hue, we select chroma plan VI W, which, when combined with the above, produces A(GY 8/8) D(Y-GY 7 — /8) *W(R 4.5/2) Z(RP 3/10). If we should find that this color chord is too strong for either our taste or our purpose, we can substitute any one of the five weaker chroma plans.

Most of us are already familiar with and can easily visualize

the hues of the circuit. After a little practice, we can become equally familiar with the distinctive character of each value and chroma plan. We can then visualize a notated color chord as readily as a musician can "hear" the music when reading a notated music score. When this stage is reached, the planning of a color chord becomes simple, direct, and rapid.

The four colors of a color chord, together with slightly lighter and darker values of each color for modeling or shading, will be sufficient for many purposes. Additional colors may, of course, be used also if desired. In that case, the additional colors are built up around the color chord that has been selected as the starting point or basic color plan.

HUE PLANS FOR THE 10-HUE CIRCUIT

The hue plans charted on pages 358 and 368 are designed for use with the 20-hue circuit. But the most complete Allcolor cabinet contains all the colors of only the 10 hues R, YR, Y, GY, G, BG, B, PB, P, RP. Some of the 10 second intermediate colors R-YR, YR-Y, etc., are not included. However, sheets of these second intermediate colors can be obtained from the Munsell Color Company and inserted in the Allcolor cabinet. Although a complete 20-hue cabinet, with all its color nuances, is the ideal instrument for the colorist, it is not absolutely necessary, since D and W color chords similar to the ones on the previous pages can be planned using the Allcolor cabinet or a 10-hue color cabinet made with the Munsell student-set color chips.

If we want to use only a 10-hue color cabinet, the following hue plans for the 10-hue circuit are used instead of the hue plans for the 20-hue circuit on pages 358 and 368.

Although the sizes of some of the color intervals will be slightly different when the hue plans for the 10-hue circuit

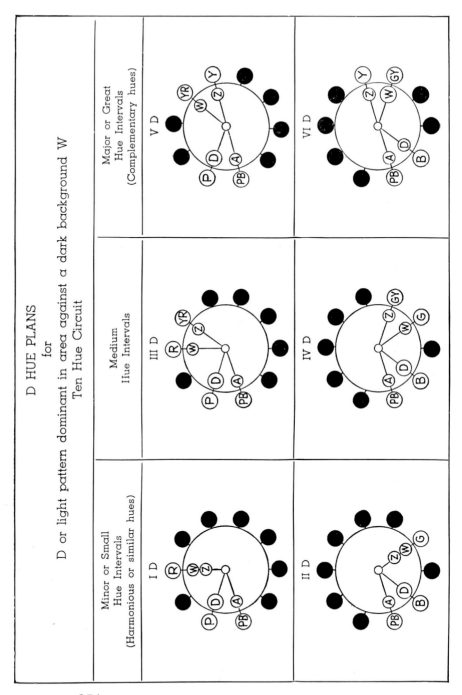

D HUE PLANS
for
D or light pattern dominant in area against a dark background W
Ten Hue Circuit

Minor or Small
Hue Intervals
(Harmonious or similar hues)

Medium
Hue Intervals

Major or Great
Hue Intervals
(Complementary hues)

I D

II D

III D

IV D

V D

VI D

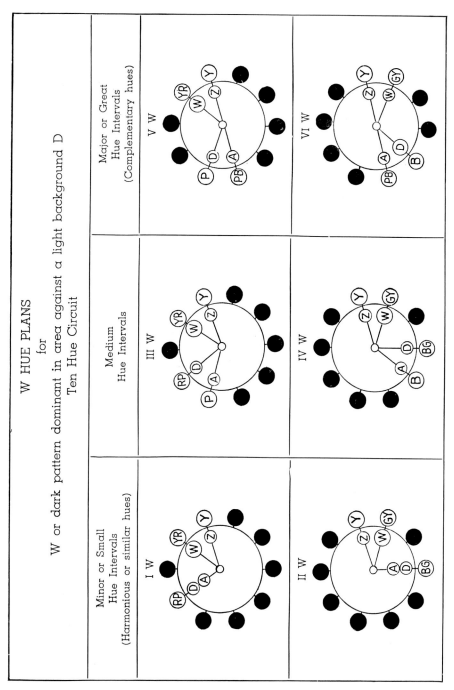

W HUE PLANS
for
W or dark pattern dominant in area against a light background D
Ten Hue Circuit

Minor or Small
Hue Intervals
(Harmonious or similar hues)

Medium
Hue Intervals

Major or Great
Hue Intervals
(Complementary hues)

I W

II W

III W

IV W

V W

VI W

are used, the order of sizes of the intervals or the color rhythm will be the same as illustrated on page 351 or on page 365.

The 10-hue-circuit plans can, of course, also be used with the 20-hue circuit if desired.

MONOCHROMATIC COLOR CHORDS

In addition to the color chords of four different hues are the many monochromatic color chords. Monochromes are colors of the same hue but different values and chromas. Therefore, in planning monochromatic color chords, only the two dimensions of value and chroma need be considered, since, all the colors being of the same hue, differences of hue are not involved. This means, of course, that a hue plan is not necessary. Because monochromatic color relationships are only two-dimensional and because a hue plan is not necessary, monochromatic color chords are the simplest and easiest to organize. The following monochromatic color chords, like the color chords on the preceding pages, are based on the same design principles of unity and variety.

The D and W monochromatic color chords can be used with any one of the 20 hues. For example, a D monochromatic color chord in blue made by combining value plan 3 D and chroma plan 2 D, would be A(B 8/1) *D(B 6.7/2) W(B 5/4) Z(B 4/4).

D MONOCHROMATIC COLOR CHORDS

*For D or Light Pattern Dominant in Area Against
a Dark Background W*

In all the D monochromatic color chords it is usually preferable to use the plan of color areas or quantities on page 350, in which D is the largest color area. However, the largest color area can consist of A if desired.

376

Although the sizes of the six color intervals will vary in each D monochromatic color chord, depending upon which D value and chroma plans are used, the order of sizes of the intervals or the color rhythm will not vary but will always be as shown on page 351 in every D monochromatic color chord, with six unequal color intervals, AZ being greatest or dominant.

Combining the D value plans on page 378 with the D monochrome chroma plans on pages 379 and 380 produces the many D monochromatic color chords. For example, one of these D monochromatic color chords produced by a combination of value plan 6 D and chroma plan 10 D is A(8/6) *D(6/4) W(3.4/1) Z(2/1). This D monochromatic color chord can be had in many hues. In red, for instance, it would be written A(R 8/6) *D(R 6/4) W(R 3.4/1) Z(R 2/1).

<center>MIXING "IN-BETWEEN" COLORS</center>

In order to create the best proportioned color intervals, it is necessary, in some cases, to use fractional values and odd-numbered chromas, such as 5.4/3. However, in mixing colors such as this, absolute accuracy is not necessary. A close approximation can easily be made as follows. Suppose R 5.4/3 is wanted. From the color cabinet select R 5/2 and R 6/4. R 5.4/3 can then easily be mixed by comparison with these two colors. Its chroma will be halfway between their chromas, and its value will be slightly darker than halfway between their values.

Other "in-between" colors can be mixed in the same way. For example, R 3.4/2 can be mixed by comparison with R 3/2 and R 4/2. It will have the same chroma as these two colors but will be slightly darker than the mid-point between them. If B 6.7/2 is wanted, it can be made by comparing it with B 7/2 and making it slightly darker.

D VALUE PLANS					
for D or light pattern dominant in area against a dark background W					
Weak value contrast, minor or small value intervals			Moderate value contrast, medium value intervals		Strong value contrast, major or great value intervals
1 D	2 D	3 D	4 D	5 D	6 D
A · 6	A · 7	A · 8	A · 8	A · 7	A · 8
D * 4.7	D * 5.7	D * 6.7	D * 6.4	D * 5.4	D * 6
W · 3	W · 4	W · 5	W · 4.2	W · 3.2	W · 3.4
Z · 2	Z · 3	Z · 4	Z · 3	Z . 2	Z · 2

D MONOCHROME CHROMA PLANS

There are 15 D monochrome chroma plans. Note that in chroma plans 1 D to 7 D the light pattern that consists of A and D is weaker in chroma than the dark background, or W and Z.

In chroma plans 8 D to 15 D the light pattern, or A and D, is stronger in chroma than the dark background, or W and Z.

378

D MONOCHROME CHROMA PLANS
for light pattern of weaker chroma than background

Weak chroma contrast, minor or small chroma intervals

I D

```
D   A
Z   W

.   .
1   2
```

2 D

```
A    D         W
     *         Z
.    .    .    .
1    2         4
```

Moderate chroma contrast, medium chroma intervals

3 D

```
A         D              W
          *              Z
.    .    .    .    .    .
1         3              6
```

4 D

```
     A         D         W    Z
               *
.    .    .    .    .    .    .
     2         4         7    8
```

Strong chroma contrast, major or great chroma intervals

5 D

```
A              D              W         Z
               *
.    .    .    .    .    .    .    .    .
1              4              8         10
```

6 D

```
     A              D              W         Z
                    *
.    .    .    .    .    .    .    .    .    .
     3              6              10        12
```

7 D

```
     A              D                   W         Z
                    *
.    .    .    .    .    .    .    .    .    .    .
     2              6                   12        14
```

D MONOCHROME CHROMA PLANS
for light pattern of stronger chroma than background

Weak chroma contrast, minor or small chroma intervals

8 D

```
A   D
W   Z
.   .
1   2
```

9 D

```
W
Z        D   A
         *
.        .   .
1    .   3   4
```

Moderate chroma contrast, medium chroma intervals

10 D

```
W
Z            D       A
             *
.    .   .   .   .   .
1            4       6
```

11 D

```
     Z   W           D       A
                     *
.    .   .   .   .   .   .   .
     2   3           6       8
```

Strong chroma contrast, major or great chroma intervals

12 D

```
     Z       W               D           A
                             *
.    .   .   .   .   .   .   .   .   .   .
     2       4               8          11
```

13 D

```
     Z       W               D           A
                             *
.    .   .   .   .   .   .   .   .   .   .
     2       4               9          12
```

14 D

```
     Z       W                   D               A
                                 *
.    .   .   .   .   .   .   .   .   .   .   .   .
     2       4                  10              14
```

15 D

```
         Z       W                   D           A
                                     *
.    .   .   .   .   .   .   .   .   .   .   .   .   .
         4       6                  12          16
```

*For W or Dark Pattern Dominant in Area Against
a Light Background D*

With all the W monochromatic color chords, the plan of color areas or quantities on page 364 is generally the most satisfactory for most purposes. However, the largest color area may consist of Z instead of W if desired.

Although the sizes of the six color intervals will vary in each W monochromatic color chord, depending upon which W value and chroma plans are used, the order of sizes of the intervals or the color rhythm will not vary but will always be as shown on page 365 in every W monochromatic color chord. There will always be six unequal color intervals, with AZ greatest or dominant.

The W monochromatic color chords are made by combining the W value plans on page 382 with the W monochrome chroma plans on pages 383 and 384. For example, one of these W monochromatic color chords in yellow, produced by a combination of value plan 6 W and chroma plan 5 W, is A(Y 8/10) D(Y 6.6/8) *W(Y 4/4) Z(Y 2/1).

W MONOCHROME CHROMA PLANS

There are 15 W monochrome chroma plans. In chroma plans 1 W to 8 W, note that the dark pattern consisting of W and Z is weaker than A and D or the light background.

In chroma plans 9 W to 15 W, the dark pattern that consists of W and Z is stronger in chroma than A and D or the light background.

	W VALUE PLANS					
	for W or dark pattern dominant in area against a light background D					

Weak value contrast, minor or small value intervals			Moderate value contrast, medium value intervals		Strong value contrast, major or great value intervals
1 W	2 W	3 W	4 W	5 W	6 W
·	·	A · 8	A · 8	·	A · 8
·	A · 7	D · 7	D · 6.8	A · 7	·
A · 6	D · 6	·	·	D · 5.8	D · 6.6
D · 5	·	W * 5.3	·	·	·
·	W * 4.3	·	W * 4.6	·	·
W * 3.3	·	Z · 4	·	W * 3.6	W * 4
·	Z · 3	·	Z · 3	·	·
Z · 2	·	·	·	Z · 2	Z · 2

382

W MONOCHROME CHROMA PLANS
for dark pattern of weaker chroma than background

Weak chroma contrast, minor or small chroma intervals

1 W
```
A   D
W   Z
.   .
1   2
```

2 W
```
              A
Z    W        D
     *
.    2    .   .
1             4
```

Moderate chroma contrast, medium chroma intervals

3 W
```
Z         W         A
          *         D
.    .    3    .  . .
1                   6
```

4 W
```
     Z         W           D    A
               *
.    .    .    4    .  .    .    .
     2                     7    8
```

Strong chroma contrast, major or great chroma intervals

5 W
```
Z              W              D    A
               *
.    .    .    4    .    .    .    .
1                             8    10
```

6 W
```
     Z              W              D         A
                    *
.    .    .    .    6    .    .    .    .    .
     3                            10        12
```

7 W
```
  Z                 W                   D    A
                    *
.    .    .    .    6    .    .    .    .    .    .
  2                                    12    14
```

8 W
```
        Z              W                        D    A
                       *
.    .    .    .    .  8    .    .    .    .    .    .
        4                                       14   16
```

383

W MONOCHROME CHROMA PLANS
for dark pattern of stronger chroma than background

Weak chroma contrast, minor or small chroma intervals

9 W

```
D   A
Z   W
.   .
1   2
```

10 W

```
A
D       W   Z
        *
.       .   .
1       3   4
```

Moderate chroma contrast, medium chroma intervals

11 W

```
A
D           W       Z
            *
.       .   .       .   .       .
1           4       6
```

12 W

```
    A   D           W       Z
                    *
.       .       .   .   .   .
    2   3           6       8
```

Strong chroma contrast, major or great chroma intervals

13 W

```
    A       D               W               Z
                            *
    .       .   .       .   .       .       .
    2       4               8               11
```

14 W

```
    A       D               W               Z
                            *
.   .   .   .   .       .   .   .   .       .
    2       4               9               12
```

15 W

```
    A       D                       W                   Z
                                    *
.   .   .   .   .       .       .   .   .   .       .
    2       4                       10                  14
```

SUMMARY

Knowledge of the principles of color organization is a supplement to but not a substitute for taste, sensitive selection, nice discrimination. If you have unerring instincts and impeccable taste, you may, perhaps, not need this information, nor need you plan your color. Nevertheless, although instinct and taste are fine equipment, this combination plus knowledge is still better equipment.

The color chords are simply new forms of color organization based on the fundamental, age-old principles of unity, variety, and rhythm. Nevertheless, like all new ideas, these color chords may, perhaps, meet opposition, particularly from older artists of established habits. Such artists will be like the medieval minstrel, who, relying on his ear, might perhaps also have been intolerant of notated scales and theory. Nevertheless, the works of great composers prove that scales and theory are not necessarily incompatible with art and also demonstrate that a knowledge of structure need not inhibit expression. It is true, however, that greatness in most creations consists of intangibles that cannot be computed. They can be learned, but can they be taught?

Although this question may be debatable, there is no doubt that principles of structure and organization are powerful instruments of expression and can be taught. Since Newton, much has been learned about color by both the physicist and the psychologist. Much still remains a mystery. Until recently most artists were not clearly aware of the three psychological color dimensions, hue, value, and chroma. They were vague in their understanding of these three ways in which colors can be identical, similar, or different. Many artists and most laymen are still hazy in their color concepts. Because many artists do

385

not understand color dimensions and color intervals, they are not aware of color rhythm and its possibilities. Their color schemes, therefore, are not so unified or so interesting as they could be, because the intervals between the colors or the color rhythm are not planned. It is a serious omission, because this relationship between the colors is as important as the colors themselves.

This blindness to rhythm seems to be quite common. Anyone who has been an art instructor will have noticed that the average person is at first usually blind to the relationship between objects while at the same time being keenly aware of the objects themselves. This is not surprising, since objects are tangible, visible, obvious, whereas relationship is intangible, invisible, often subtle, frequently hidden. The relationship between things is proportion or rhythm, which is as important as the things themselves. When someone becomes so preoccupied with things that he forgets this truth, we say, "He has lost his sense of proportion." When an artist loses his sense of proportion, he ceases to be an artist. Great artists are men with unique senses of proportion. A poor or undeveloped sense of proportion accounts for weak and chaotic life drawings and also explains why color rhythm is often completely overlooked.

Until recently a lack of color knowledge, color terminology, color notation, and measured color standards has retarded the development of color rhythm. Approached with these new tools and a clearer perception, the color realm now expands, revealing unusual and stimulating possibilities.

QUESTIONS

1. Do you dislike certain colors? If so, what are they? Do you know of any association or experience that might account for your dislike?

386

2. Have you a favorite color? If so, do you know of any reason that might explain this preference?

3. Would you use complementary or strongly contrasting hues of strong chroma and a major value key for

 a. A poster or magazine cover? Why?
 b. A hospital ward? Why?
 c. A night club or bar? Why?

4. What colors do you think best express:

 a. War?
 b. Carnival?
 c. Mystery?

5. What are the four requisites of a good color scheme?
6. What does color rhythm mean?
7. What is a color chord, and how is it created?
8. What are the principles of design on which the color chords are based?
9. One of the purposes of the color chords is to create unity. In what three ways is this unity produced?
10. What are the four kinds of variety that make interesting color?
11. The plans of color areas or quantities are designed to produce what results?
12. What is a color cabinet?
13. What are the advantages of using the color plans and a color cabinet?
14. What does "rotating a hue plan" mean?
15. What is the difference between clockwise and counterclockwise hue plans?
16. What is the Table of Maximum Chromas and what is it used for?
17. What is the difference between the D color chords and the W color chords?
18. What is the difference between the 10-hue circuit and the 20-hue circuit?
19. What is a monochrome?
20. Is it necessary to have a hue plan for a monochromatic color chord? Why?
21. Is the total color interval or contrast between R 8/6 and R 6/4 greater than, equal to, or less than the total color interval or contrast between R 6/4 and R 3/2? Why?
22. Given a color cabinet and asked to mix R 5.4/3, which two colors would you select from the cabinet to help you make this color?

23. Which two colors would you select from the cabinet to help you mix R 3.4/2?

24. Which color would you take to help you mix B 6.7/2?

25. How is a W monochromatic color chord made?

EXERCISES

1. Write a short essay explaining how an understanding of color notation and the principles of color organization can be of value to an artist.

2. Take some of the compositions that you have made as suggested under Exercises in Value Pattern or Composition VII on page 311 or Composition VIII on page 350, and do them in four colors of different hues using either D color chords that you have planned yourself or the following D color chords:

 A(BG 6/6) *D(B 5— /2) W(RP-R 3/4) Z(R 2/4).
 A(G 6/4) *D(GY 5— /2) W(YR 3/2) Z(R-YR 2/2).
 A(G 8/6) *D(GY 7— /2) W(YR 5/4) Z(R-YR 4/4).

3. Do Composition VI on page 311 or Composition IX on page 364 or one of your own designs, using either a W color chord that you have planned yourself or the following W color chord:

 A(GY 8/8) D(Y-GY 7—/8) *W(R 4.5/2) Z(RP 3/10).

4. Do Composition VII on page 311 or Composition VIII on page 350 or one of your own compositions in both blue monochrome and red monochrome. Plan your own D monochromatic color chords or use the following:

 A(B 8/1) *D(B 6.7/2) W(B 5/4) Z(B 4/4).
 A(R 8/6) *D(R 6/4) W(R 3.4/1) Z(R 2/1).

5. Do Composition VI on page 311 or Composition IX on page 364 or one of your own compositions in yellow monochrome. Plan your own W monochromatic color chord or use the following:

 A(Y 8/10) D(Y 6.6/8) *W(Y 4/4) Z(Y 2/1).

5. PROCEDURE IN PLANNING A COMPOSITION

Planning a composition is like juggling many objects at once. Color, subject matter, arrangement, all must be considered and

388

integrated. Many artists find that an orderly approach clarifies the problem and eliminates wasteful, fatiguing confusion.

Illustrators and advertising designers as well as all mural painters and stage designers make many preliminary sketches and plan their color schemes beforehand. In all mural competitions preliminary sketches are required and must be approved.

Although the following procedure may seem unnecessarily elaborate, you will find that it will give you greater freedom in composing and will also frequently eliminate laborious and sometimes expensive changes in the finished composition.

1. *Blocking in the Composition.* Work in simple masses with broad side of gray chalk. Express or suggest rather than describe. Description inhibits creation.

Don't draw in line or consider detail at this stage.

Think in terms of shapes, sizes, and directions.

The following is a condensed reminder of some of the important design principles.

The aim of composition is to create an interesting unit. Interest is the result of variety. Unity is created by dominance.

	Variety (contrast)	Unity (dominance)
I.	Variety of content or action	One action or idea dominant
II.	Variety of elements.	
	a. Lines: straight and curved	One line dominant
	b. Directions: horizontal, vertical, oblique	One direction dominant
	c. Shapes: angular and curved	One shape dominant
	d. Sizes: large and small	One size dominant
	e. Textures: rough and smooth	One texture dominant
	f. Values: dark and light	One value dominant
	g. Hues: warm and cool	One hue dominant
III.	Variety of intervals or contrast between elements creates interesting rhythm.	
	a. Large, strong, or major intervals and small, weak, or minor intervals.	One of the major intervals should be strongest or dominant.

389

The composition may be built on repeated variations of a characteristic motif, as in Victor Keppler's toothbrush photograph or "Saratoga Nineties," for example (see pages 138, 261).

2. *Drawing*. When the composition has been satisfactorily blocked in with simple masses, it is time to consider detail and drawing. Tack a sheet of tracing paper over the rough sketch. You can now calmly concentrate on the drawing without having to worry about the placement of the figures or detail.

3. *Pattern*. The dark-and-light pattern is planned as demonstrated in Planning a Value Pattern on page 314 and in Selecting a Value Chord on page 309.

Make several experimental patterns.

Select the best one.

4. *Tracing*. Make a rough carbon tracing of the drawing on a canvas panel or illustration board.

5. *Color*. Plan color chord (see page 370).

6. *The Color Sketch*. You now have your drawing and your dark-and-light pattern. The color chord is planned. With oil paint or tempera, paint in the colors over the tracing of the drawing that is on the panel. This is the preliminary sketch. It will give you a rough but comprehensive idea of how the finished design will look. On this sketch you can make any changes you wish before going ahead with the final painting.

7. *Enlarging*. If you are making a large painting, the little sketch can be projected on the canvas with an opaque projector that will enlarge it to the desired size, or a lantern slide can be made and projected.

6. OPTICAL ILLUSIONS OF COLOR

Sometimes facts, capable of measured proof, appear visually false. Almost everyone is familiar with such optical illusions,

which are sometimes quite amusing and which must be measured to be believed. There are many examples of lines and shapes that appear larger or smaller than others of the same size and of lines that must be curved slightly to make them appear straight and horizontal. Examples of the latter may be seen in Greek temples.

As with lines and shapes, so it is with color. There are certain optical illusions that modify its theoretical application and that must be considered in practical usage. Some of these are as follows.

Contrasts intensify each other. A straight line will accentuate the curve of an arc. Blue emphasizes the warmth of orange, and black makes gray and white seem brighter. This contrast sometimes creates vibration. Thus, an intense vermilion on a strong blue-green background appears to glow and pulsate.

Adjacent hues induce their complement or opposite in each other. For example, if yellow and red are adjacent, the yellow will appear slightly greener than if it were by itself, and the red will appear cooler and a little more purple.

The tendency of a hue of strong chroma is to induce its opposite in a neutral. For instance, a spot of gray on a red background will appear greenish. The induced hue is strongest when the neutral is the same value as the color. Therefore, it is necessary to counteract this effect if harmony of hue is desired. If gray is to harmonize with orange, for example, it must be warmed; with blue it must be cooled.

THE EFFECT OF A STRONG VALUE CONTRAST UPON
HUE AND CHROMA

A light hue of moderate chroma will appear weak and whitish when placed on a black background, because the strong

391

contrast of value considerably overpowers the hue and chroma. The same color will seem much stronger in chroma when placed on a white background. For the same reason, a spot of dark blue or red on white will look almost black and colorless, whereas on black these pigments will appear more brilliant. This tendency of a strong value contrast to overpower and neutralize hue and chroma somewhat can be used to advantage. For example, light contrasting hues of strong chroma can be harmonized by surrounding or outlining them in black. Repetition of the black also helps to unify the design. Stained-glass windows, in which each pane is outlined with black lead, demonstrate this principle.[10] The same harmonizing effect is produced by outlining or surrounding dark contrasting hues of strong chroma with white, silver, or gold.

IRRADIATION

This is an optical illusion that causes a white area or one of intense chroma, when seen against a dark background, to appear larger than it really is. The area seems to radiate light, appearing to be a glowing blur that expands beyond its edges. Thus, a white square on a black ground seems larger than a black square of the same size on a white ground.

This effect is sometimes called *halation*. It also creates an opposite result, so that an intense light background will overlap the boundaries of a dark shape seen against it and make the dark shape appear smaller. A common example is a tree branch seen against the sun. If the branch is thick, the edges will seem to be blurred and gouged out; if thin, the branch disappears in a haze of light. The effect is due to a stimulation of the retina around the image.

[10] Integrating strongly contrasting hues by surrounding them with a heavy black outline is also illustrated in Pablo Picasso's paintings of the so-called "stained-glass" period. See rose window on page 44.

Red is an aggressive or an advancing color; blue is a retiring or receding color. The reason is that these colors are refracted differently and consequently affect the focus of the eye in different ways. Red rays are refracted or bent only slightly by the lens of the eye. They focus at a point behind the retina. To focus a red object sharply on the retina, the lens bulges and becomes more convex, just as it does to focus on a closer, neutral-colored object. This compensating lens action pulls red nearer the eye, and we see it as if it were closer than it really is.

Blue is refracted more and consequently focuses at a point in front of the retina. To see it clearly, it must be focused on the retina. This is accomplished by the lens flattening and becoming more concave. This lens action pushes blue back, and it is seen as if it were farther away than it really is. Blue, therefore, is a retiring or receding color.

The different refractive indexes of these two colors probably accounts for the vibration or movement that is felt when one looks at a blue design on a red background of the same value. The muscular pulsation set up by the lens of the eye as it alternately contracts and expands in an effort to focus these two colors simultaneously probably causes the sensation of vibratory movement.

Yellow and purple are neither advancing nor retiring. These two colors are not distorted but are focused normally by the eye. When used for type and background, they function excellently by eliminating eyestrain and increasing legibility. Purple has also been successfully used for the felt coverings of billiard tables.

In recent years industry has discovered that the proper use of color can increase production and lower costs. The greater

illumination provided by painting grinding machines and lathes white, where the cutting operation takes place, increases efficiency by reducing eyestrain. At the American Rolling Mill, Ford, Toledo Scale, and Simmons Saw plants, the morale of the worker has been raised by painting machines, tools, and castings in pleasantly contrasting colors that also make the work more visible. By eliminating errors and poor workmanship due to fatigue, boredom, and eyestrain, color, in some instances, speeds production 60 per cent.

QUESTIONS

1. In what way do opposites such as red and blue-green or black and white affect each other?
2. What color does a spot of N 5/ appear to be when seen against a R 5/5 background?
3. Does a spot of dark blue or red look stronger in chroma against a white background or against a black background? Why?
4. What is one way in which contrasting hues of strong chroma and similar values may be harmonized? Where may this method be seen demonstrated?
5. What causes blur or irradiation? Give an example.
6. Is red an advancing or a retiring color? Why?
7. Is blue an advancing or a retiring color? Why?
8. Name two hues that are neither advancing nor retiring. Where does this characteristic of these two colors find practical use?
9. How is color used in some industries to increase the efficiency of the workers?

7. COLOR AND INTERIOR DECORATION

Color of strong chroma, being stimulating, eventually tires the spectator. In interior decoration, it is most successfully employed in small rooms or rooms intended for transient use, such as reception rooms, foyers, powder rooms, night clubs, or bars. Colors of weak or moderate chroma are less insistent and consequently more restful. They are, therefore, best suited to rooms where much time is spent, such as schoolrooms, offices,

living rooms, and libraries. This does not mean, however, that these color arrangements need be monotonous. On the contrary, they should have interest created by the use of subdued contrasts of value, hue, chroma, or texture.

HARMONIC REPETITION OF HUE

A suite of rooms may be unified by harmonic variations on a hue theme. Suppose the plan of the principal room consists of three hues, a harmony of two warm hues with cool, contrasting accents. Adjacent rooms may be harmoniously related by repeating one or more of these three hues with variations. In one of the rooms, the theme may be reversed, with the cool hue as the dominant and warm accents. The warm hues used as a harmony may be the basis of a color scheme of another room. A third room may be done in one of the hues employed as a monochrome. This is the color design of a unit, a suite of harmoniously related rooms.

Harmonious repetition of color may also be used in a single room to unify its color scheme. A living room designed by Allan Walton[11] clearly illustrates this plan and also demonstrates some of the other color principles that have been previously mentioned. The color scheme of this living room consists chiefly of the harmonious hues, yellow and green, and the contrasting hues, green and red. The hue key or dominant hue of the room is green. Although variety of hue and variety of minor and major hue intervals (that is, yellow to green and green to red) create considerable interest, the room nevertheless remains quiet and restful because the values of these hues are harmonious and because the largest areas are weak or moderate in chroma. The principal colors are echoed by colors

[11] Plate 1 of *Color Schemes for the Modern Home* by Derek Patmore, published by Studio Publications, New York.

of the same hue but stronger chroma that are confined to the smaller areas of the accessories and furniture, such as a centralized red chair. On the chair a small green, yellow, and red cushion, with the green predominating, repeats the color scheme of the entire room and forms its color climax.

When a painting is designed for a particular room, its color plan must be considered as a practical decorative problem. The color scheme of the painting may be planned in one of the three following ways.

1. The dominant hue of the painting may be the same or nearly the same as the dominant hue of the interior, with variations of value and chroma. This means that the painting would be done in only one hue or monochrome, such as a green painting for a green room or a brown contè and sepia wash drawing for a pine-paneled room.

2. The dominant hue of the painting may be the same or nearly the same as the dominant hue of the room, with one of the subordinate hues of the painting harmonizing with the dominant hue and the other serving as contrasting accent. The color scheme of a painting for a green room might, therefore, be green, yellow, and red, with the green predominating and the yellow and red subordinate. The cushion in the living room described above exactly illustrates this color scheme.

3. The dominant hue of the painting may be in contrast to the prevailing hue of the interior, and the subordinate hues of the painting may repeat the dominant hue of the room, as well as echoing some of the other hues in it. The

red chair with the cushion is just such a color combination.

These alternatives should be considered in choosing decorative accessories such as rugs, drapes, ceramics, and flowers.

The foregoing plan can also be used when the color scheme of a room is planned in relation to a painting, rug, or screen.

PERIOD COLOR SCHEMES

It would be rash to designate any one color combination as most characteristic of our times. We are now in the midst of an unusually swift and complicated historical change, in which no one of the many contending forces dominates as yet. It seems logical, therefore, that a period so lacking in homogeneity would also lack a dominant color scheme. Contemporary color combinations are derived from heterogeneous sources including all periods from the classic to the Victorian.

Color schemes of these periods are illustrated in a compact and most useful little book *Historical Color Guide* by Elizabeth Burris-Meyer.[12] The color combinations are accurately copied from tapestries, interiors, frescoes, and paintings, each an authentic example typical of the particular period. The colors are notated according to the Munsell system, which is the most concise and accurate way of specifying colors.

A few of the original colors, such as Y 8/14, are uncommonly strong in chroma and must have been produced by intense native dyes or pigments. The other colors may be selected from a color cabinet. For colors such as Y 8/14, take the nearest available color, such as Y 8/12. If you do not have a cabinet, you may approximate the colors with the help of the value scale and the hue circuit on pages 11 and 12. Remember that

[12] Published by William Helburn, Inc., New York.

397

chromas 2 and 4 are weak, 6 and 8 are moderate, and 10, 12, 14 are strong.

In the following period schemes from this colorful little book, the last color in each group is dominant, that is, largest in area.

Egyptian: YR-Y 8/8, R 4/10, BG 6/8, Y 6/4, G-BG 5/2.

Greek: Y 8/6, GY-G 6/2, 7PB 7/6, R-YR 4/2, RP 6/4.

Pompeian: YR-Y 6/12, RP-R 8/10, Y 6/2, RP-R 5/14, BG 6/6.

Italian Primitive: PB 6/10, R 5/10, YR 8/4, Y 8/12, Y-GY 6/4.

Italian Renaissance: BG 3/4, R-YR 3/4, Gold, BG-B 4/4, R 3/10.

Flemish Primitive: YR-Y 3/4, GY 6/4, PB 8/2, R-YR 8/8, Y-GY 3/2.

French, Louis XV: PB-P 6/8, B-PB 7/6, GY 8/6, R 8/10, P-RP 8/4.

French, Louis XVI: R-YR 5/10, Silver, YR-Y 8/2, P 5/6, B-PB 7/1.

French Empire: PB 7/2, PB-P 7/1, R-YR 8/2, YR-Y 6/6, N 3.

English Eighteenth Century: GY-G 5/4, 7PB 4/8, RP-R 6/2, YR-Y 8/4, N 7.

Victorian: RP-R 5/6, RP-R 7/6, GY-G 4/6, YR 3/2, P 3/6.

Chinese, Sung Dynasty: BG 6/6, PB 8/1, R 2/2, Black, Y 8/2.

Persian Fresco: YR-Y 8/4, RP-R 3/8, R-YR 8/1, GY-G 4/6, 8PB 6/6.

Persian Miniature: R-YR 7/12, R 5/12, 3YR 8/4, B 6/6, G-BG 3/2.

Spanish, el Greco: Y 6/4, G 4/2, 7PB 5/2, RP-R 2/6, N 5.

Mexican: P-RP 6/8, 8PB 2/2, 6Y 8/4, YR-Y 8/10, R 5/4.

Peruvian: GY-G 6/10, 3GY 8/6, Y 8/14, 3RP 5/12, 7PB 3/12.

Early American: G-BG 4/4, PB 6/4, PB 2/6, R-YR 7/6, YR 3/4.

QUESTIONS

1. Which is more restful, color of strong chroma or color of weak chroma? Why?
2. Colors of strong chroma function best in what types of interiors?
3. For which rooms are colors of weak chroma most appropriate?
4. If a room is done in quiet, subdued colors of weak chroma, how may monotony be avoided, that is, how may variety or interest be created?

EXERCISES

1. Plan color schemes for a four-room suite according to the plan suggested under Harmonic Repetition of Hue on page 395. Plan the color scheme of the principal room yourself, or use one of the period color schemes. The color plans of the other three rooms should be derived from and harmoniously related to the color plan of the principal room. Prepare a plate showing the four color schemes, together with notes regarding the colors and textures of the rugs, drapes, and accessories. If possible, paste actual samples or swatches of these materials on the plate.
2. Plan the color scheme of a decorative painting for one of the foregoing rooms according to alternative 2, under Planning the Color Scheme of a Painting in Relation to a Room on page 396.
3. Plan the color scheme of a design for a folding screen to be used in one of the other rooms according to alternative 1.
4. Plan the color scheme of a painting for one of the foregoing rooms according to alternative 3.

8. PSYCHOLOGY OF COLOR

It is a well-known fact that color can affect us powerfully and induce definite moods. Such common expressions as "seeing red," "feeling blue" indicate definite attitudes toward these colors. Literature and poetry, both ancient and modern, contain many such color similes and metaphors. That color affects physical and mental activity has been proved, and experiments have been made regarding the curative value of color upon neurotics. Many religions have recognized the significance of color and have formulated color symbolisms. Most great schools of painting and historical periods have established a

399

characteristic color scheme as a result of a deep-felt necessity. The interior color schemes of the classic, Byzantine, and Louis periods, for example, are all distinctive and different. This is by no means accidental, since the home expressed the life and psychology of the inhabitants, and color selection is an important factor in such expression. In this connection, the tendency of some contemporary painters to use blackish yellow-browns and raw dark greens is perhaps significant. Whether it is due to melancholia induced by the present world chaos, a rise of the proletarian spirit, or a combination of both is difficult to decide. The effect is morose and morbid and in some cases admittedly and intentionally so. It is the antithesis of the lyric and romantic color of the early years of this century.

It has been proved that most persons have the same reactions to color. In individual cases, this reaction is sometimes conditioned by early associations, usually forgotten. The effect, however, persists in the form of prejudices. Then, too, the individual sensitivity to color varies, ranging from the color-blind to the supersensitive person whose color sense is as acute as his sense of taste, smell, and hearing.[13] Persons of the latter class are the great colorists. Although ideas or experiences associated with a particular color can modify the emotional reaction to a considerable extent, they are not usually the chief cause of this reaction. This has been demonstrated by the responses of children, who are usually ignorant of color symbolism and who have had few experiences associated with color. Our responses to color are more often as instinctive and as devoid of associations as our reactions to musical chords, which are melancholy or gay in themselves. A color can affect us as strongly as a

[13] Tests made at the U.S. Bureau of Standards indicate that color sensitivity varies even among those with normal color vision, changing with age and state of health (Letter Circulars 417 and 454).

400

a sacred hue in China and also in Western Christian civilization, where it is used in the churches in the form of gold-leaf backgrounds of sacred paintings and altar coverings to signify light and divine glory.

Yellow was much in fashion during 1890–1900, the period that is sometimes known as the "yellow nineties." It was the favorite hue of Burne-Jones, the Pre-Raphaelite painter, and of the literati Morris and Rossetti. The unlucky Oscar Wilde popularized it. Aubrey Beardsley, the exotic illustrator, affected lemon-yellow gloves and even had his entire studio on Warwick Square painted a deep, rich yellow with black wood trim. In the "greenery-yallery, Grosvenor Gallery," celebrated by W. S. Gilbert in *Patience*, yellow was the prevailing hue. Evening gowns of yellow satin were the rage, and *The Yellow Book*, published by Matthews and Lane at Bodley Head, created a literary sensation. During the same period in Paris, Toulouse-Lautrec was making lavish use of yellow in his now famous posters, and many of the popular novels had covers of the same hue.

Unpleasant. The darker and the more neutralized yellows and greenish yellows, such as Y 8/1, Y 5/4, and Y 2/2, are the most unpopular and disliked of all colors. These yellows are associated with sickness and disease, indecency, cowardice, jealousy, envy, deceit, and treachery. The yellow flag is flown on quarantined ships and sometimes hospitals. In tenth-century France, the doors of the houses of traitors and criminals were painted yellow, and Judas was pictured as clad in yellow garments. In ecclesiastical color symbolism, saffron stands for the confessors. With the advent of Christianity, the warm pagan or primitive colors, red and orange, fell into disfavor with the

church, and the use of the cool colors was encouraged. Today the terms "yellow dog" and "yellow streak" convey the ideas of treachery and cowardice. Nevertheless, these yellows, although unpleasant by themselves, may be satisfactory and even beautiful when properly related with other colors.

RED

Characteristics. Of all the colors, red has the strongest chroma and the greatest power of attraction. It is positive, aggressive, and exciting.[15] It is the most popular color, particularly with women. Red was the first color to be designated by name in primitive languages and the color most used in primitive and classical art. There has been much speculation as to the reason for this, and many hypotheses have been advanced to account for it, such as color blindness to blue. The one that has not been mentioned to my knowledge and the one that seems to me the most logical is as follows. Primitive art as well as classical was essentially an outdoor art; that is, it dealt chiefly with the decoration of façades, painted statues, and totem poles, war galleys, chariots, and the like. The background for this art was the blue sky and green vegetation. Therefore, the use of the warm colors, particularly red, would result in the most effective contrast against such a background, whereas blue and green would be overwhelmed and lost. I do not say that this was the only reason for the prevalence of the warm colors, but, unless the ancients were blind to color contrasts, it seems logical that their choice of color must have been influenced by the foregoing conditions. The same predominance of reds and yellows may be noted in the outdoor decora-

[15] Red light, it has recently been discovered, accelerates the pulse and raises blood pressure. Blue light has an opposite effect; it retards pulse rate and lowers blood pressure.

404

tions of today, exemplified in such things as beach and garden furniture and billboard advertising.

Yellow and red, the Classical colors, are the colors of the material, the near,[16] the full-blooded. Red is the characteristic color of sexuality . . . hence it is the only color that works upon the beasts. It matches best the Phallus-symbol. . . . Yellow and red are the popular colors, the colors of the crowd, of children, of women and of savages. For red and yellow, the . . . polytheistic colors, belong to the foreground even in respect of social life; they are meet for the noisy hearty market-days and holidays, the naive immediateness of a life subject to the blind chances of the Classical Fatum, the point existence.[17]

Symbolism and Associations. Red in general symbolizes the more primitive passions and emotions. It is associated with rage and strife, danger, courage, virility, and sex. In China it is used in connection with the marriage ceremony. In Occidental religion, red symbolizes martyrdom for faith. The Roman battle flags were red, and the same color is used today by anarchists and terrorists as an emblem of defiance and violence. The "red-light district" and the "scarlet woman" are allusions to the sexual aspect of this color.

Although bright red is stimulating and, in general, pleasing, when it is used too extensively or in too large quantities it becomes fatiguing and generates a desire for its complement blue-green.

PURPLE

Characteristics. Stately, rich, pompous, and impressive.

Symbolism and Associations. This color, a combination of blue and red, combines also the attributes of these two colors, that is, red—courage and virility—and blue—spirituality and nobility. It is the color of royalty and was favored by the ancient kings.

[16] See Color Refraction, p. 393.
[17] SPENGLER, OSWALD, *The Decline of the West.*

Characteristics. Cool, negative, and retiring. Similar to blue, but more subdued and solemn. It has a melancholy character, suggesting affliction and resignation.

Symbolism and Associations. As a religious symbol, violet denotes penitence of saints. Spengler says, "Violet, a red succumbing to blue, is the color of women no longer fruitful and of priests living in celibacy." Apropos of this, it is significant to note how apt is the reference to the nineties as the "mauve decade," as proved by popular acceptance. This was the end of an era dominated by the aged queen Victoria.

BLUE

Characteristics. Cool, serene, passive, and tranquil. Goethe calls it an "enchanting nothingness."

Blue and green are . . . spiritual, non-sensuous colors. . . . The Faustian, monotheistic colors . . . those of loneliness, of care, of a present that is related to a past and a future. . . . Blue . . . a perspective color. . . . It does not press in on us, it pulls us out into the remote.[18] . . . Blue and green are . . . essentially atmospheric and not substantial colors. They are cold, they disembody, and they evoke impressions of expanse and distance, and boundlessness.[19]

Symbolism and Association. With the church, blue signifies sincerity, hope, and serenity. Among the Spaniards and the Venetians, the elite affected blue or black, aware of the aloofness inherent in these colors. Today the expression "blue-blooded" denotes aristocracy, and the term "true blue" signifies fidelity.

GREEN

Characteristics. Similar to blue. Compared to the other colors, green is relatively neutral in its emotional effect, tending to be

[18] See Color Refraction, p. 393.
[19] SPENGLER, OSWALD, *The Decline of the West.*

406

more passive than active. For this reason it is often considered the most restful of colors.

Symbolism and Associations. Spengler calls it the specifically Catholic color. In religion, green represents faith, immortality, and contemplation. Used at Easter, it symbolizes the Resurrection. Pale green is the color of baptism. In ordinary usage "green" expresses freshness, raw, callow youth, and immaturity. The olive branch is the symbol of peace, and the laurel wreath, of immortality.

WHITE, GRAY, AND BLACK

Although white, gray, and black are, strictly speaking, not colors, they also are capable of inducing moods, which, however, are neither so strong nor so definite as those produced by hues.

WHITE

Characteristics. Positive and stimulating, as compared with gray or black. Luminous, airy, light, and delicate.

Symbolism and Associations. Purity, chastity, innocence, and truth. In modern slang, "white guy" signifies honesty and integrity. In China, white is the color of mourning and bereavement; with us it is the traditional color of the bridal costume. Another association is the white flag, signifying a truce or surrender.

MIDDLE GRAY

Characteristics. As might be expected, middle gray partakes of the character of both black and white. It has a mellow richness that is lacking in the shriller white. On the other hand, it is free of the depressing heaviness inherent in black. For this reason it is the most popular and pleasing of the grays and is

407

generally preferred to either black or white. A middle gray is the ideal background for most colors. It is on a gray ground, tinged with its complement, that a pure color appears to best advantage. For example, saturated red on greenish gray.

Associations and Symbolism. Gray generally symbolizes sedate and sober old age, with its passive resignation and humility.

BLACK

Characteristics. Subdued, depressing, solemn, and profound.

Symbolism and Associations. In Western civilizations, black has always signified sorrow, gloom, and death. Fear of darkness is natural to savages and children and persists with many adults. It is also indicative of secrecy, terror, and evil. The "black hand," the black flag of piracy, "black tidings," "black Friday," and the "Prince of Darkness" exemplify the significance of black. Although black by itself is somber, if used as a background with accents of white or color it achieves a smart formality.

COLOR HEARING (SYNESTHESIA)

Color hearing is a form of synesthesia that manifests itself by the appearance in the mind of colors or shades of gray whenever certain sounds are heard. For some people all the notes of the scale within certain regions have the same color; for others, each note has a distinct color.

Each instrument has really its own color, which may be defined as its special character, admitting at the same time that this resemblance may vary with different observers, perhaps owing to the differences in the conformation of the eye or of the ear.[20]

[20] LAVIGNAC, ALBERT (Professor of Harmony at the Paris Conservatory), *Music and Musicians.*

The horn is yellow, a brilliant coppery yellow. . . .

The family of trumpets, clarions, and trombones, presents all the gradations of crimson; mingled with the horns, gives orange; while the cornet, trivial and braggart, utters a note of very ordinary red, ox-blood, or lees of wine.

The warm sound of the clarinet, at once rough and velvety, brilliant in the high notes, sombre but rich in the chalumeau registers, calls up the idea of a red brown, the Van Dyke red, Garnet.[21]

. . . yellow and red . . . the colours of nearness, the popular colours, are associated with the brass timbre the effect of which is corporeal often to the point of vulgarity.[22]

BROWN

The bassoon, sombre, sad, painful, with feeble, timid, and inconspicuous timbre is certainly a dark brown, not a clean color, but a little mixed with gray.[20]

VIOLET

. . . the poor cor anglais, so melancholy, corresponds to violet, expressing affliction, sadness and resignation.[20]

BLUE

To most persons, as to myself, the ethereal, suave, transparent timbre of the flute with its placidity and its poetic charm, produces an auditive sensation analogous to the visual impression of the color blue, a fine blue, pure and luminous as the azure of the sky.[20]

The strings of the orchestra represent, as a class, the colors of the distance.[21]

GREEN

The oboe, so appropriate to the expression of rustic sentiments, appears to me distinctly green, a rather crude tint.[20]

WHITE, GRAY, AND BLACK

The percussion instruments, kettle drums, bass drum, make great black holes in the mass of sound; the roll of the side drum is grayish; the triangle, on the other hand, can be nothing less than silvery.

[21] LAVIGNAC, ALBERT (Professor of Harmony at the Paris Conservatory), *Music and Musicians.*

[22] SPENGLER, OSWALD, *The Decline of the West.*

As for the piano, it is a percussion instrument,—black. The music of the piano is, then, black and white, like a drawing in pencil, a charcoal sketch, an engraving. The cross-hatchings are to the Sketcher what the tremolo is to the pianist, the role of the pedal is like that of the stump, mingling, blending, strengthening, or reducing, according to the manner of using it and the occasion for its use.[23]

COLOR MUSIC

Although attempts to develop such an art were not made until the sixteenth century, certain similarities between color and sound had been noted much earlier by the Greeks. Aristotle, in his *De Sensu,* had commented upon the analogy between sound harmony and color harmony.

One of the first attempts to merge the arts of painting and music was made in the sixteenth century. Arcimboldo, a Milanese painter, devised a method of color harmony established upon a color scale similar in its system to the musical scale.

Later, in the seventeenth and eighteenth centuries, inspired by Newton's color experiments, further attempts were made to link the spectrum colors with the notes of the diatonic scale.[24] To an era fond of philosophizing upon "the music of the spheres," it seemed obvious that there was some obscure but basic connection between sound and color.

Recently Albert Lavignac wrote in his *Music and Musicians:*

The art of orchestration seems to me to have much similarity to the painter's art in the use of color; the musician's palette is his orchestral list; here he finds all the tones necessary to clothe his thought, his melodic design, his harmonic tissue; to produce lights and shadows, he mixes them almost as the painter mixes his colors.

From a point of view like this, military music, the fanfare, corresponds to different kinds of decorative painting. Like it, they proceed in grand masses, they neglect details, employ strong procedures, and aim especially

[23] LAVIGNAC, ALBERT, *Music and Musicians.*
[24] See the comment of Sir James Jeans on p. 320.

410

at effects from a distance. And chamber music would be the water color . . . having very tender delicate gradations of color.

The Russian composer Scriabin was credited with the faculty of color audition. His composition, *Prometheus, the Poem of Fire* for which he devised an accompaniment of changing colored lights, made its debut in Moscow in 1911.[25]

It has been the dream of many men to build a "color organ," an instrument that would combine color and music. What was perhaps the first attempt was made in 1757 by Castel, a Jesuit priest and mathematician. He designed and built what was probably the first contrivance of its kind, a stringed musical instrument combined with moving transparent and colored tapes.

The latest experimenter in this field is Thomas Wilfred, an American. Unlike most of his predecessors, he does not attempt to combine sound and color. Previous attempts to do so were erroneous, in Mr. Wilfred's opinion, in which he is supported by other students of the subject. His instrument, which he calls the "Clavilux," projects mobile color patterns upon a screen.

Although light and sound are similar in certain respects, it is generally agreed that the attempts to formulate a system of color music based on the musical scale have been faulty and unsuccessful. The originators of these systems have generally not considered the limitations of the analogy, the essential differences between the ear and the eye and other factors. Despite these failures, it is agreed that an art of mobile color similar to music would be possible if this art were based on the same structural principles as music but developed according to

[25] A choreographic symphony presented by the Ballet Russe in New York in 1936 was a splendid example of integrating movement, color, and sound. The music was Brahms' Fourth Symphony. The choreography was by Léonide Massine, and the scenery and costumes, by Constantin Terechkovitch and Eugene Lourie.

411

the laws governing the eye and light. A collaboration of Pablo Picasso, Deems Taylor, Léonide Massine, and the Walt Disney Studios might produce a pioneer creation in this field.[26]

9. ABSTRACT FILMS

Today, new instruments have expanded the range of visual art by enriching it with the added factors of time intervals and movement. These new instruments, the moving-picture camera and projector, now make possible a new art form . . . the abstract film.

A pioneer in this new art medium was the Cubist painter Léopold Survage, who, as early as 1913, realized the potentialities of cinematography. Foreseeing a new art form and visualizing the extension of abstraction from the static canvas to the mobile screen, he wrote:

> An immobile abstract form does not say much . . . it is only when it sets in motion, when it is transformed and meets other forms, that it becomes capable of evoking a feeling. . . . Upon becoming transformed in time, it sweeps space; it encounters other forms in the path of its transformation and they combine; sometimes they travel side by side, and sometimes battle among themselves or dance to the cadenced rhythm that directs them . . . the transformations begin anew, and it is in this way that visual rhythm becomes analogous to the sound-rhythm of music.[27]

Survage originated the procedure that is the basis of the technique used in the abstract film and animated cartoon of today. This consists in the preparation of a series of master drawings that are then copied on celluloid by assistant draftsmen and animators who also make the transitional steps be-

[26] Since this was written Walt Disney and Deems Taylor have collaborated on *Fantasia*, the first feature-length semi-abstract film. (See *The Art of Walt Disney* by Robert Feild, The Macmillan Company, N.Y., 1942.)

[27] Translated by Samuel Putnam from pp. 180–184 of *Transition*, Vol. 6, September, 1927. (See Conflict, p. 81.)

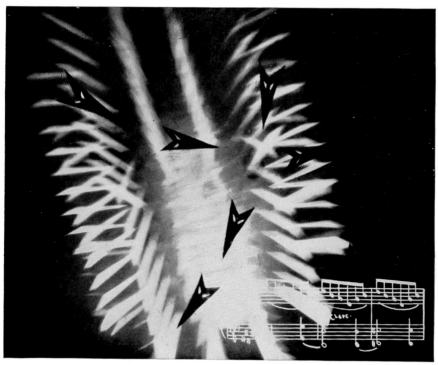

DESIGN FOR THE ABSTRACT FILM *Danse Macabre* BY MARY ELLEN BUTE
Photographed by Ted Nemeth. (*Courtesy of Expanding Cinema.*)

tween the key drawings. When photographed and projected, the designs are blended into a smoothly flowing sequence. The labor involved in making an abstract film is prodigious. Each design or frame must be drawn and colored by hand, and even for a film lasting only 10 minutes over 14,000 frames must be prepared, because they are projected at the rate of 24 frames a second. Survage labored hopefully on his proposed film for years while eking out a meager living as a piano tuner, only to see his dream frustrated by the war.

It was not until 1919 that the first nonrepresentational film, *Diagonal-Symphonie*, was finally produced by the Swedish artist, Viking Eggeling, in Berlin. This film was followed by

413

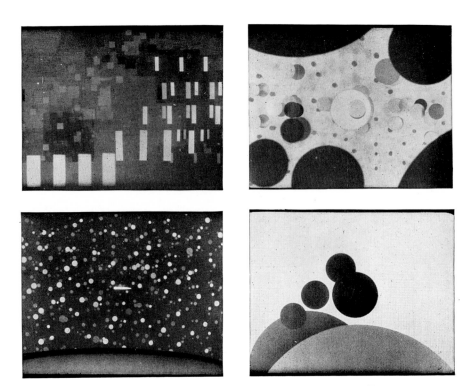

STILLS FROM THE METRO-GOLDWYN-MAYER ABSTRACT FILM
Optical Poem BY OSKAR FISCHINGER

Prelude and Rhythmus 21[28] by Hans Richter, who was Egge-ling's friend and collaborator. Also, at about this time, Walter Ruttman, the German painter (now a film director), produced *Opus* I, II, *and* III. Since then many other abstract films have been made in France, England, and America.

Some of these are in color and are synchronized with music. In England, the Australian painter Len Lye has made *Color Box*[28] (1935), *Rainbow Dance* (1936), and *Trade Tattoo* (1937), which were shown as advertisements for the British Post Office, and *Swinging the Lambeth Walk*[28] (1939). An-

[28] Included in the Museum of Modern Art Circulating Film Library, New York. This film library is at the disposal of colleges, museums, and study groups. The conditions under which films may be borrowed may be learned from the Film Library.

other British abstract film, $X + X = A$ *Syn Nt*[29] by B.G.D. Salt and Robert Fairthorne, is designed for educational use in illustrating problems of higher mathematics in animated form.

In America, Maude Adams of *Peter Pan* fame, who has done considerable research in light and color, was one of the first to design an abstract film *Color Dynamics*, which was produced by the Eastman Kodak Company in 1925. Among American nonpresentational films are *Escape*[30] and *Rhythm in Light*[31] (sychronized to Grieg's *Anitra's Dance*) by Mary Ellen Bute and Theodore Nemeth, *Parabold*[30] by Rutherford Boyd, *Fantasmagoria*[30] by Douglas Crockwell, and *Synchrony No. 2,*[32] which is synchronized to Wagner's *Evening Star.* Another unique and vivid abstract color film synchronized to Liszt's *Hungarian Rhapsody No. 2* is *Optical Poem*[33] produced by Metro-Goldwyn-Mayer. *Optical Poem* was composed by Oskar Fischinger, who subsequently joined the staff of artists at the Walt Disney studio in Hollywood.

Mary Ellen Bute, the distinguished young American composer of abstract films, in describing her technique, says

The art of the abstract film is the elaboration and inter-relation of the phenomena of light, form, movement and sound . . . combined and projected to stimulate an aesthetic idea unassociated with ideas of literature, religion, ethics or decoration.

Here light, form, and sound are in dynamic balance with kinetic space relations. In the absolute film the artist creates a world of color, form, sound, and movement, in which the elements are in a state of controllable

[29] Included in the Museum of Modern Art Circulating Film Library, New York. This film library is at the disposal of colleges, museums, and study groups. The conditions under which films may be borrowed may be learned from the Film Library.

[30] Included in the Museum of Modern Art Film Library.

[31] May be obtained for a nominal rental from Expanding Cinema Productions, 422 West 46th St., New York.

[32] May be rented from Commonwealth Pictures Corporation, 729 Seventh Avenue, New York.

[33] May be rented from Teaching Film Custodians, 25 West 43d St., New York.

415

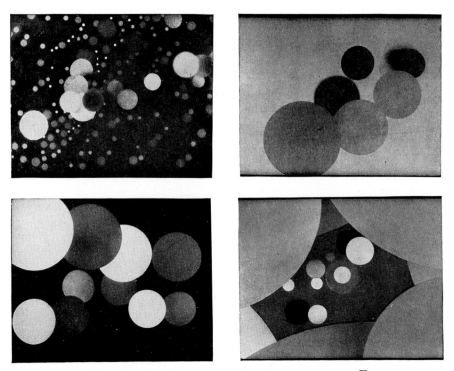

STILLS FROM THE METRO-GOLDWYN-MAYER ABSTRACT FILM
Optical Poem BY OSKAR FISCHINGER

flux—the two materials, visual and aural, being subject to any conceivable inter-relation and modification.

A mathematical system serves as a basis for our particular work in the inter-composition of these visual and aural materials in the time continuity. We take the relationship of two or more numbers—for instance, 7:2, 3:4, 9:5:4—fraction them around their axes, raise to powers, permutate, divide, multiply, subtract, and invert, until we have a complete composition of the desired length in numbers.

Then we realize this composition in the materials we have selected to employ. We use this composition of numbers to determine the length, width, and depth of the photographic field, and everything in it. This numerical composition determines the length, speed, and duration of a zoom, a travelback with the camera, the curve and angle at which the camera approaches a subject, etc.

It determines the shape, size, color, and luminosity of the subject—how,

416

when and in what relationship to other elements of the composition it develops and moves.[34]

QUESTIONS

1. What are the general attributes or characteristics of warm colors as compared with cool colors?
2. Is color blindness more prevalent among women or among men?
3. When used in small areas, are pure, strong colors generally preferred to weak shades and tints?
4. When used in large areas, are weak shades and tints generally preferred to pure, strong colors?
5. Which color combination is generally most preferred, complementary, harmonious, or monochromatic?
6. What are the characteristics, symbolism, and associations of yellow? red? purple? violet? blue? green? white? gray? black?
7. What is "color hearing," or "synesthesia"?
8. Name one philosopher and one musician who agree that certain musical sounds are associated with certain colors.
9. What composer was credited with the faculty of color hearing, or synesthesia? How, when, and where did he use it?
10. Who was the inventor of one of the earliest color organs?
11. Name one contemporary experimenter in the field of mobile color pattern. What is his instrument called?
12. Name one abstract color film that has been successfully synchronized with music.

[34] See *The Mathematical Basis of The Arts*, J. Schillinger, Philosophical Library Inc., N.Y. 1948.

Conclusion

ALTHOUGH words about art may suggest the reality, complete comprehension comes only through practice. Nevertheless, words may help to a better understanding of structure, which is as necessary to the painter as it is to the poet, writer, architect, or musician.

Ignorance of structural principles may inhibit the artist, whose timidity will be reflected in negative and vague designs. Weak composition stifles expression and blurs the artist's personality.

But understanding inspires confidence and guides the designer in his selection of materials and means. It enables him to express himself with clarity and vigor, certain that a lack of organization will not choke the free, strong flow of his emotions and ideas.

To the artist, therefore, knowledge of design principles is essential, for art is man-made order that is based on these timeless absolutes, unity, conflict, and dominance. If this book has helped to make clear these principles, it has achieved its purpose.

418

Glossary

Advancing or Aggressive Color. Red, caused by Color Refraction, which see.

Aerial Perspective. The representation of space by gradations of color that parallel the effect produced by various densities of air on the appearance of objects.

Alternation. Reciprocal repetition. Regular and repeated interchange in succession. See p. 115.

Architectonic. Implies the characteristics of sound architectural design, such as stability, strength, constructive organization, formality.

Balance. Equilibrium of opposing visual attractions or forces.

Bas-relief. Carved design projecting from a background to which it is attached. See Janniot, p. 107.

Broken Color. See Pointillism.

Ceramics (Keramics). From a Greek word meaning earthenware or pottery.

Chiaroscuro. An Italian word meaning literally light (*chiaro*) and dark (*oscuro*). See Modeling.

Chroma. Degree of intensity, strength, saturation, or purity of a color.

Classic. (1) Pertaining to the art and literature of ancient Rome

and Greece. (2) A work of art or literature of high order and acknowledged excellence.

Clavilux. An instrument for projecting mobile color patterns on a screen.

Climax. Culmination or center of interest.

Color. A sensation produced by excitation of the eye by various stimuli such as light, drugs, pressure, or electricity.

Color Blindness. The inability to distinguish colors properly that is associated with subnormal perception of hue and chroma. It may be inherited or due to injury of the eye. Color blindness is more common among men than women.

Color Cabinet. A filing cabinet containing the indexed Munsell colors.

Color Chart. A cardboard rectangle containing value, chroma, and hue plans and the Table of Maximum Chromas that expedites the planning and selection of color chords.

Color Chord. A color combination in which the colors and the intervals between the colors, or the color rhythm, are planned according to the principles of design. This term distinguishes such an organized color relationship from a color combination in which the color rhythm is not so planned. See Composition VIII, p. 350.

Color Dimensions, Physical. Spectrophotometric analysis or physical measurement of color or light that is specified in dimensions of wave length, amplitude, etc.

Color Dimensions, Psychological. Hue, value, and chroma are the three psychological color attributes or qualities. These dimensions are measured in degrees of difference of color sensation.

Color Dominance. See Hue Key.

420

Color Hearing or Audition. A form of synesthesia that is manifested by the appearance in the mind of colors or grays whenever certain sounds are heard. See Synesthesia.

Color Interval. The degree of visual difference between two colors measured in steps of hue, value, and chroma.

Color Notation. Specification of a color by written symbols and numerals. See Munsell Color Notation.

Color Path. See Color Scale.

Color Refraction. The bending or deflection of a chromatic light beam in passing obliquely from one medium into another in which its velocity is changed, as in its passage from the air into the eye.

Color Rhythm. Measured, proportioned color intervals.

Color Scale. A series of colors that exhibit a regular change or gradation in one or more dimensions. See pp. 344 to 346.

Color Standard. A color whose psychological dimensions have been accurately measured and specified according to the Munsell Notation.

Color Symbolism. The use of color by religions, cults, nations, political parties, etc., to signify, represent, or express particular qualities, attributes, or characteristics.

Color Tree, Sphere, or Solid. A three-dimensional structure that shows all the colors in an orderly arrangement that is based on their hue, value, and chroma relationship. See p. 332.

Complement. That which completes. Complementary hues are two hues that differ most radically from each other, such as red and blue-green, which are diametrically opposite on the hue circuit and which produce a neutral or gray when mixed in the right proportion.

Composition. See Form and Design.

Continued Proportion. A recurrent or repeated ratio.

Contrast. A combination of opposite or nearly opposite qualities. Opposition, unlikeness, variety, conflict.

Contrasting Hues. Hues opposite or nearly opposite on the hue circuit, such as red and blue-green. See Complement.

Convergence. The approach to a common point. The opposite of Radiation, which see.

Cool Hues. Blue-green, blue, purple-blue, and purple.

Cubism. One of the art movements or phases that followed impressionism and that were distinguished by opposition to the scientific and naturalistic character of impressionism and neoimpressionism. It stressed aesthetic organization rather than representation, emphasized volumes, and used geometrical shapes and solids only. See cubist paintings by Georges Braque, Pablo Picasso, and Juan Gris.

Dadaism. From "dada," a child's word, cockhorse, hobby; a symbol in vogue during 1918–1920. The cult of Dada, started in France and Switzerland during World War I (1914–1918), was anarchy and iconoclasm in art and literature. Dadaism was art without objectives. It asserted that the objective importance of things is purely arbitrary. Although its doctrine was intentionally obscure, Dadaism advocated nihilism or deliberate destruction of the social order and romantic art. It has been said that by thus liberating art from the inertia of tradition, Dadaism served the negatively constructive function of the house wrecker and cleared the way for a new order. As was inevitable, Dadaism and Communism soon converged. . . . Some Dadaists were, in fact, communists. But it was in depressed postwar Germany that the Dadaists were most active politically. These German Dadaists, together with other

422

radical groups with which they were associated, were later "purged" or exiled by the Nazis. For manifestations of Dadaism and other phases of postimpressionism see *Fantastic Art, Dada, Surrealism,* a publication of the Museum of Modern Art, New York.

Design. The art of relating or unifying contrasting elements. Man-made order, structure, composition, organization, form. The art of creating interesting units.

Dimensions, Visual. The visual elements or qualities and quantities that constitute a unit. Visual attributes and characteristics, such as texture, color, size, etc. Compare Elements below.

Direction. Attitude or position, such as horizontal, vertical, left and right oblique.

Discord. Extreme contrast, opposition, or conflict.

Divergence. See Radiation.

Dominant. Preponderant, outweighing, predominant, principal, emphatic, accentuated. Dominant implies the presence of subordination, which is its negative opposite, because making one unit dominant automatically makes the other subordinate.

Dynamic Unity. Characteristic of units whose design suggests movement, action, life, and flowing continuity.

Elements. The basic materials or factors with which all visual art is built, such as line, color, texture, shape, etc. The visual dimensions, quantities, qualities, or attributes of units. See Dimensions.

Emphasis. See Dominant.

Etching. An intaglio printing process. An ink impression made on paper from a metal plate upon which a design has been scratched with a needle (dry point) or upon which a de-

sign has been etched or bitten by dipping the plate in acid. See "Coal Heavers," p. 52.

Fibonacci Series. One of a summation series in which the Golden Mean, or approximately 1.618, is the constant factor, such as 8, 13, 21, 34, 55, 89, 144, . . . , etc. Named after the early thirteenth-century Italian mathematician Leonardo Fibonacci, who calculated this to be the rate of propagation of a pair of rabbits.

Form. In the fine arts, form means man-made order, structure, design, composition, and organization, such as literary form, musical form, etc. Form is sometimes used as a synonym for bulk, mass, volume, and solid, which connotations are misleading and confusing if not incorrect.

Fresco. From the Italian *fresco,* or fresh. A water-color painting on freshly spread, moist plaster. When dry, the painting and plaster are permanently bonded by chemical action.

Futurism. A postimpressionism art movement that attempted to place the observer within the picture and show simultaneously a number of movements and appearances. See pp. 50, 124.

Golden Mean. The Golden Mean is 1.618, which is the geometric mean and also the constant factor in the geometrical progression 1, 1.618, 2.618, . . . , etc.

Gouache. Opaque water color or tempera.

Gradation. A sequence in which the adjoining parts are similar or harmonious. Transition, flowing continuity, crescendo, diminuendo, contiguous progression, regular and orderly change, blending. Steps, stairs, or scale.

Harmonious Hues. Adjacent or similar hues, such as blue-green, green, and green-yellow.

Harmony, Consonance. A combination of units that are similar in one or more respects. A medium interval or difference in one or more dimensions, qualities, or attributes.

High Key. A composition in which the general or prevailing tonality or dominant value is approximately 7, 8, or 9.

Home Value Level. The value level at which the strongest possible or maximum chroma of a hue is reached.

Hue. The quality or characteristic by which we distinguish one color from another, a red from a yellow or a green from a purple. The name of a color.

Hue Circuit. A progressively graded series of visually equidistant hues arranged in a circle. See p. 12.

Hue Key. The hue of largest area or dominant hue determines the hue key of a composition and may be warm, temperate, or cool.

Impressionism. A school of painting based on the theory and practice of expressing broadly, simply, and directly immediate visual impressions without minute analysis and detail. See paintings by Camille Pissarro and Claude Monet.

Ink Number. A number printed on the back of the Allcolor sheets that specifies the International Printing Ink number with which the color was printed.

Intaglio. Literally, cutting in, engraving, carving, or incision, as in etching, sculpture, gems, seals, and dies for coins.

Integrate. To unify, to make one complete whole.

Intermediate Key. A composition in which the dominant value is approximately 4, 5, or 6.

Interval. The degree of difference between quantities or magnitudes of the same nature, kind, or class, such as time, space, length, area, angle, value, color, etc.

425

Irradiation. The apparent enlargement of a bright object seen against a dark background, caused by a stimulation of the retina around the image.

Line. A continuous, unbroken mark made by a pen, pencil, brush, or drawing instrument. Also a series of separated points or other units that lead the eye along a path.

Linear Perspective. The science of representing objects in three-dimensional space with line on a two-dimensional surface.

Lithograph. A planographic or surface printing process. An ink impression on paper made from a design drawn with a greasy lithograph crayon on a special kind of stone or a specially prepared metal plate.

Low Key. A composition in which the dominant value is approximately 1, 2, or 3.

Major. Large or great interval, strong contrast, such as between values that are 5, 6, or 7 steps apart.

Measure. Size, area, or quantity. Although spatial dimensions, per se, may be absolute, the conception of measure is necessarily relative, because it is impossible to imagine one size except in comparison with another. For this reason, measure implies ratio or proportion.

Medium. The instruments, agencies, materials, or means of expression, such as oil paint, water color, stone, wood, metal, words, sound, etc. Also the liquid or vehicle with which pigment is mixed such as oil, water, varnish, wax, or egg.

Minor. Small interval, closed up, muted. Subdued, muffled, or weak contrast such as between values that are three steps apart or less.

Modeling. The use of values, tones, or light and dark shading to depict illuminated volumes or solids.

426

Monochromatic Color Chord. A color chord consisting of colors of the same hue but of different values and chromas.

Monochrome. Any combination of colors of the same hue but of different values or chromas.

Monolith. A large single block of stone shaped into a statue or monument.

Monotheism. A doctrine of, or belief in, one god. Monism.

Munsell Color Notation. A system consisting of accurately measured, standardized color scales by means of which any color may be precisely described and specified by written symbols and numerals and its relation to any other color stated in terms of definite color intervals.

Mural. From the Latin *muralis,* or wall—a wall painting. See "Mexican Frieze" on p. 216.

Neoimpressionism. A more rigidly scientific development of impressionism in which the pointillist technique was used.

Neutral Color. Black, white, and grays that have no hue or chroma.

Notan. A Japanese term designating arbitrary value pattern in contradistinction to naturalistic light and shadow and realistic modeling or chiaroscuro.

Period Color Scheme. A color combination characteristic of a historical period such as the Victorian, French Empire, Early American, etc.

Philosophers' Stone. An imaginary stone believed by medieval alchemists to have the power of transmuting other metals into silver or gold.

Photometer. An instrument for measuring the intensity of light.

Plans of Value or Color Quantities. Approximate proportions

of value or color areas planned according to design principles.

Plein-Air. Designating open-air painting and pertaining to impressionist landscapes.

Pointillism. A technique invented by the French impressionists of suggesting light effects by means of tiny points of pure pigment that are blended by the eye. Modern photoengraving and color printing employ the same device. See "The Parade" by Georges Seurat, p. 245.

Polytheism. The doctrine of, or belief in, a plurality of gods. Pluralism.

Principle of Design. A law of relationship or a plan of organization that determines the way in which the elements must be combined to accomplish a particular effect.

Proportion. In the fine arts, proportion means a designed relationship of measurements. It is a ratio of intervals or of magnitudes of the same nature, kind, or class, such as time, space, length, area, angle, value, color, etc.

Pure Color. An unadulterated pigment of its strongest possible or maximum chroma, such as cadmium red.

Radiation. A divergence from a common point in different directions, as nonparallel arrows. The opposite of convergence.

Ratio. See Proportion.

Receding or Retiring Color. Blue, caused by Color Refraction, which see p. 393.

Renaissance. Literally, being born again. The revival of classical art and learning in Europe (fourteenth to sixteenth centuries), marking the transition from medieval to modern times. The style of art that then prevailed.

Repetition. Repeating or echoing of a shape, hue, value, direction, etc. Recurrence, succession, continuation.

Rhythm. Measured, proportioned intervals.

Scale. See Gradation.

Sequence. See Gradation.

Shade. (1) A mixture of pure color and black. (2) A surface in shadow.

Shape. A two-dimensional pattern such as a circular disk, a square, a rectangle, a triangle, etc.

Silhouette. A flat, empty, cut-out shape or pattern. Named after Étienne de Silhouette (1709–1767), a French politician.

Spectrophotometer. An instrument for comparing and measuring colors.

Spectrum. A colored image produced when white light is so dispersed by a prism or a diffraction grating that its component rays form a gradation in the order of their wave lengths.

Static Unity. Characteristic of a unit whose design suggests inertia, passive or formal regularity, stiffness, rigidity, and uniformity.

Subordination. Subduing or making less emphatic and less important. Conformity to an imposed order. Subordination implies the presence of dominance that is its positive opposite.

Surrealism. A school of subjective painters who opposed the cubists' intellectual, abstract art and suppression of literary content in painting. They experimented with fantasy, with weird psychological effects, explored the dream world, and tried to reveal with grotesque and extravagant symbolism the workings of the subsconscious. See the paintings of Salvador Dali and his fifteenth-century Flemish predecessor Jerome Bosch (1450–1518), also "The Temptation of St. Anthony," painted by Jan Mandijn about 400 years ago. See also pp. 82, 83.

Symmetry. Reverse repetition on opposite sides of a center or an axis, as in animals, insects, fish, and flowers. Equilibrium, balance. See pp. 146–147.

Synesthesia. Concomitant experience of different kinds of sensation, as when sounds are apprehended as having characteristic colors. See Color Hearing.

Table of Maximum Chromas. A chart showing the strongest or maximum chroma attained by each hue at each value level.

Temperate Hues. Green and red-purple, the hues that are between the warm and cool halves of the hue circuit and are relatively neither hot nor cold.

Texture. The quality of a surface, such as rough, smooth, mat, or dull, glossy, etc.

Tint. (1) A mixture of pure color and white. (2) A thin transparent color wash or stain on white paper or textiles.

Tone. In America, tone means any value. In England, tone signifies the predominating value or color of a picture and suggests its Value Key, which see.

Transition. See Gradation.

Unity. Cohesion, consistency, oneness, coherence, integration.

Value. Degree of luminosity or brightness of a color or of a neutral gray.

Value Chord. A value combination in which the values and the intervals between the values, or the value rhythm, is planned according to the principles of design. This term distinguishes such an organized value relationship from a value combination in which value rhythm is not so planned. See Composition II, p. 298.

Value, Chroma, and Hue Plans. Certain specified combinations of values, chromas, or hues that are related according to

the principles of design. Combined in various ways, these plans produce different color chords, which see.

Value Key. A particular relationship of values in a painting, lithograph, etching, etc., which is specified according to the dominant value and to the darkest and lightest values in the composition.

Value Level. A horizontal cross section through the color solid on which all colors are of the same value.

Value Rhythm. Measured, proportional value intervals.

Value Scale. A series of visually equidistant neutral grays lying between black and white. See p. 11.

Vignette. From "vine." An irregular, unframed design that tapers or shades off gradually. See Composition I, p. 311.

Vorticism. An art movement initiated by the English painter Wyndham Lewis in London, 1914. Vorticism, influenced by cubism and futurism, advanced the theory that art should express the complexity of modern industrial civilization and the machine.

Warm Hues. Red, yellow-red, yellow, and green-yellow.

Woodcut. A printed impression on paper made with black or colored inks from a design cut in either intaglio or relief on a block of wood. See "Rain," p. 57, "The Wave," p. 92, and "Forest Girl," p. 290.

Index

436

437

W